THE STREET PHOTOGRAPHER'S MANUAL

NEW EDITION

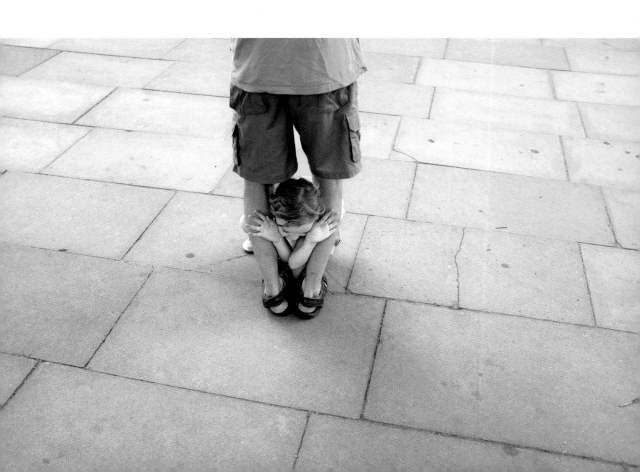

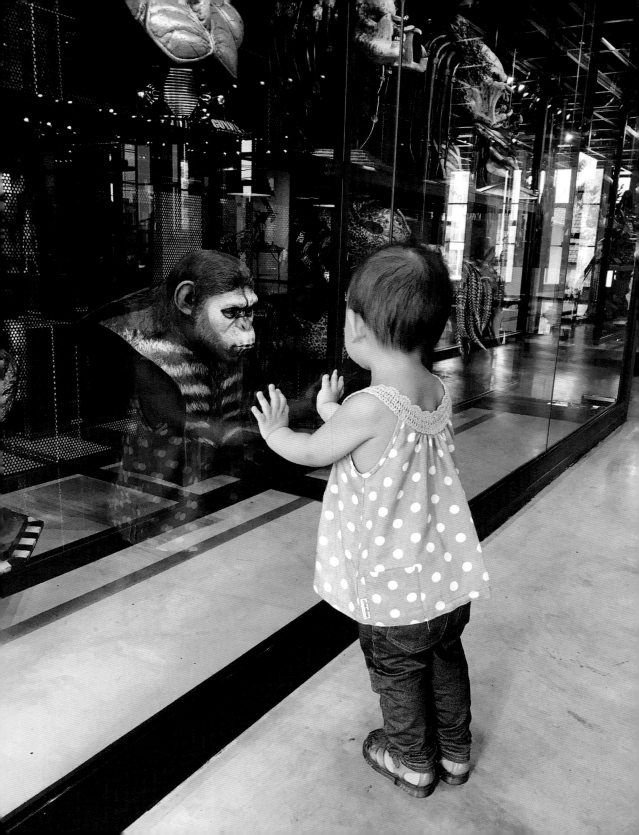

DAVID GIBSON FOREWORD BY MATT STUART

THE STREET PHOTOGRAPHER'S MANUAL NEW EDITION

For my Mother: Margaret Gibson (1923–2008)

First published in the United Kingdom in 2014 by Thames & Hudson Ltd,
181A High Holborn, London WC1V 7QX

First published in the United States of America in 2014 by Thames & Hudson Inc.,
500 Fifth Avenue, New York, New York 10110, USA

This revised edition first published in 2020

Reprinted in 2021

British Library Cataloguing-in-Publication Data
A catalogue record for this book is available from the British Library

Library of Congress Control Number 2019939101

ISBN 978-0-500-54526-3

Printed in China by 1010 Printing International Limited.

Image Credits

Cover © Jonathan Higbee

Page 1: David Gibson, London; 2017
Page 2: Sukanya Cherdrungsi, Bangkok; 2017

Blake Andrews 84–85; Narelle Autio 173; Richard Bram 28; Melissa Breyer 125; Sukanya Cherdrungsi 2;
David Gaberle 151, 152–153; Michelle Groskopf 167; Fan Ho 11; Troy Holden 56–57; Nils Jorgensen 65, 91;
Rinzing Kelsang 12–13; Jesse Marlow 136–137; Andy Morley-Hall 31; Johanna Neurath 144–145;
Shin Noguchi 102–103; Colin O'Brien 20–21; Trent Parke 131; Maria Plotnikova 72–73; Sasikumar
Ramachandran 22–23; Jack Simon 119; Merel Schoneveld 79; Matt Stuart 15, 67; Angkul Sungthong 40–41;
Roza Vulf 48; Craig Whitehead 179

Magnum Photos: Henri Cartier-Bresson 7, 18–19; Leonard Freed 43; Elliott Erwitt 51; Bruce Gilden 63;
Sergio Larrain 33; Trent Parke 131; Martin Parr 25; Gueorgui Pinkhassov 113; Raghu Rai 10;
Marc Riboud 39, 97; Ferdinando Scianna 16; Alex Webb 34–35

Maloof Collection, Ltd: Vivian Maier 77

Mary Evans Picture Library: Roger Mayne 44

Simone Giacomelli: Mario Giacomelli 107

All other photographs © David Gibson

While every effort has been made to credit contributors, Quarto Publishing would like to apologise should
there have been any omissions or errors, and would be pleased to make the appropriate correction for
future editions of the book.

Be the first to know about our new releases,
exclusive content and author events by visiting
thamesandhudson.com
thamesandhudsonusa.com
thamesandhudson.com.au

CONTENTS

FOREWORD 6

INTRODUCTION 7

CHAPTER 1 / BUSY INTRO 46
 ELLIOTT ERWITT 50
 ORDER 52
 TROY HOLDEN 56
 EVENTS 58
 BRUCE GILDEN 62
 SEQUENCES 64
 MATT STUART 66
 LINING UP 68
 MARIA PLOTNIKOVA 72

CHAPTER 2 / QUIET INTRO 74
 MEREL SCHONEVELD 78
 WAITING 80
 BLAKE ANDREWS 84
 FOLLOWING 86
 NILS JORGENSEN 90
 BEHIND 92
 MARC RIBOUD 96
 LOOKING DOWN 98
 SHIN NOGUCHI 102

CHAPTER 3 / ABSTRACT INTRO 104
 BLURRED 108
 GUEORGUI PINKHASSOV 112

 LAYERS 114
 JACK SIMON 118
 SHADOWS 120
 MELISSA BREYER 124
 REFLECTIONS 126
 TRENT PARKE 130
 DOUBLES 132
 JESSE MARLOW 136

CHAPTER 4 / STILL INTRO 138
 EMPTY 142
 JOHANNA NEURATH 144
 OBJECTS 146
 DAVID GABERLE 150
 GRAPHIC 154

CHAPTER 5 / SUBJECTS INTRO 158
 CHILDREN 162
 MICHELLE GROSKOPF 166
 PROJECTS 168
 NARELLE AUTIO 172
 VERTICAL/HORIZONTAL 174
 CRAIG WHITEHEAD 178
 ETHICS 180

REFERENCE CONCLUSION 182
 GLOSSARY 184
 BIBLIOGRAPHY 186
 INDEX 188

FOREWORD

I have known David Gibson for a long time. Our common love for photography, specifically street photography, has kept us good friends for over two decades. I have never told him this, but David was one of the first photographers who truly inspired me, and he was actually the first person to make me realise that this type of photography could be done, and in fact was being done really well in London. His work was a revelation to me.

Fast forward 20 years or so and David and I are still friends. Although we see each other less, we try to keep in contact whenever we are both in town. I now take photographs and teach street photography workshops around the world, in collaboration with both Leica and Magnum Photos. *The Street Photographer's Manual*, first published in 2014, now seems to follow me around on my travels – I have even signed a few copies, because I am one of the photographers featured. There is something else about this book that connects with many street photographers who are starting out though, as is evidenced by its many enthusiastic reviewers, stating amongst other things; '*Well written by someone who clearly knows his trade*' and '*I looked forward to reading* The Street Photographer's Manual. *I was not*

disappointed; in fact I had trouble putting the book down. The book has a sort of stream-of-consciousness style, must be much like attending one of his workshops. This style makes it quick reading, interesting and never boring'.

The point about David's book is that you have to be receptive; you have to be open and ready. No book or workshop is perfect, but David's knowledge and passion for street photography is second to none, and it pours out from these pages. In this new edition there are inspirational new profiles from emerging photographers, additional information on Instagram and updated resource lists.

The Street Photographer's Manual has now been translated into seven different languages. I have seen it in Amsterdam, Beijing, Bangkok, Paris and New York...if photographers turn up to one of my workshops with a copy, I feel better. I know that they want to learn, that they are serious, and that we are speaking the same language, no matter where in the world we are.

Matt Stuart

INTRODUCTION

Wandering around with nothing particularly in mind to photograph may seem strange, but when that bit of magic happens, it becomes the most natural and wonderful thing to do.

WHAT IS STREET PHOTOGRAPHY?

In the photography section of a bookshop, the least interesting shelves for me are those with the instructional and technical books. I do not understand these books, either practically or emotionally. When I first studied photography in the late 1980s, the theory almost put me off taking photographs. It stifled my confidence and this is still deeply ingrained in me. I am much more interested in looking at great photographs, especially street photographs. That is where I have learnt photography and I wish to set that as the tone for this book. Indeed, I hope that the photographs alone in this book will be an inspiration to readers who may already be curious about street photography.

I should insert another caveat early on – that personal opinion is probably unavoidable, such as my dislike of technical matters, for example. In writing this book I have become more aware of intolerance and how easy it is to become rigid in your views. Everyone has different opinions about pictures, including how they come about. Henri Cartier-Bresson was intolerant towards some photography; he had discipline and high aesthetic standards, yet he distrusted colour photography intensely. That was his view, but he was not necessarily right.

This book could well be aimed at my younger self – an innocent who had just embarked on a life-long interest in photography, hungry to soak up more and find a direction for my own practice. Innocence is meant in the sense of a child-like wonder, which invariably becomes challenged and changed as you grow older. I am acutely aware of this initial learning period, this obsessive steep learning curve that I can never quite return to. Yet through teaching workshops on street photography, I have encountered a similar hunger in others. Someone else's fresh enthusiasm is a great tonic.

This book is about looking at and recognising the process whereby street photographs come about. You cannot teach luck, you cannot teach passion for street photography, but if the seed is already there this book might clarify or even accelerate the process.

My copy of *The Complete Photographer* by Andreas Feininger (1968) has a striking cover portrait of an Asian woman, with her black hair merging into the background with splashes of red light. I'm hooked on the design of this book with its distinctive font; it is an impressive tome on the technical aspects of photography, and includes numerous diagrams, charts and equations. Feininger was a fine photographer but he does concede:

'Photography can be taught only in part – specifically, that part which deals with photo-technique. Everything else has to come from the photographer.'

I find this admission reassuring, yet ironically this book will probably end up in the 'how to' section in bookshops rather than amongst the collections of great photographers' work. In truth this is an in-between book; it deals with the practicalities of street photography but attempts to break down the different approaches into clear concepts that photographers can

use. I was fearful that some of these concepts might be obvious, but then remembered a casual piece of advice I once gave to someone struggling with what to photograph on the street. My suggestion to get on a bus, watch the world go by and get off when he saw something interesting, was a revelation to him. I was surprised because I have done this for years; it seems obvious to me but it can be helpful to others.

While covering some of the general history of street photography, I have also found it fascinating to consider the eyes and minds of 20 individual photographers. They bind this book together; they show what is possible and how photography gives greater meaning to their lives. Overall I hope that this passion for street photography, which is shared by many others around the world, shines through.

In his musings on the meaning of subjects and personalities in photography in *The Ongoing Moment* (2005), Geoff Dyer asks the intriguing question, what is the difference between a road and a street? He concludes:

'It is not a question of size (some urban streets are wider than country roads). A road heads out of town, while a street stays there, so you find roads in the country but not streets. If a street leads to a road, you are heading out of town. If a road turns into a street, you are heading into town. Keep on it long enough and a road will eventually turn into a street but not necessarily vice versa (a street can be an end in itself). Streets must have houses on either side of them to be streets. The best streets urge you to stay; the road is an endless incentive to leave.'

Henri Cartier-Bresson, Shanghai; 1948

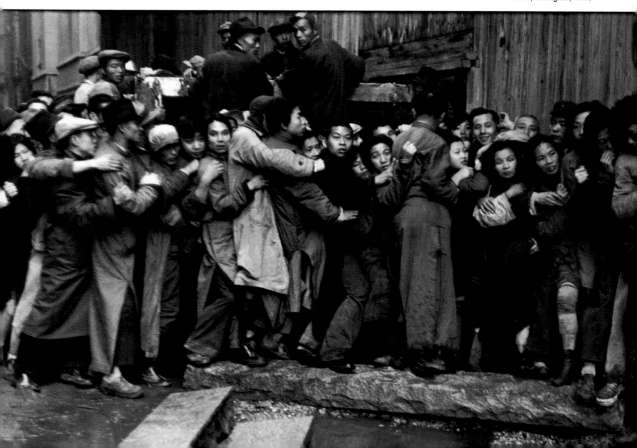

This is a delicious prospect but ultimately it leaves you confused about where you might be, quite literally. However, the point is who cares if you took the photograph on a road or a street? Furthermore, street photographers sometimes take road trips but they are not road photographers.

Dyer also wrote a very moving book about jazz – *But Beautiful* (1992) – a genre to which street photography has some kinship. Both forms of art were developed by mavericks. I make this seemingly odd connection as a prelude to offer an alternative name for street photography, which relates to jazz and how it plays around with melodies. Above all, I identify an empathy with the mindset of jazz musicians. They get lost; they have an idea where they are going, they are in control but they are open to chance and what feels right in the moment. That alternative name for street photography could be 'lost photography' – street photographers need to get lost.

Many street photographers allude to this mental state of getting lost – of finding a portal or being in the zone. It's almost a rite of passage, a secret knowledge that can only be experienced in the practice of it. Such motivations give us a better understanding of street photography. Nick Turpin, the founder of In-Public, the international collective of street photographers, offers his own sense of wonder on the process:

'How many other forms of photography essentially have "wonder" at their heart? That's what makes street photography almost a spiritual process for many because it is so personal and so akin to a kind of photographic enlightenment. Street photography helps me understand the nature of my society and my place in it, I do it more for myself than I do for an external audience and like Buddhist enlightenment I do achieve a happiness through gaining that understanding. I have certainly experienced Matrix-like moments of revelation when in a public place I see things; moments just reveal themselves because I have put myself in the right situation for it to happen.'

Offering a definition of street photography, both spiritual and prosaic, is one of the underlying themes of this book. A short description is any kind of photography taken in a public space. It is usually of ordinary people going about their everyday lives. Street photography's core value is that it is never set up; this aspect is 'non-negotiable' because the guiding spirit of street photography is that it is real.

The word 'street' itself suggests this authenticity: it is 'streetwise', it has attitude but, equally, public spaces can offer a whole range of poignant human moments. Street photography can be dark, edgy and surreal but it can also be light, warm and joyous. Crucially, it does not necessarily require people – evidence of people is just as valid. Everything goes into the pot and this is clear from the 20 photographers profiled, a fact which also highlights the difficulties of defining street photography. The choice of profiles set a tone, and I gladly concede that the process was a little haphazard; it grew organically and became a mixture of 'big names' and those more connected with the online growth of street photography.

The majority of landscape photographer Kate Kirkwood's work is taken on the Lake District farm in the UK where she lives. Her series *Spine* is basically the hide of cows interwoven with the hills and sky. The colour photographs are astonishing but when I showed them at a workshop in Athens, one of the participants exclaimed, 'this is not street photography', and he had a point. Street photography is any kind of photography taken outside of your front door, but does it extend to farm animals and landscape?

Paul Russell, based on the UK's south coast, has a liking for agricultural shows. These involve people and show the eccentricities of the English at play. Russell is regarded as a quintessential street photographer with a quirky sense of humour, even though his territory is not usually urban centres. The idea of street photography can extend far beyond the big city.

LOCATION AND COMMUNITIES

Location is a factor in street photography, and arguably some countries are more 'advanced' than others. Africa appears not to be on the street photography map, but this could be a blinkered view. There is regrettably an absence of street photographers profiled here from Scandinavia, and also South and Central America, although street photography is certainly active in those areas. There is a very focused community in Stockholm, for example, led by CUP (Contemporary Urban Photographers), who invite photographers to conduct workshops and organise exhibitions there, which have included their own work. CUP is a fairly typical community of street photographers: they are a small core of local enthusiasts who, buoyed by the Internet, decided to group together to promote the genre more effectively in their home city.

I have without doubt and for various reasons left out some great street photographers. I am aware of Invisible Photographer Asia (IPA) in Singapore, the hub of Asia but also the hub of photography in Asia. IPA, which was founded in 2010 by Kevin WY Lee, already has a massive following in the region and reaches out online but also personally. Lee has a strong belief in tangible contact, seeing and sharing physical prints on the wall of the IPA gallery, appreciating and producing photographic books, and also through organising workshops.

In 2012 IPA produced a fascinating list of the twenty most influential photographers in Asia, which placed Daido Moriyama, Nobuyoshi Araki and Raghu Rai respectively as numbers one, two and three. Also in the list was Fan Ho, a photographer, actor and filmmaker from Hong Kong (China). To me, and many others, Fan Ho's finely tuned black-and-white photographs of Hong Kong (China) from the 1950s are a revelation. To discover a fairly obscure photographer with such beautiful work strengthens your belief that there is always more to discover.

Raghu Rai, Mumbai; 1995

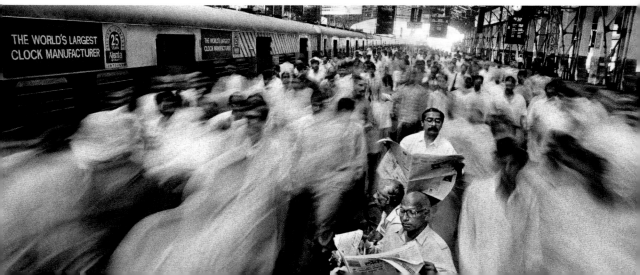

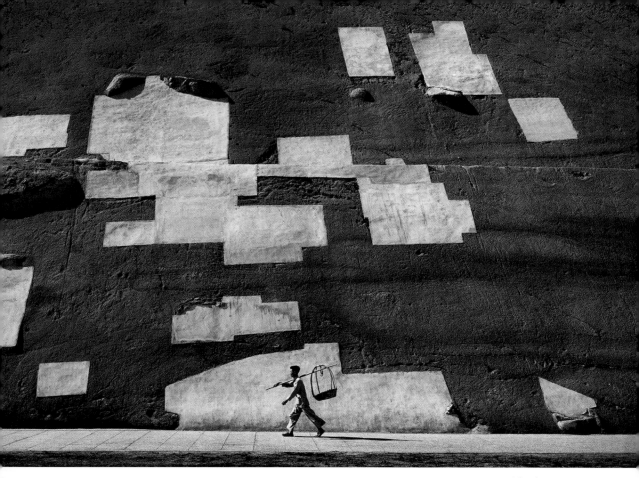

Fan Ho, Hong Kong (China); 1956

A separate but related point is the prospect of street photography being located in commercial galleries. This is a complex issue about perceived values, hype and presentation – or maybe just plain luck or ambition. The photography market is a big subject; I would venture only to say that street photography ends up in highly priced galleries more through luck than design.

THE ENERGY OF STREET PHOTOGRAPHY VARIES FROM CITY TO CITY AROUND THE WORLD. SOME ARE MORE PROMINENT THAN OTHERS BUT THE POTENTIAL IS ALWAYS THERE.

SUBJECTS

What word best describes aspects of street photography that might be at the edge or don't quite fit? Perhaps fiction, although that suggests something made up, which is unpalatable for many street photographers. It is a grey area. However, there is a place away from the centre of street photography that does need mapping. Not everyone will go there, but it is important to acknowledge that other places, with possibly different cultures, exist.

You might call one region 'distortion', anything that moves away from what the eye sees naturally. Extreme wide-angle and long lenses come within this area, although at least these lenses are still looking at reality; they are not setting up or rearranging reality.

Some years ago, I was wandering the streets of London with fellow photographer, Matt Stuart, when we saw a sign by some roadworks that read 'Extreme Danger'. In a light-hearted moment, I asked Matt to stand on his head behind the sign so that only his legs were showing. It's a funny photograph but I hardly ever show it because it was set up. I am acutely aware of this, and perhaps like a pack of cigarettes it requires a health warning writ large – 'this photograph was set up' – because to present it as a real moment would be deceitful; it would break trust both personally and in the wider community of street photography. This might sound dramatic but there are definite codes of conduct and a sense of responsibility within street photography. It could best be described as 'zero tolerance'.

A well-known photographer allegedly once said that looking for his type of photographs 'is like looking for a needle in a haystack, but sometimes it helps to throw another needle in the haystack'. This is a little ambiguous. Every street photographer at some point has probably been 'tempted' when it comes to still life on the street. How many street photographers can honestly say that they have never kicked away a small distracting element from their intended framing?

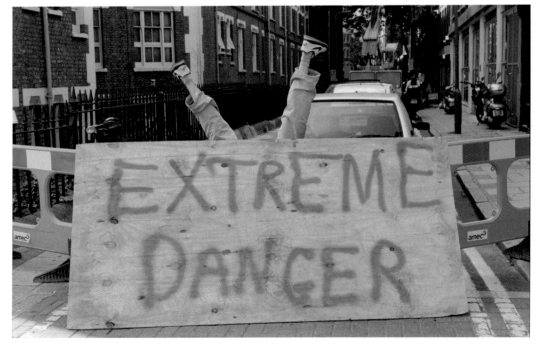

David Gibson, London; 2001

Matt Stuart, London; 2004

KNOW THE DIFFERENCE BETWEEN PHOTOGRAPHS THAT ARE SET UP AND THOSE WHICH ARE COMPELLINGLY REAL.

There is also the prospect of adding to a scene, or making it just right. A photographer once told me of his fascination for a poster that had two pigeons in it. Close by were some pigeons so he scattered some bread just below the poster and discreetly stepped back. Two pigeons, one black and one white, in perfect unison with the poster, duly obliged. The photographer got the shot that he wanted. This is arguably only mild interference, although some photographers might be reluctant to admit to such a deed.

This is a very sensitive issue and hugely important when interference goes beyond a certain point, but it essentially revolves around honesty. The consolation hopefully is that the trained eye usually sees dishonesty – what is unnatural in a photograph – whether a photograph has been set up, or worse, when digital manipulation has completely falsified it.

The latter is a separate and even more sensitive issue but again it comes back to honesty. 'Digital manipulation' are not dirty words. They are part of what was once the wet darkroom, which was also vulnerable to 'abuse'. Printers fiddled in the darkroom, sometimes too much. So, use digital manipulation

reasonably, but do not 'move the pyramid' and present it as real. This is absolutely unequivocal. Elliott Erwitt holds a commonly shared view on the subject:

'I'm almost violent about that stuff – electronic manipulation of pictures. I think it's an abomination. I reject it all. I mean, it's OK for selling corn flakes or automobiles or for taking pimples out of Elizabeth Taylor's face, but it undermines the thing that photography is about, which is about observation and not about manipulation of images.'

In the digital age, art and photography coexist, and it is an uncomfortable mix for many photographers. These two worlds sometimes collide when an artist 'who uses photography' plays around with the two mediums. I personally dislike this type of 'photographic art' – what might be called composites – but if the artist is honest in what they are presenting and the work comes with a 'health warning' that is absolutely fine.

The worst scenario is one where photographers, as opposed to artists, 'cheat'. Hopefully there are not many such photographers, but inevitably some dubious photographers will overly move or add things. Again, it is acceptable if they are completely open about their methods, but they must not hide those methods in the small print. It is usually only the detectives – other photographers – who hunt for clues.

Fashion photography has its critics; models are digitally made slimmer, for example, but generally it is honest and you accept it at face value. The clothes on the models are the purpose of the shoot and you know it's not quite the real world anyway.

Ferdinando Scianna, Sicily; 1987

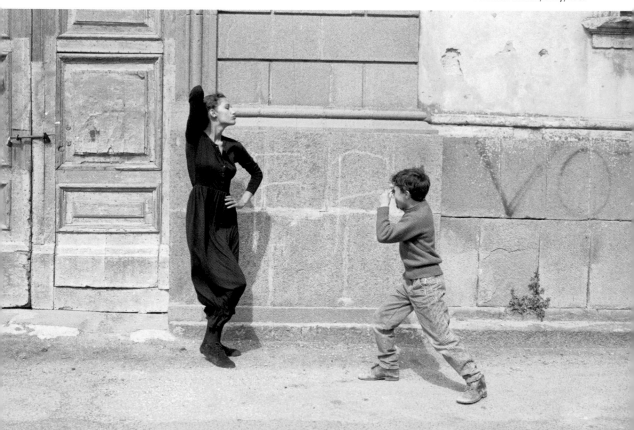

One of the constants of this book is resisting labels because inspiration can visit from many different areas. Street photography has a core list of important photographers, but inspiration can as easily come from the margins. Sometime former model Sarah Moon turned to fashion photography in the 1970s, but even that label is misleading. She was the first woman to shoot the Pirelli calendar, but her atmospheric photographs, many taken on the street, are a hybrid of fashion, film noir and documentary.

Street fashion and street photography might appear surprising bedfellows, but the pairing only emphasises the constant cross-pollination within photography. David Bailey is forever branded as the doyen of the 'swinging sixties', but what photographic label would you attach to him? Certainly portrait and fashion but he also did documentary work, and was an admirer of Henri Cartier-Bresson and Picasso. Fashion photography on the street is clearly a collaboration between model and photographer, but its spirit is within 'proper' street photography. William Klein, David Bailey, Terence Donovan and Ferdinando Scianna are just a few of the photographers who have led or responded to this free and real way of shooting fashion.

STREET PORTRAITS

A genre of photography that should arguably be consigned to the margins of street photography is street portraits – where the subject consents to be photographed. It is one of the most common misconceptions about street photography, where photographers believe they are practising street photography even when they interact with their subject who might acknowledge and approve of being photographed and even pose for the shot too. This is not street photography; it's taking a staged portrait. Unfortunately, street portraits are ubiquitous on street photography blogs and web pages, which is misleading and somewhat false.

Street photographers can include the occasional street portrait in their wanderings. Jack Simon in San Francisco, for example, occasionally asks permission to take someone's portrait. Some street photographers are very sociable and taking the occasional portrait on the street comes naturally, but they are usually aware that it is a separate discipline. Cartier-Bresson took portraits but they were not street portraits; he was interacting with the subject and quite often it was a commissioned shoot.

Shooting from the hip is random and serendipitous, but there is some reluctance to push it wholly to the margins because it is such an irreverent approach to street photography. It is loose and random and in keeping with the true spirit of the genre, but does it result in many great images? Arguably, street photography is controlled luck with the camera held to the eye to give you at least a chance. Shooting from the hip on a busy street is fun, but ultimately there are far more misses than hits.

Alias Johnny Stiletto's book, *Shots from the Hip: Another Way of Looking Through the Camera* (1992), is idiosyncratic and infectious, and certainly raises questions about how to take photographs. He breaks the 'rules'. His technique was 'firing blind', which is contentious, but the book is unpretentious and oddly very wise about photography. Sometimes you have to consider what is at the edge to understand better what is at the centre.

I wanted to include more of Fan Ho's work in this book and also extend an appreciation to Germany's Erwin Fieger's colour photographs. These two photographers are not big names and they have widely contrasting styles. Fan Ho's photographs are graphic and lyrical, while Fieger, who died in 2013, has a rare colour palette and significantly used a long lens creatively. I have mixed feelings about the use of long lenses for street photography. I'm usually quite damning – it is lazy and the pictures look bunched up – but with Erwin Fieger I'm suddenly curious, and inspired.

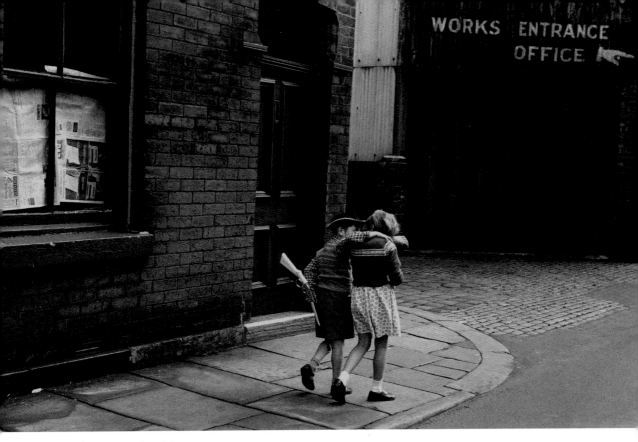

Colin O'Brien, London; 1960

One of my most prized books is Fieger's *London: City of any Dream* (1962), which I picked up in a second-hand bookshop many years ago. It's a beautiful and surprising book about another London, the majority of it shot with a telephoto lens. One of the projects I have left out of this book is one using a long lens. Fieger's words in his book set the challenge:

'The telephoto lens proved to be immensely useful for my particular method of working, since it made it possible to isolate the significant details from the midst of a bewildering profusion.'

Colin O'Brien is another obsessive London photographer whose archive goes back to the late 1950s. This evocatively titled photograph, 'The Cowboy and His Girlfriend', captures the time when children played cowboys and indians on the street.

I am often asked if people have ever objected to being photographed by me on the street. This is a loaded question and immediately tells me that the question comes from someone who is anxious about photographing people. My instinct is to sidestep the question because if you ask such a question your approach is already set. This mindset needs to be undone completely, otherwise you will not be doing street photography properly.

YOU CANNOT DO STREET PHOTOGRAPHY IF YOU ARE ANXIOUS ABOUT PEOPLE'S REACTIONS.

This may sound harsh but there are two approaches to street photography – the desire to do it or a half-hearted interest in it. Of course, part of this is an awareness that there might be legal issues or actual restrictions in taking street photographs. You could fill a book with the legal aspects of privacy and photography, which, crucially, varies around the world, but that is not this book. My only comment on the subject is that common sense should always prevail.

MOBILE PHONES

One of the most fascinating and occasionally troubling issues for me has been how to address mobile phone cameras; whether to treat them as just another camera or as a powerful new movement with different attitudes. Photography has always sat on the edge of upheaval and mobile phone photography could be likened to finding a parallel universe. Put simply, another audience with different values has recently come to photography. This is not just the world of the Internet but a vast 'mobile phone' audience who might drag photography through some interesting changes.

The overriding question is whether mobile phone cameras will release a new creative energy, or deaden or ignore a tradition that is precious to many serious photographers. What would Henri Cartier-Bresson think of mobile phone cameras, or more precisely, what would he think of the people who use them? His world was shaped by the technology available at the time. He was born in 1908, not 2008. The profound hope must be that mobile phone cameras are in reality just another tool, which, in the right hands, carry on a tradition, spiking it with different styles and attitudes but basically continuing the aesthetic. The 'right hands' motif applies to all cameras because surely what always matters is the images produced. That belief underpins this book; it may veer slightly towards naivety because technology does alter the aesthetic, but photographers will always hopefully remain more interesting than the equipment they use.

CATEGORISATION

Some of the profiled photographers are 'proper' street photographers, who sit comfortably with the label of street photography, not least because they are obviously part of that community. With others the label applies less surely, and a few photographers might even resist what they consider an easy or ill-fitting categorisation. I remember hearing a Magnum photographer talk a few years ago at a street photography festival; he was happy to be included but also slightly bemused at being considered a street photographer. There are several Magnum photographers in this book – if you consider the best in photography, you have to consider this legendary agency. Ultimately, the best photographers make nonsense of labels.

It is easy to go round in circles trying to prise street photography away from documentary photography and vice-versa. It is a fruitless exercise, but it should be acknowledged that the recent online revival of street photography drives this book. The rise of the Internet has produced a new energy and community for street photography which embraces all the great photographers of the past while also acknowledging both the present and future.

The choice of 20 projects in this book highlights even more the difficulties of breaking down 'how to do' street photography. A paradox is always at play – being open to luck and just wandering, yet also absorbing and being consciously aware of the process. In a sense, street photography is always about soaking up what is possible – like learning to play a song – but then, with the learnt chords, producing your own song. It is important to remember that street photography is not an exact science, so perhaps this book is a selection of different guitar chords – and tunings – with a few suggested songs.

Sasikumar Ramachandran, Chennai; 2016

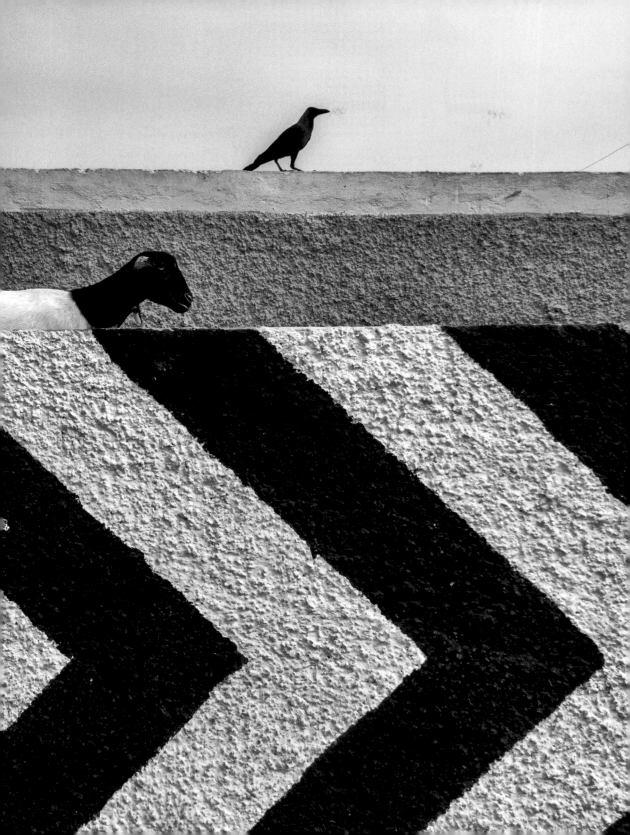

COLOUR VS BLACK AND WHITE

An issue I should address early on is the use of colour or black and white, specifically when they appear in close proximity; in this book both are appreciated but I confess to being wary of mixing them because I know that it simply does not always look very good. The mediums clash and send out a confused message. This is not an absolute and any kind of history or instructional book is probably excused this aesthetic, but this consideration – some would call it a rule – is important.

So to some extent I have side-stepped this issue and would add only that virtually all the photography books that I mention are either entirely colour or monochrome because it is a rare ability for a single photographer to mix the two comfortably in one place.

OBSESSION

You could assert that British documentary photographer Martin Parr has balls (see page 25). He gets close. But it's not for everyone. Obsession, however, is a prerequisite; nothing comes from half-heartedness and it is common for the best photographers to have had an early period of intense learning. This 'apprenticeship' can be several years. The veteran *National Geographic* photographer William Albert Allard reckoned that it took roughly seven years to 'get there'. There are no short cuts, but if you're hooked on something, obsession has little regard for time.

'YOU NEED OBSESSION, DEDICATION AND BALLS. GET OUT THERE WHILE YOU STILL CAN.' MARTIN PARR

If you want to delve into the driven mind of a photographer and taste that obsession, you cannot do better than Australian photographer Trent Parke (pages 130–131) as an example. Parke is restless and demands a lot of himself:

'It's always difficult talking about old work. I live in the moment of right now, this very second, and trying to talk about work I made even a month ago is difficult. It comes down to the fact that at the very moment I am making work on a new story, every single thing around me is important. Once I am in the zone of something, every daily occurrence, influence is or could be, vital to the outcome. One thing leads to the next. And then once I finally find an answer, I move onto the next thing and start again…'

Parke considers himself to be foremost a storyteller, where the single picture has a transient value:

'Single pictures are not enough to keep me interested these days. Yes there is a great challenge in street photography – in capturing a fleeting moment – and I did this for many years. I absolutely respect the craft and the time it takes to come up with these great single images but those stand-alone photographs are hard to work into narratives. They become collections of photographs, of a place or a city, which of course are important. But I am interested in emotion. How you can change the context of say forty photographs that bear no real relation to each other but when sequenced in a particular way can tell a very different story. For me this is the greatest challenge. The book is the work. I am always learning. This is what drives me forwards. Making new discoveries. I have always used the camera as a way of exploring the world around me and questioning everything. And I am still learning my craft. The day I know everything is the day photography dies for me. Coincidence, chance, mistakes and luck play a big part in what I do.'

Parke was a recipient of the W. Eugene Smith Memorial Award in 2003, which is totally appropriate because Smith, an American photojournalist famous for his Second World War photography, was an obsessive, too. He pursued the story in the format commonly referred to as the photo-essay, which on several occasions resulted in a singular iconic image, such as in Minamata, Japan with *Tomoko Uemura in Her Bath* (1971).

Obsession can sound a little joyless, but I came across the book *Occam's Razor* (1992) by Bill Jay years ago, which touched upon this subject. Jay recalled a television interview with a great violinist in which the violinist described a typical day:

'The musician said he read scores over breakfast, then composed music in the morning, thought about music during a walk, practised the violin in the afternoon, played a concert in the evening, met with musician friends to play together, then went to bed dreaming of the violin. Asked if this seemed a narrow life, the violinist said, "Yes, initially my life was becoming narrower and narrower in focus but then an extraordinary thing happened. It is as though my music passed through the tiny hole in an hour glass and it has become broader and broader. Now my music is making connections with every aspect of life".'

INSPIRATION

Inspiration is the single most important factor in any artistic endeavour; it is not necessarily an explosion of energy, but more a measured determination to achieve something. Photography can draw inspiration from many artistic fields; the struggles or achievements of any artist can be reassuring and give fresh impetus. Inspiration for photography can also be specific because any true beginning requires a direction and it is not uncommon for photographers to recall a particular spark that ignited their future path. It is important to recognise this potential 'eureka' moment because if you sense that something is there, you start to look for it more consciously.

Photography books are the lifeblood of any serious photographer, and you can just as easily mention looking at photographs online because there is a profusion of inspiring websites. The Magnum website should always be bookmarked, but it is worth remembering that Magnum photographers work towards producing books because that is the most satisfying presentation for their work. There are exhibitions, beautiful magazines, websites and apps, but books are more tangible. If you see an inspiring exhibition your thought will surely always be to buy the book.

This might be a traditional view but arguably you cannot surpass looking at photographs on the printed page, away from the distractions of a computer screen. Photographic books are produced specifically to allow the work to be fully absorbed. It is also the most respectful and personal way to engage with a photographer's work. Books can also be beautiful objects, just like cameras. People spend a great deal of money sometimes on photographic equipment but would never really consider spending a sizeable percentage of it on photography books. A camera is a tool, but a small library of photographic books contributes far more towards the goal of taking meaningful pictures. It can constantly be referred to and functions as an excellent source of inspiration.

Should a fledging collection of photography books include Robert Frank's *The Americans* (1958)? The answer is definitely 'yes', and not least because it is easily available and good value. A book recommended to me long ago is *On Being a Photographer* (2001) by Bill Jay and David Hurn; it is still one of the most clear-sighted on what is required to be a photographer, but beyond that, as with technical advice, I hesitate to offer specific recommendations.

Several other photography books are referenced throughout the text and a comprehensive bibliography can be found on page 186.

YOU CANNOT DO STREET PHOTOGRAPHY IN ISOLATION, YOU WILL ALWAYS NEED DIRECTION OR REASSURANCE. ABOVE ALL, YOU NEED INSPIRATION, AND BOOKS PROVIDE THAT.

David Gibson, Henley-on-Thames; 1997

Richard Bram, Angel, London; 1998

ONLINE COLLECTIVES

In his book *Why People Photograph*, Robert Adams wrote: 'Your own photography is never enough. Every photographer who has lasted has depended on other people's pictures too – photographs that may be public or private, serious or funny, but that carry with them a reminder of community.'

This was written in 1994, a good few years before the Internet first gripped people's lives, but the word 'community' is, if anything, even more relevant. There have always been groups of photographers who might be just friends, but sometimes it becomes more than that. There is strength in numbers and groups provide support, but crucially they become a focus or even a movement. In short they become important, which was not necessarily the original intention, but groups and schools of photography as they become known, and now online collectives, fix attitudes and effect change.

Nick Turpin, a successful advertising and editorial photographer in London, formed In-Public in 2000 with the desire to bring together like-minded photographers. In-Public was billed as 'the home of street photography' and it quickly gathered a nucleus of committed street photographers in London, New York and Australia. The fledgling collective had a raw energy, but its destiny was really tied to the Internet; as the new medium started to enter everybody's lives, In-Public reached out to more photographers around the world. It became both a reference point and a source of inspiration. The first of its kind, it has inevitably spawned imitators in a similar spirit. Being the first at something does not necessarily mean being the best, but In-Public undoubtedly has a core of very talented and enduring photographers. The group has had an immeasurable impact that continues to play out and Turpin deserves credit for initiating such a vital platform and gallery for street photography.

Although In-Public now has 22 members worldwide, it does not have a carefully thought out system for recruiting new members. The process has always been haphazard and organic, which reflects the nature of street photography. Certainly an acquired responsibility rests on their shoulders, but they remain at heart a group of like-minded street photographers who have witnessed a huge popularity surge in what they do. Richard Bram, left, is one such member, as is Andy Morley-Hall whose work is featured on page 31. Morley-Hall's capture is one of his most enduring; air cadets in London's Berkeley Square present a very surreal scene. What has happened; is someone to blame? A long-time member of the In-Public collective, Morley-Hall is now based in New Zealand.

Street Photographers is another more recent collective that already has a large following, especially on Facebook. They currently have 21 members, which perhaps hints at a natural number that collectives should reach. If a collective gets too big, it becomes unwieldy and is in danger of losing touch with its original aims, and, more importantly, letting standards slip. Street Photographers has maintained a very high standard and declares a simple manifesto on their well-designed website:

'Street Photographers is an international collective of photographers, whose members carry on the tradition of street photography. They capture unposed moments, interpreting life around them and challenging our perceptions of the world. The collective also aims to bring an appreciation of street photography to a wide audience. It does so through public forums, exhibitions and publications. Street Photographers believes that its efforts can inspire a growing interest in the genre and encourage the development of emerging photographers.'

The common aim of the online collective world is always to translate its energy into a tangible form, through books and more frequently with workshops and exhibitions. Workshops can be the currency and the voice for collectives but they are very dependent on reputation. The yardstick is probably Magnum, whose photographers regularly conduct workshops around the world.

One of the most interesting collectives is Un-posed, because it is wholly made up of Polish photographers. Set up in 2011, the ten photographers are not all based in Poland – Damian Chrobak, for example, is in London – but the unifying spirit is commendably Polish. Indian collective That's Life, while smaller, is in the same vein. There is something pure about this approach; That's Life, in particular, because its photographers interpret just India, and it would conceivably lose its identity if it showcased photographs taken away from India.

ONLINE COLLECTIVES ARE AN UPDATE OF THE INSTINCTIVE NEED FOR PHOTOGRAPHERS TO GATHER TOGETHER WITH OTHER LIKE-MINDED PHOTOGRAPHERS.

All of these collectives have originated in the last five years or so and could well be attributed to Thames & Hudson's *Street Photography Now* book (2011) and its ensuing online energy. Burn My Eye, like Street Photographers, has a strong Greek presence – three of its photographers are Greek – yet it has since recruited widely and not stuck with one generation. The recent addition of Don Hudson from the United States, who was born in 1950, has given the collective access to work taken in the 1970s. Burn My Eye are clearly being both imaginative and careful about whom they add to their numbers.

Maintaining a tight edit of members is just as important as the folios being edited tightly. I remember a Magnum photographer once being asked about the difficulties of recruiting new members. The reply was that the 'real problem was getting rid of members'. I suspect that he was only half-joking.

The collective communal world of street photography naturally extends to blogs and inevitably Facebook. All the collectives have a Facebook page but there are significant individuals too – who act almost as one-man collectives – and Eric Kim deserves credit there for his social media skills, which he has brought to the street photography world. His Facebook page is a hub of information and is followed by many thousands of people. US-based Kim is a devoted and knowledgeable fan of street photography, who is also known for the workshops he does around the world, often in collaboration with others. It is the collaborative element of his energy and his generosity that has marked him out. He has brought a lot of people to street photography, not necessarily the so-called advanced photographers, but he has certainly raised the banner for street photography.

If a new street photography collective forms you can guarantee that Kim will probably know about it from early on. An interview with one of its members will suddenly appear on his blog, which will be flagged up on his Facebook page, where he enjoys compiling lists on all things related to street photography. Generally 'Facebook photography' could be seen as being a mixed blessing. It does far more good than harm but it is disconcertingly random and lacking in quality control. Arguably it rivals Flickr in that it provides both a forum for feedback and a platform for sharing, but how many photographers want to 'work' on their Facebook page rather than on their photography?

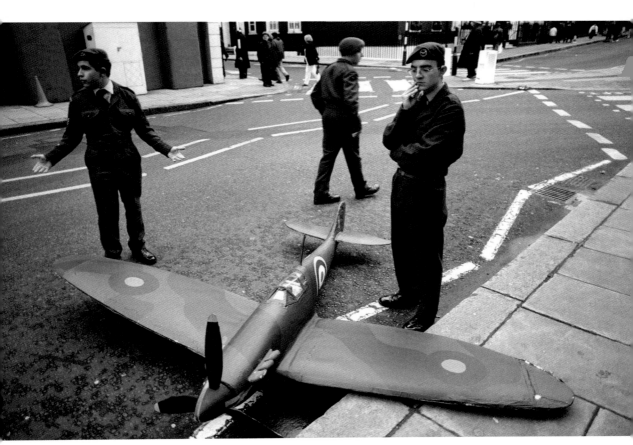

Andy Morley-Hall, London; 2000

The below extract, taken from Kim's piece *103 Things I've Learned About Street Photography*, gives a flavour of Kim's ethos and exemplifies some of his more useful words of wisdom.

Joel Meyerowitz is a positive example who, like Kim, understands the potential of Facebook to reach out to people. It's a promotional tool but when it's done sincerely, it is rewarding for everyone. Just look at Meyerowitz's page – people follow his photographic diary because they respect what he stands for.

Similarly, the Paris-based photojournalist and self-declared street photographer, Peter Turnley, regularly updates his page with photographs and commentary. Facebook does not necessarily belong to a younger generation and it is heartening to see an articulate photographer share his photographic life with others. Like Meyerowitz, Turnley dips into his archive; not everything is from last week. Both these photographers – who are actually behind their pages – have depth, and they raise the standard for photography pages on Facebook.

Chilean photographer Sergio Larrain on the other hand, whose work features opposite, avoided the spotlight during his later years, which he chose to spend in spiritual retreat. Facebook or Tumblr would have been the wrong communities for him; Larrain was a man who wrote letters, not emails. Paradoxically, his photos now reach an online audience. Clearly communities of all kinds have provided artists through the ages with both interaction and solace.

ERIC KIM'S ADVICE FOR STREET PHOTOGRAPHERS

- It isn't the quantity of social media followers you have that matters, but rather the quality of followers you have that matters.

- Buy books, not gear.

- The only way money might make you happier in photography is if you invest it in experiences (travel, workshops, teachers) rather than material things (cameras, lenses, gear in general...).

- Most famous photographers are only known for their two or three most popular images after they die. If you accomplish this you have made your contribution as a photographer.

- Street photos of people just walking by billboards are boring.

- No amount of post-processing will transform a mediocre photograph into a good photograph.

- Watermarks in online street photographs interfere with the viewing experience of your audience.

- Spend 99 per cent of your time editing your photos (choosing your best images) and only 1 per cent of your time post-processing them.

- Avoid the easy lure of capturing homeless people and street performers. Despite their assumed exoticism, like any other subject they rarely make good photos.

- Don't respect the critique of other photographers unless you have seen their portfolio.

- 99 per cent of people on the Internet don't know what a great street photograph is. Don't always trust the comments, likes and favourites you get from the Internet on social media sites. Rather, stick around in public street photography critique groups (or private ones).

- If you are working on a project and photographers discourage you by saying 'it has been done before', ignore them. Nobody has done it like you before.

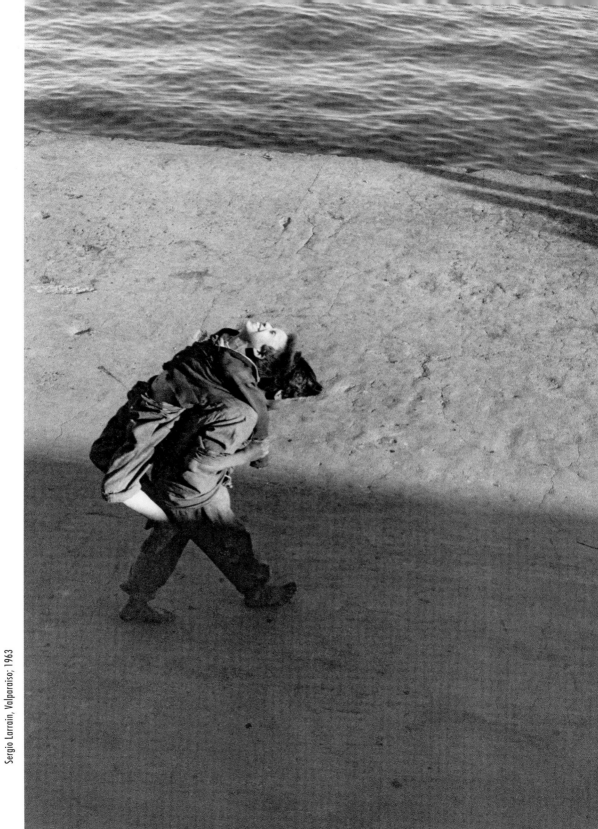

Sergio Larrain, Valparaíso, 1963

CAMERAS

The technical aspects of photography are very important for some people; they might even enjoy cameras more than the pictures they take. I sometimes encounter these people in the workshops I conduct and as we walk and talk I am aware of possible pictures coming together. I am listening to them, but the street distracts me. Isn't that the idea of street photography, wandering and being distracted by potential photographs?

Cameras excite photographers because they enjoy equipment, but also because they offer impetus to their photography. There is nothing like having a new camera to make everything seem fresh and full of potential. There is always the latest 'must have' camera, but would it be interesting if the actual cameras used by photographers appeared on the covers of their books rather than the images they take?

I am always reluctant, except for the basics, to give technical advice, particularly when it comes to camera settings. Paradoxically, some sound advice given to me recently was 'keep the technical jargon free from opinion', which clarified for me the pitfalls of entering into this very personal aspect of photography. Years of experience amount to little sometimes, except to, say, find a camera that you are comfortable with and understand. You may have several cameras, and there is no right or wrong type or make. Too much technical advice is like telling someone what food they should like.

However, there are some common things to consider. My technique is to get the technique out of the way so that I can take pictures.

When I began photography seriously, I shot exclusively in black-and-white with a manual Nikon FM2 camera. I constantly had the shutter speed at $\frac{1}{60}$ or $\frac{1}{125}$ of a second and I nearly always used a yellow filter and that was it. I should add that I used three lenses, a 35, 50 and sometimes an 85 mm lens. An 85 mm is a slightly longer lens and certainly not

extreme, but I was often grateful to get a little closer. This range of lenses was fairly common and has just been translated to digital cameras. When you start to consider simple film cameras, you realise how complicated digital cameras have made photography. They have many advantages, but they do not take better pictures. I admit to being spoilt by digital cameras and have occasionally felt that I might have lost something in the transition from film. Film is a good habit because each frame is precious. You might only have one film of 36 exposures, which seems ridiculous when you consider that now a typical memory card routinely has at least ten times that number.

An online discussion on my early black-and-white work observed that I did not seem too concerned about my images being in sharp focus. I was a little startled by this comment, but have to agree that this is a valid point. I was never that interested in taking absolutely sharp images, partly because the film speed in low light conditions dictated a slower shutter speed, but mostly because my concern was just getting the picture. My photography has evolved and digital cameras have made it far easier to shoot in low light conditions, which is a huge difference. Consequently, my images have become sharper but not necessarily better.

I now mostly use a Canon 5D with a standard pancake lens. I usually have the camera on the 'P' (programme mode) setting – allowing the camera to 'decide' – but will sometimes take photographs using the shutter speed priority (or 'Tv' mode on a Canon). I will set the 'Tv' at $\frac{1}{250}$ or $\frac{1}{500}$ of a second, for example. So my technique is 'P' or 'Tv' and I use the auto-focus on the back of the camera.

Yet these considerations are all essentially habits – what I feel comfortable with – to enable me to take photographs. I know that many photographers would give far more consideration to the depth of field by

adjusting the aperture setting, but that is not my habit. I am often surprised by people who are just starting with street photography, who decide to shoot film, especially black-and-white, and even decide to do darkroom printing. They sense a tradition, and if I were to venture any advice to a serious beginner, I would suggest that at some point they shoot black-and-white film and follow the journey of that film. Learning to process film and printing is a very thoughtful experience – everything is slowed down and more appreciated. It used to be a necessity for many photographers, but to experience a wet darkroom, even briefly, connects you to what photography really is.

Many photographers steeped in the workings of a darkroom now habitually use desktop editing suites, such as Photoshop or Lightroom. But photographs are prints – we should never forget that. We see photographs all the time but we seldom hold them. Books can be precious but there is nothing better than a photographic print.

I have allowed some of my personal preferences to seep in here and not just with regard to equipment and technique. There are commonalities but every photographer is different.

This is the post-analogue photographic life of In-Public member Paul Russell:

'When digital came along, it re-ignited my interest in photography – the instant feedback from the LCD plus the ability to take a huge amount of pictures without worrying about cost spurred me on…I bought the digital Nikon D70 when it came out in 2004 along with the 18–70 mm kit lens, and I still use that lens today. I also switched from predominantly black-and-white to colour with the advent of digital.

With compacts I end up with a lot of pictures, a tiny percentage of which are acceptable to me, whereas with SLRs I take very few pictures due to the camera's size but get a much higher proportion of "keepers". There are situations where you want to look like a complete bumbling amateur, and compacts are good for that.

An additional point to consider about compact digitals is that they usually give a 4:3 aspect ratio instead of the 3:2 ratio of digital SLRs (and 35 mm film). This difference in image shape can cause a headache when building consistent collections of photos.

Currently I'm using an inexpensive Nikon digital SLR with my old kit zoom and a manual focus 20 mm Voigtlander lens. I've also used a 28 mm lens a lot on my "crop" SLRs. As an equivalent to 42 mm on a full-frame camera, it's the closest thing to a lens where the view matches what the eye sees (43 mm being a "standard" lens on a full frame or 35 mm film camera).

I go with APS-C SLRs – full-frame models are too big for my liking. I walk around in aperture priority mode, keeping an eye on the ISO and shutter speed at all times.'

'IF YOU REALLY UNDERSTAND APERTURE, SHUTTER SPEED, ISO AND EXPOSURE COMPENSATION, YOU CAN'T GO WRONG.' PAUL RUSSELL

Another In-Public photographer, Nils Jorgensen, has arrived at a similar point of familiarity:

'After years of trial and error using almost every camera and lens ever made, I have found my dream street kit. I am currently using a DSLR with a 28–300 mm zoom lens. Mostly I put my camera on "P" (for "Professional" of course) mode.'

Jorgensen, I suspect, wants to keep technical concerns at arm's length and just get on with taking pictures. Not all photographers are comfortable with a zoom lens but many settle for the 'P' mode on their camera.

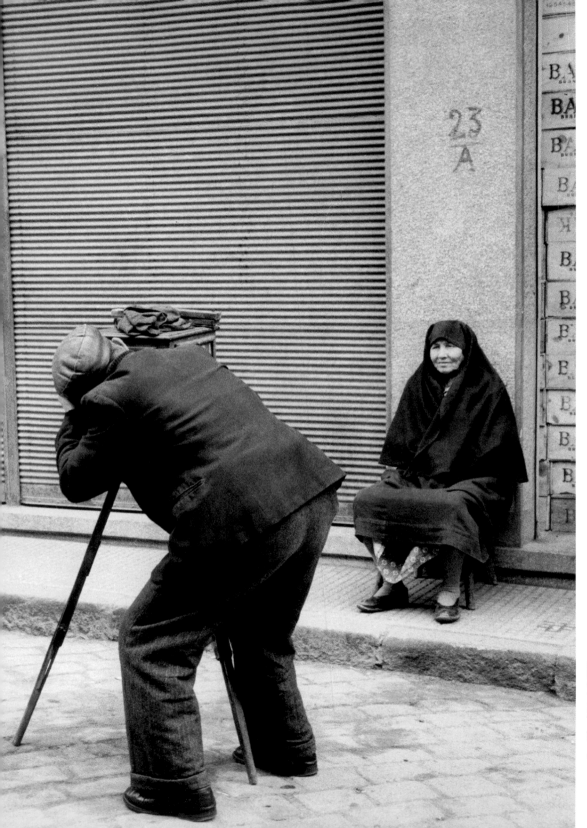

Marc Riboud, Istanbul; 1955

PREPARING YOUR PHOTOS FOR INSTAGRAM

What camera, post-production, software or apps are best to use? These creative photographers on Instagram offer some clues.

SO ASA | so.asa
• iPhone. • Snapseed: contrast and white balance, some small adjustments with selective editing tools on iPhone or iPad.

MELISSA BREYER | melbreyer
• Fujifilm X-Pro1. • Photoshop: depending on the image use auto tone, desaturation (for colour) or black-and-white conversion, play with curves and sometimes structure, dodge/burn.

DAVID GABERLE | davidgaberle
• Fujifilm GFX 50R. • Lightroom: cropping and sometimes correcting perspective, choosing the right colour profile, adjusting exposure, vibrance/saturation (for colour), playing with individual colours in the image, dodging/burning and finalising with checking for the right white balance. • Photo app: to do final adjustments for phone screen.

JESSE MARLOW | jessemarlow
• Leica Q2. • Lightroom: basic adjustments to exposure, whites, blacks, contrast and minor cropping, if needed.

GUSTAVO MINAS | gustavominas
• Fujifilm X-T2, Fujinon 27mm f2.8 or 18–55mm f2.8–4. • Lightroom: Classic Chrome profile and my personal preset — adjusting exposure and contrast, RGB curves, adjusting each colour individually on HSL panel, cropping and perspective correction, noise reduction, split toning and/or white balance to correct tones in shadows and highlights, some local adjustments with masks, mostly for adjusting exposure. • Instagram's Lux slider; for final adjustments.

SHIN NOGUCHI | shinnochiphotos
• Leica MP • Negative film developed by Kodak official lab. • Scanning on Nikon CoolScan 5000ED using Mac scanner software with color and tone adjustments preset. • Resizing low-res jpg and delete Exif date on ImageOptim. Send to iPhone via Send Anywhere file sharing service. • Write title, caption, hashtags in Mac Simplenote. • Post with texts from Simplenote for iPhone to Instagram.

RAMMY NURALA | rammynarula
• Leica Q and iPhone X. • Lightroom for Q • Default camera app for iPhone — I prefer higher contrast and darker shadows, so use sliders and clarity and saturation for more pop. Exposure, dodging and burning depends on the photographs.

VINEET VOHRA | vineet_vohra
• Leica M10, 28mm Summaron, mostly between f11–f16. • Photoshop CS8: just add sharpening and saturation when posting on Instagram.

ROZA VULF | rozavulf
• Leica M240 with 35mm Summicron or Fujifilm X100S. • Lightroom: for checking exposure and white balance, cropping and correcting perspective (if needed), adding contrast and curves adjustment (especially black point)
• Whitagram: sometimes used for borders.

CRAIG WHITEHEAD | sixstreetunder
• Fujifilm X-Pro2. • Lightroom: exposure/white balance etc., curve adjustment and HSL panel, tweaks — sometimes a small amount of split toning to highlights or shadows to counteract other colour tweaks earlier on and keep a natural look.
• Snapseed: to add a border.

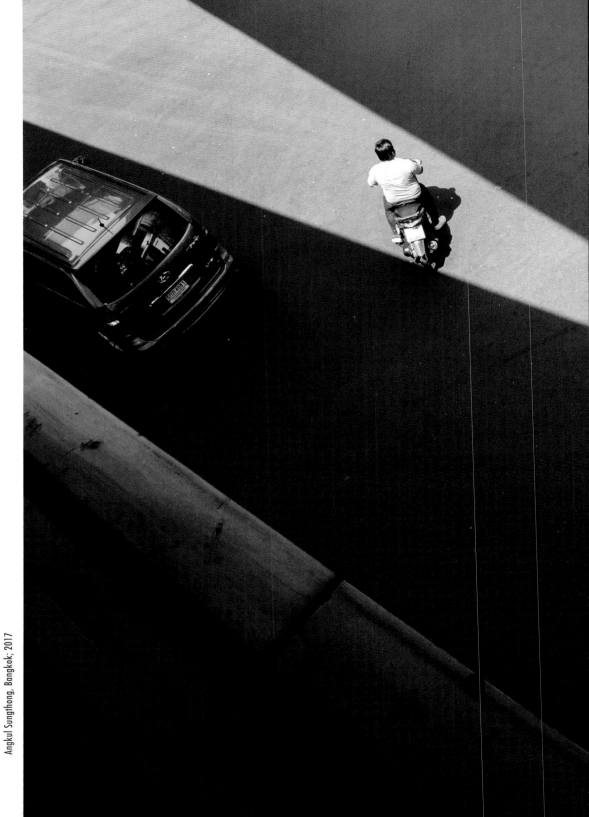

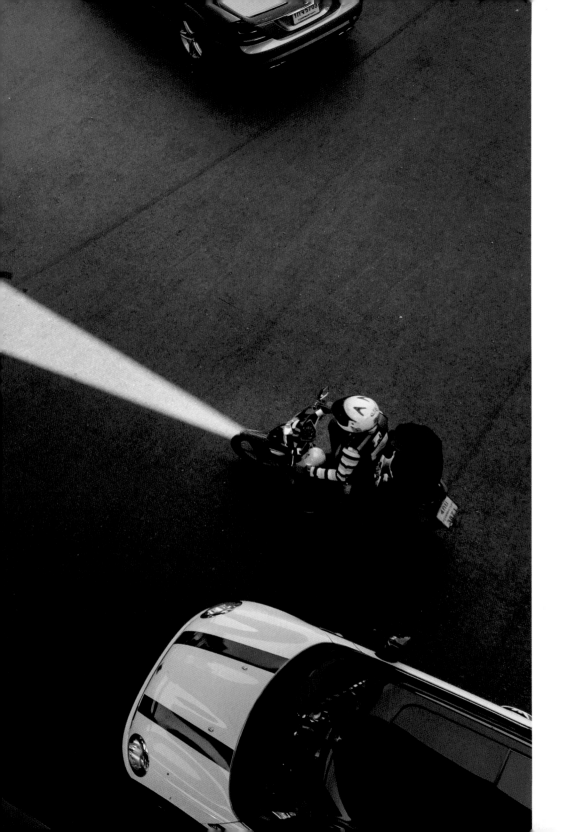

THE WIDER CONTEXT

When I first became serious about photography, the label that I related to was 'humanistic photography'. It was the Magnum photographers that inspired me and my memory is that the term 'street photography' in the late 1980s was not prevalent. My perspective could be a little narrow, as I was just beginning to catch up on all the history, but I suspect that the term 'street photography' was in the doldrums.

In-Public's Nick Turpin advocates that street photography is photography itself and that every other strand of the medium should be arranged around street photography. He asserts:

'Now I understand that "street photography" is just "photography" in its simplest form, it is the medium itself, [and] it is actually all the other forms of photography that need defining: landscape, fashion, portrait, reportage, art, advertising…these are all complicating additions to the medium of photography, they are the areas that need to be defined, ring fenced and partitioned out of the medium of "street photography".'

In some ways the history of photography has been unfair on street photography. If you take three of the important histories on the medium by Beaumont Newhall, Helmut and Alison Gernsheim and Ian Jeffrey, none of them use the term 'street photography'. Nor does Susan Sontag in *On Photography* (1978), a stalwart book on course reading lists, but this is being a little pedantic.

Of course, street photography is there; you just have to extract it from the bigger history, which has tended to ignore the term more than the photographers who take photographs on the street.

WHY SHOULD STREET PHOTOGRAPHY, WHICH HAS SUCH A STRONG SPIRIT AND FOLLOWING, BE BURIED IN THE GENERAL HISTORY OF PHOTOGRAPHY?

It is likely that street photography has unsettled historians because they don't know where to put it or how to attach a purpose to it. Street photography has functioned too long in disguise but arguably there is a new history being written by the Internet, which separates it more clearly from the general mass.

Street photography began with the advent of the lightweight 35 mm camera and specifically the original Leica camera, which first appeared in the mid-1920s. Hungarian-born André Kertész was one of the first photographers to realise its potential. Cumbersome big cameras prevailed in the 1950s, but by then they were like leftover dinosaurs. By the 1960s, the 35 mm camera was the norm for most photographers outside of the studio. New technology, as it often does, produced a new attitude, which was embraced by another generation of photographers. The photograph opposite by Magnum member Leonard Freed perfectly sums up that new freedom.

Something of this history that includes the important influences inevitably comes out in

Leonard Freed, New York City; 1963

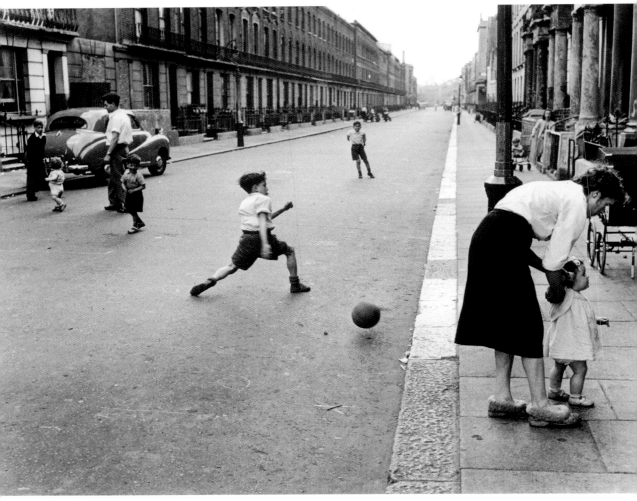

Roger Mayne, London; 1956 © Mary Evans Picture Library

the projects presented here and especially in the profiles. There is a grapevine testimony that pushes the same names, which cannot be a coincidence because photographers are always sincere about the photographers who have moved them. I therefore make no apologies for punctuating much of this book with references to Henri Cartier-Bresson.

However, I actually delight in the alternative view, and reading, for example, about photography classes conducted by the Swedish photographer Christer Strömholm, I was struck by the stance he took on Cartier-Bresson. Strömholm's classes began in the late 1950s – the perfect time, when it was all beginning – and they covered amongst others Robert Frank's 'studies of American society', Edouard Boubat's 'sensitive, poetic images' and Robert Doisneau's 'charming but arranged pictures'. W. Eugene Smith ranked high for his 'moralism and involvement' and they admired the work of Kertész and also Cartier-Bresson, whom Strömholm regarded as 'great but restrained'. This is refreshing and a perfectly valid assessment of Cartier-Bresson's work. Yet Strömholm's classes were not strictly about street photography, they were an immersion in the emotion of photography, with strong references to documentary and art photography too. Once again, the extraction process applies.

It is hard to imagine the world of the 1950s for a fledgling photographer; there were virtually no bookshops with a well-stocked photography section, not to mention something as science fiction as Google, which puts history and inspiration at your fingertips. In the austere European 1950s, everything photographic was tactile, including the darkroom, and 'sharing' photographs was a tangible experience. Photography books were shared at camera clubs and a pivotal book, such as Cartier-Bresson's *The Decisive Moment*, published in 1952, would have been a rare treat. I have heard the British photographer Roger Mayne talk of this moment in photographic history at a symposium on Cartier-Bresson, and you sense just how precious that encounter was to him and others at the time. Mayne (opposite) subsequently photographed one street close to Notting Hill in London over a prolonged period in the late 1950s.

The received history is that *The Decisive Moment* and Robert Frank's *The Americans* in 1958 were the catalysts for a new kind of photography. Frank's skewed and loose photographs were a departure and took some years to actually make their mark. But the history of street photography cannot be overly attached to those two photo-books. It is as likely that street photography, as we know it today, simply emerged out of a changing society, from the formal to the informal. The parallel might literally be the freedom of taking photography out of the studio and onto the street. Lightweight cameras were available, together with faster film speeds, but also a less reverential society that wanted something less starchy. Street photography in many ways responded to a change in social attitudes.

The 1960s were especially a time of change, and it was during this decade that some of the most influential street photographers emerged. Cartier-Bresson's influence never wavered; his precise geometry and startling echoes continued to set a standard but it was another generation inspired by Cartier-Bresson and Kertész that fixed street photography more in the mainstream.

Bystander: A History of Street Photography by Colin Westerbeck and Joel Meyerowitz diligently chronicles the rise of street photography, and it is a very enjoyable and reliable resource. However, the 2001 paperback edition seems out of date for a phenomenon such as street photography. The book ends tentatively with the Internet on the verge of transforming everything. An afterword in *Bystander* states: '*Throughout the history described in this book, there have been key periods when a group of street photographers have come together to share their work, their ideas and in some cases a sense of social purpose*'. How true this is, but it could equally be referring to the future.

1 BUSY

Joel Meyerowitz views street photography as an 'optimistic sport'. We have to enjoy the energy and the challenge to hit the target.

Any examination of street photography must begin with busy spaces; to use a fishing analogy, you simply fish where most of the fish gather in the river. Given the choice on a weekend of heading into a busy market or the more empty business district of a city, most photographers would opt for the busy area.

I am often drawn to the noise of schools, and being high up in Darjeeling I was able to look down into this school playground (see opposite). I was struck by the riot of blue and had a slightly long lens but probably felt that I wanted to get closer. But you make do, and this scene became an arrangement of shapes and colours. There is a dog walking through the middle though you can hardly see it, and the girl on the bottom left with her raised arm adds balance, but everything is really a celebration of the colour blue.

There is a fascinating high-definition video by New York artist James Nares called *Street* (2011), which shows street life dramatically slowed down by a high-speed camera. For any street photographer this unscripted film is compelling because it shows the almost hidden dimension that a photographer seeks. Suddenly every subtle gesture and nuance of human movement is there to be seen more clearly.

Unfortunately that half-speed world does not truly exist for photographers – they could pick off targets at will if it did – but it is worth approaching the busy

'IF YOU CAN SMELL THE STREET BY LOOKING AT THE PHOTO, IT'S A STREET PHOTOGRAPH.'

BRUCE GILDEN

street with this possibility in mind because all these slow motion moments do exist. It is the task of the photographer – together with fortune – to glimpse these moments. Put simply, on a crowded street the camera freezes a moment that we often only half see.

There's something in the imagination, too, that makes you want to romanticise street photography in a city like New York in the mid-1960s; especially that of three kindred spirits – Joel Meyerowitz, Garry Winogrand and Tod Papageorge, who all went out shooting together. They would sometimes bump into Lee Friedlander; they knew Diane Arbus; and they met a Frenchman once on the street who continually ducked in and out of the crowd. It was Henri Cartier-Bresson in his prime. These are all legendary figures and Meyerowitz has talked about knowing Robert Frank before he became Robert Frank. This is somehow reassuring – everyone has to start somewhere.

PROJECTS

*ORDER page 52
*EVENTS page 58
*SEQUENCES page 64
*LINING UP page 68

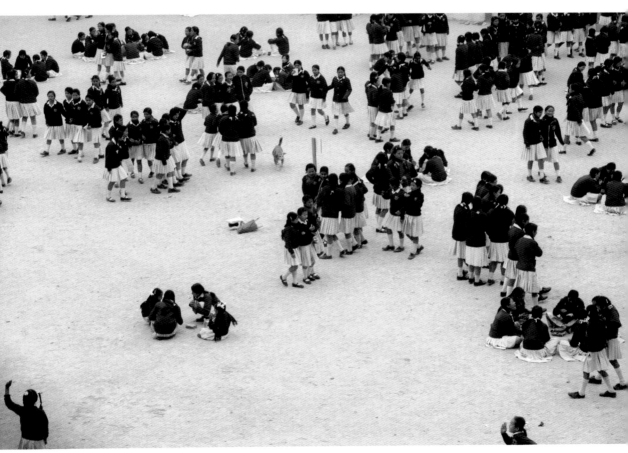

David Gibson, Darjeeling; 2009

There are latter-day spirits, such as Jeff Mermelstein, Gus Powell and Melanie Einzig, but they all share that same New York attitude – a little brash, frenetic and slightly crazy. At least that's what they photograph, the craziness. Even the light in New York seems crazy.

In the late 1990s Jeff Mermelstein typified the 'in your face' New York style with his book *Sidewalk* (1999). Gus Powell's work has a little more distance and is more driven by the subtle interplay between people.

And below these streets is the New York subway. What is it about this subterranean world that it can offer up such a myriad of different faces? Perhaps it's all those melting pot origins. You need only look at Christophe Agou's *Life Below* series, which follows that great tradition of photographing busy subterranean streets, to get a flavour. Joel Meyerowitz and Garry Winogrand, both of Jewish origin, had chutzpah that is made for the street. Bruce Gilden has continued that

energy in his own particular way; he seems almost to have sprung from a Martin Scorsese film set.

What is it, though, that all these New York photographers have tried to do in their photographs? Put simply, they have attempted to make order out of chaos, somehow compelled by the congested streets. Diane Arbus liked the chaos in people more than the street; she was drawn to the humanly strange. Similarly, one of her daughters, Amy Arbus, continued this tradition of street portraiture and has subsequently broken new ground with her masterpiece collections *On the Street* (2006) and *The Fourth Wall* (2008), in which, within the contexts of self-expression and performance, an element of fantasy is deftly introduced into everyday life.

Roza Vulf, London; 2015

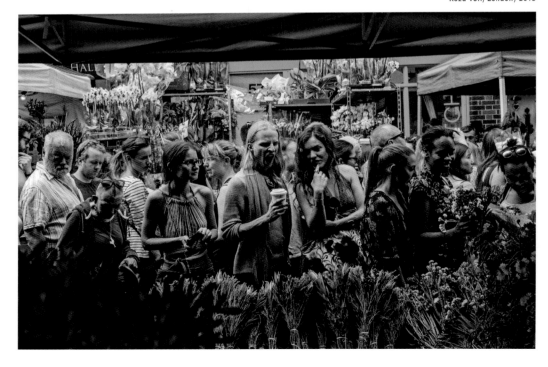

While taking street portraits Diane Arbus interacted with her subjects and this is a legitimate but quite separate genre of street photography. There is a trend for this sort of photography that probably draws the kind of photographer who enjoys interaction, performance even, and for some the 'combat' rush of adrenalin. Some photographers literally shove the camera in a person's face and their reaction is the photograph. Bruce Gilden has been accused of this, but he does it with empathy; he gives people time, he avoids conflict. Unfortunately some street photographers enjoy conflict. Unlike Gilden, they are not members of Magnum.

So get close – and if it's your preference for interaction then fine – but it should never be about causing agitation. It is not a badge of honour to have confrontations with people, not to mention security staff or the police. This is occasionally unavoidable, but perhaps a Robert Capa-like maxim should apply:

IF YOU GET STOPPED TAKING PHOTOGRAPHS, YOU'RE DOING SOMETHING WRONG.

This point can be taken a little further. If you're in a workshop that deals with knowing your legal rights and handling resentment, it's the wrong workshop.

A familiar criticism heard while poring over photographs is that some are 'too busy' or, taken a step further, when processing images, 'there is too much noise'. In a busy area you expect more but it does not always happen. There is a flower market in London's East End early every Sunday. The main street is soon jammed with people; it is actually quite difficult to move, let alone take photographs. Yet, some photographers thrive in such conditions. Roza Vulf's photograph on the left is reminiscent of Leonardo da Vinci's *The Last Supper* – the line of people remarkably choreographed, each face individually painted.

Other photographers would understandably move away from the centre of the market. People buy huge pot plants and you can see them struggling with them a mile away on their way home. They have come from a busy area and that is the photograph. The heat of a busy area can be felt more comfortably a little away from the centre.

Colour can be busy and it is interesting to consider how the Canadian photographer Robert Walker first tackled it in a subtle, conventional way. His *New York: Inside Out* (1984) uses colour beautifully and in an almost old-fashioned way. Some years later he confronted colour more boldly in *Color Is Power* (2002). The pictures in this book are big, powerful and a little garish, but an honest view of how colour bombards us in a big city. An older Robert Walker was suddenly wearing loud shirts and enjoying it.

Martin Parr does loud colour too, and he frequently depicts a busy overloaded world with garish clashing colours. Parr's photographs are seldom calm and his camera has often fallen upon tourists. Some photographers in busy cities actually avoid tourists because they want everything to look indigenous. They might be happy to photograph in Tokyo, which would be full of Japanese people, but a busload of Japanese tourists in a European city is different. Tourism is part of many cities and maybe this jars a little with what street photography strives to be. Quite possibly it goes deeper, a wish that the world be authentic and in the past perhaps it was when mass travel was not so common.

The world's cities keep getting busier and street photography reflects that. Virtually all the images taken travel round the world, too; and are instantly shared online. Wherever people are, if they see street photographs taken in Italy, for example, it is comforting for them to recognise Italy in the images. The paradox is that everything is faster but we still crave an ideal. Street photography helps with that.

ELLIOTT ERWITT

born 1928, Paris. www.elliotterwitt.com

While trying to avoid fawning or speaking in clichés, Elliott Erwitt is simply one of the best photographers since the invention of the medium, who, as importantly, has influenced a great many other photographers. His witty black-and-white photographs, his *Personal Exposures*, which is also the title of one of his many books, are his legacy, and it is one that few can equal. Like Henri Cartier-Bresson, his words are also very succinct in how they understand photography. They cut through a world of photographic pomposity.

In many ways he is a street photographer because much of his personal work is taken on the street. In reality, Erwitt is a highly successful commercial photographer, who is known for his personal work. One feeds the other, but it is an important distinction to make.

Also one of the best-known Magnum photographers, Erwitt is renowned for his sharp sense of humour. His whole being seems to poke gentle fun at the absurdities in everyday life; he has a nice perspective and also a vast body of work that arguably buries some of his more poignant and serious work. He does visual puns – better than anyone – and everybody knows of his interplays between dogs and their owners, although there is much more to his work.

Consider 'The Family of Man' exhibition, one of the pivotal moments in the history of photography in the 20th century; it included Erwitt's 1953 photograph of his wife staring lovingly at their newborn daughter on a bed in low light, which is still a perfection of its kind. The word 'iconic' could genuinely be applied to this and several more of his photographs. Elliott Erwitt has taken great photographs, he has taken iconic photographs, and some of them are historical, too. Maybe the term 'iconic' actually encompasses all of these aspects of his work.

There are the photographs he took of Marilyn Monroe, Jackie Kennedy, Khrushchev and Che Guevara. In the first decades of his career he photographed practically everyone of prominence it seems; however, it is his photographs of ordinary people, animals and humorous subjects that really stand out. Erwitt is endlessly inventive and you keep coming back to his sense of fun. He also pokes fun at himself; there have always been self-portraits taken in strange attire, often on commercial shoots.

Selecting just one example of his work is difficult; you feel the need to avoid his oft-published and numerous pictures of dogs, or the obvious Erwitt puns. In the end, however, one of his best-known images is irresistible. Taken by Erwitt in Nicaragua in 1957, this woman's face says it all.

Perhaps this humorous image sums up street photography – the photographer delights in the happenstance, and in this case when the subject eventually looks at the camera she is mystified by his interest. Surely however, even she would laugh if she knew why.

This is a great visual pun, and part of the fun is that the woman has absolutely no idea why a camera is pointing at her. It's the kind of luck that continually visits a photographer like Erwitt.

ORDER

Believe absolutely that extraordinary luck is possible for the photographer who dedicates time to taking photographs on the street.

Making order out of chaos is an abiding principle of street photography, particularly when confronted with a busy scene. There are few photographers who can successfully celebrate the mess of a group of people on a street. Lee Friedlander sometimes 'overloaded' his photographs with traffic and street signs and Daido Moriyama has photographed the mess looking upwards at electric cables. Generally, though, the overriding aim of street photography is a pleasing order.

The idiom that 'two's company, three's a crowd' is appropriate here because a crowd requires orchestration.

Henri Cartier-Bresson took a perfectly orchestrated photo in Shanghai in 1948 (page 7). Taken for *Life* magazine it captures the pandemonium incited by a currency crash during which ten people were suffocated, yet the photograph still has a graceful flow and symmetry. Queues naturally snake horizontally.

There is a slight parallel with my group photograph here, though it was, of course, taken under very different circumstances. This is not a moment of distress or danger, but one of joyful expectation. In London's West End, this group of children in their *Annie* musical dresses had just arrived in front of the theatre. They then proceeded to walk round to the back entrance for what I think was an audition. I followed them and fired a sequence of shots, particularly when they lined up – in a gaggle – to go in. I was acutely aware of the potential of this scene and worked quickly hoping it might all come together. Fortunately it did. I was there standing across the road from them for just a few minutes. The background is a factor in this photograph; the wall and the No Parking sign help, but the 'magic' is that every person in the photograph is positioned almost perfectly. For such a large group, it is rare for nearly all the faces to be visible and therefore contributing to the overall impact. Not one person is doing anything 'wrong' or breaking the rhythm of the scene. Except, as a counterpoint, the boy wearing black with his back turned, who holds the picture together; the black nicely breaks the line of red.

This sequence of shots illustrates a day when the 'One-Eyed God of Photography' was looking kindly on me. Imbued in the one good shot is twenty-five years of wandering around taking photographs. On that day in February 2008 I had that familiar, vague feeling that it is mostly fruitless, nothing will happen, I'm not seeing, etc. I felt flat, and suddenly something happened; an opportunity was given to me, which I like to think I deserved.

I HAD AN ADRENALINE RUSH AFTER TAKING THESE PHOTOGRAPHS AND THAT FEELING, THAT CERTAINTY, HAS HAPPENED PERHAPS ONLY THREE OR FOUR TIMES BEFORE.

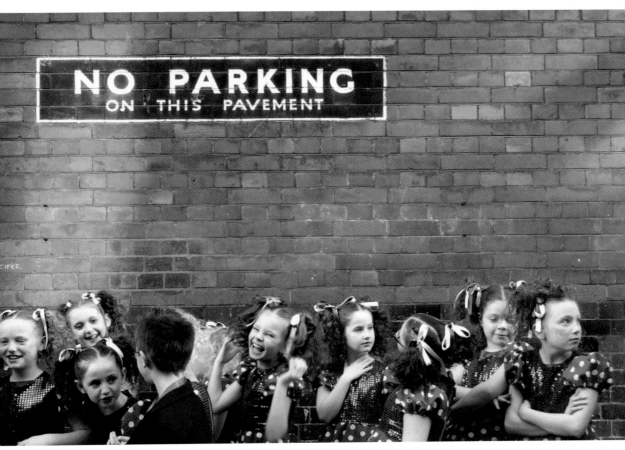

David Gibson, London; 2008

▷ 1A

▷ 2A

▷ 3A

▷ 4A

▷ 5A

▷ 6A

⟑ 7A ⟑ 8A

⟑ 9A ⟑ 10A

CONCLUSION

There are nine children in this photograph, which ordinarily might be too many to orchestrate. Most people on the street usually move in pairs or perhaps a group of three or four, which is visually far more manageable.

- Before action (if digital), do a test shot for exposure. Decide on the camera settings before you proceed.
- Look at the whole frame as you shoot; be aware of distractions because they can spoil a potentially good photograph.
- Believe that luck and awareness can bring order to chaos.
- Think rhythm, balance, flow.
- Practise on the flow of people coming towards you on a busy street, or from a fixed point at a busy exit at a railway station.
- Consider street corners, catching two flows of people.
- Clearly seen faces are not always necessary, shapes are just as important.

TROY HOLDEN

born 1975, Grand Rapids, Michigan. www.instagram.com/troyholden/

Troy Holden devotes most of his time to walking through the downtown neighbourhoods of San Francisco, particularly one very interesting five-block stretch of Market Street, in search of photographs that capture the action of the city. He shoots both before and after work during the week, occasionally stopping for lunch, and dedicates two to three hours each day at the weekend to his photography.

Holden talks like a street photographer, using short sentences and shutter speed-like actions. His aim is always to get: 'Cheap shots. Hopefully keepers. Everyday life mixed with bursts of gut reaction.'

Everything seems boiled down with no waste. There is no exotic travel. Holden shoots with a simple compact camera with no aperture or exposure control, which he has used since he started out in 2011. So, no fancy camera or words, just a get out there and do it attitude.

Holden's focus is utterly upon San Francisco. You could call it raw, proper street photography. He has a big Instagram following because people get the immediacy, the craziness and pathos of his streets.

A great example from Instagram that sums up Holden's San Francisco is the close-up of a man apparently about to bite the head off a pigeon. He's surely play-acting for the camera, but there is a look on his face of pure relish. The streets are crazy.

Look at the photograph here of a couple on the edge of kissing. One comment on Instagram sums it up: 'Whaaat? F***ing beautiful.' It is a tender, private moment in the middle of a busy street. Are they

bidding farewell, to see each other later that day? Is he a military man of some sort? Holden offers this:

This tender, private moment is juxtaposed with the hustle and bustle of the San Francisco street.

'FROM HIS UNIFORM, IT LOOKS LIKE HE'S IN ONE OF THE US MILITARY BRANCHES. I THOUGHT THIS SHOT ROSE ABOVE OTHER SHOTS OF COUPLES KISSING BECAUSE THE WOMAN IS QUITE DOMINANT, HOLDING HIS WAIST WITH HER ARM AND GOING IN FOR A SMOOCH, WHEREAS MOST SHOTS OF COUPLES KISSING, THE MAN IS THE DOMINANT ONE AND IN CONTROL.'

Perhaps the photograph would be better vertical, but then you realise that Holden seldom abandons his left, right and middle perspective. Feet cut off is not a problem; what matters most is the energy of the moment. Holden seldom does refined or quiet. Besides, his patch of San Francisco is noisy, garnish and full of characters.

It suits a particular ethos, in part inspired by Holden's photographic heroes. Garry Winogrand, Helen Levitt and Jeff Mermelstein were his early influences and still impact his work. He also admires the work of Paul McDonough, Richard Sandler, Daniel Arnold, John Harding and Patrick D. Pagnano. No doubt they would all, especially Winogrand and Mermelstein, appreciate this on-the-hoof shot.

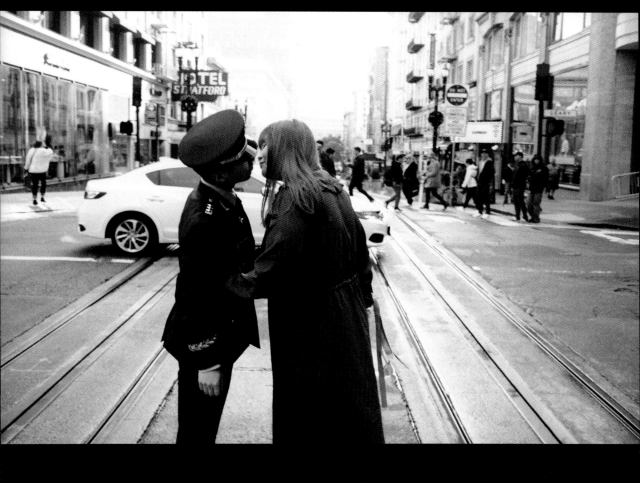

EVENTS

Events are fertile ground for a street photographer, but avoid documenting the event directly; the edges are far more interesting.

Events, parades, protests and any kind of gatherings understandably attract photographers, because they offer the potential for worthwhile photographs. In addition it is easier to take photographs in a crowd because you are far less conspicuous. Everybody is taking photographs and it is fairly easy to get right in close.

However, I believe that photographers – including those just starting out – should to a large degree avoid the event itself in their photographs. For example, The Chinese New Year celebrations in theory are a must to photograph, but consider what you really want to achieve. There is of course absolutely nothing wrong with documenting such an event; it is a great place to start, always head for crowds and gatherings, always look for 'triggers' that can stimulate your senses to get your eye in. The aim is to find your own event within the big event.

Many times I have photographed events, they provide a purpose and a starting point. But equally quite often after the initial rush of excitement of arriving in the crowd a sense of vague disappointment washes over me. It is then that I have to dig and find my own way. I look for 'my photographs'; I am not documenting it for someone else.

The subject matter of street photography should be broad and ambivalent otherwise it merges back into documentary photography. Photographing a series of events under one broad theme is arguably different. Tony Ray-Jones obsessively chronicled the English at play in traditional festivals and at seaside resorts in a body of work that became the book, *A Day Off: An English Journal* (1974). His approach was meticulously planned over a prolonged period with a real intention to gather the material into a book.

Consider too his 1960s photographs of the St Patrick's Day parade in New York, which is one of the best street events around. How many photographers, both high profile and otherwise, have weaved in and out of a crowd like that? New York has many parades – it has Polish Day, Veteran's Day, Israeli Independence Day, Easter Parade, Thanksgiving Day Parade, to name but a few – that can only emphasise the advantage of being close to a big city.

Parades are fixed events, but big cities are the hub for protests too and they can spring up at any time. Protests can of course be tricky, there are police present and there might be violence, but the same principles apply for the street photographer. What do you want to photograph and do you want your photographs to be a very obvious record of an event?

This first photograph (opposite) of the man standing on a bike was taken at the Queen Mother's funeral in London in 2002, which was a big 'event' – historically and emotionally – for many people. There were many photographers there that day officially, but others like myself were trying to observe things around the edge. I remember briefly meeting In-Public's Matt Stuart, but neither of us had time to waste; we had to get back to the crowds. Street photographers always meet up after the event, or when the light is fading.

The cyclist here looks as if he is from the 1960s and is a very particular kind of Englishman. Look at those cuff links. But what is he looking at, when was it

taken, and how does he manage to stand on the bike with such elegance and confidence?

It is very interesting to compare the work taken by different photographers of the same public event, because it becomes clear that the 'selfish' photographers take the more distinctive and lasting images. This might be contentious, but they use the event to take 'their photographs'. If there is a marathon race through the centre of a city, photographing the runners is limiting, but turning the camera the other way, towards the crowd, is better. You could argue that this is a misleading practice because it might be an historic event, but the press covers these events, it is their job. The ethos of street photography is to be free of obligations.

A particular example – and one imagined because I have never taken such a shot – would be after a marathon. People often dress up in funny costumes, so imagine two men on the subway still in their costumes, two halves of a cow removed from the original event and context. Photographs are sometimes only as good as your imagination and this returns to the idea of knowing from experience what is possible with luck. Quite possibly the potential for luck increases at events and this is why they are the life-blood for street photographers.

This photograph on the left was taken at the VJ Day Anniversary in London in 1995. How do you photograph such an event? You don't; you just follow your instincts. Does it help to know the story behind this photograph? It is interesting, but equally the photograph has more impact without the backstory. Someone commented that this couple had been sitting there for fifty years, which would make it another anniversary.

CONCLUSION

The whole of a city or town is an event itself, and most street photographers cover a lot of ground as they wander. The delight of wandering with no particular agenda is coming upon a gathering of people engaged in some sort of event. It's unexpected, something that would be difficult to know about in advance perhaps. Street photographers develop an antenna for what might be interesting, but equally when they arrive they know instantly if it has been worthwhile. Even if they spend just 15 minutes there, it is not wasted, they are still out with their camera.

- Research events both fixed and random. Ten minutes online might reveal potential for where to start that day.
- Big cities have ethnic communities that have their own particular events, such as Holi.
- Equally, just wander, head for noise or crowds gathering.
- London has Speakers' Corner, in Hyde Park, an area for open-air public speaking. Many other cities have something similar.
- Go to small local events: local fetes, boot fairs, agricultural shows, etc. These are often not in big cities but in small towns, villages and seaside resorts.
- At protests don't overly concentrate on placards; they are easy shots.
- At events avoid directly photographing people in silly costumes; the better shots are usually when they are removed from the event.
- Even bad weather is an event, especially when it's wet and windy; it alters the way people behave on the street.

BRUCE GILDEN

born 1946, New York. www.brucegilden.com

To omit Bruce Gilden in any survey of street photography would be like going against some sort of trade description. You sense, as was the case with Garry Winogrand, that if you want to find him, you will have to go looking for him on the streets.

The streets are his territory; he doesn't exactly own them but he is at home there. In a sense, he's everything a street photographer should be – tough, tenacious and in possession of a wealth of stories about his street encounters. Yet the real story is how he has dealt with these situations and no doubt a degree of charm has always helped. This is a documentary photographer who has got right up close – literally – and this has included shoppers on the streets of Derby, UK, as well as gangsters in Tokyo. His up-closeness is his trademark. Not everybody likes this approach and his style is always going to be divisive.

He is, however, one of the most copied street photographers, or at least his manner is copied because few so-called 'aggressive' photographers are accepted into Magnum and there is considerably more to his work once you delve beyond the up close with flash pictures. You get the impression that he photographs what he cares about and he pursues projects with real dedication. In 2013 he was awarded a Guggenheim fellowship, the same award that enabled Robert Frank to produce *The Americans* many years before.

Gilden's photographs are dynamic; they deal with the theatre of the street and can lean towards the outrageous, wherever he goes. His technical aesthetic is his flash. Consider his 2002 book, *Coney Island* – the place was surely made for him; he photographed on the beach, which is an overspill of the street. Again, these are photographs taken at close range, with mounds of flesh everywhere; they are certainly not beautiful but they are honest. The style and texture is a little reminiscent of William Klein.

The work of both Klein and Diane Arbus has influenced Gilden; the grotesqueness of Arbus is apparent but tempered by Klein's busy and careful composition. Gilden's distinct subject, however, is his 'characters' and best of all the characters seen on the street.

It is interesting that his no-nonsense approach finds a favourable reception when he does workshops. Photographers may not instinctively warm to his style, but he does shake up attitudes and challenge people's comfort zones. He practises what he preaches and these attributes are always good for any kind of true learning.

The two women 'mugged' in the photograph from his first major book *Facing New York* (1992) is typical Gilden – you smell the street immediately and he has kept faith with that style. It's not beautiful but it's real.

Gilden is right in there, up close and very personal. These New York women in the startling 1990 time capsule is exactly what he wanted.

3 SEQUENCES

Sometimes several pictures are better than
one to show what happened next, because
the unexpected can be a wonderful story.

Sequences occupy a strange place in street photography
and not many photographers would even remotely
consider them, either consciously or even sub-consciously
– they would not recognise the possibilities and this
reveals the main dilemma of how deliberate sequences
can be. For the curious, the serendipity of sequences is
part of their charm.

Typically Elliott Erwitt, who loves the fun of the
unexpected, is a frequent 'sequencer'; it is part of his
repertoire, sometimes with just two pictures as below,
sometimes with several. The couple in deckchairs in
Cannes are there in one frame and gone in the next,
seemingly catapulted by alarmingly strong winds.
Individually the photos are meaningless but as a
sequence, they tell a story.

Nils Jorgensen is one of those rare 'sequencers'
on the street. Forever taking photographs he likely
gathers more untold stories than most. Maybe he
consciously looks for them; like many aspects of street
photography, one success primes the next.

Jorgensen is a cat watcher; he has time for them because
he understands that cats have time to consider the small

moments in life. In the sequence on the right nothing
really happens, it's just a charming, quiet encounter on the
street, with a beginning, middle and an end.

CONCLUSION

It is a pity that few street photographers produce stories
in sequences; they are too preoccupied with the single
shot. Perhaps it is another sort of language, and film
or video can do it more easily. It requires patience, too,
because you do not know how long to wait, but street
photography is a continual sequence anyway – of near
misses and hope.

- Look at 'sequences' in your contact sheets or scroll through
 your digital images. Two or more photographs might work
 better than one. A story might already be there.
- Think 'story' – one, two, three – beginning, middle, end.
- Take a photograph to pair with a photograph
 already taken.
- Be aware of people arriving somewhere to do something –
 think story unfolding – man with ladders putting up large
 poster or billboard. Something unexpected might happen.

 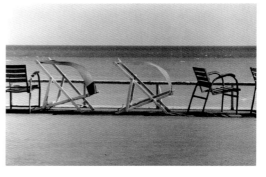

Elliott Erwitt, Cannes; 1975

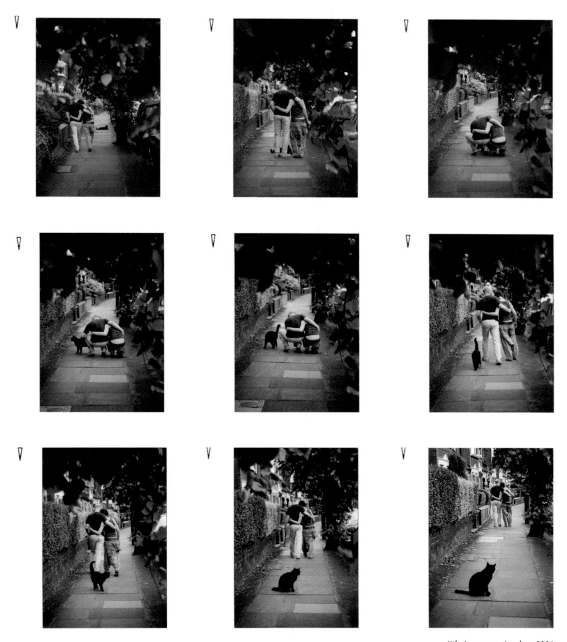

Nils Jorgensen, London; 2006

MATT STUART

born 1974, London. www.mattstuart.com

Matt Stuart takes a lot of photographs and he is extraordinarily 'lucky'; the two factors are inextricably linked. He knows exactly what he is looking for and is always primed for the absurdities that come his way.

His now iconic photograph of the striding pigeon (page 15) seemingly leading a group of figures – all in black and all in step – in front of London's National Portrait Gallery is the perfect example of a great street photograph. This is a hard photograph to take and it emphasises his singular style.

That style is again illustrated here with his photograph taken of a New York policeman with the shadowed moustache; again, what 'luck'! You have to check his moustache to make sure what it is.

Stuart's background is one of changing obsessions; first the trumpet, then skateboarding and finally street photography. Crucially connected to this was the influence of Matt's father, David Stuart, who was very successful in the design world after setting up a prominent London design group and who also co-wrote an important book, *A Smile in the Mind* (1996). This book could almost be a template for Stuart's clever observations, some of which – to some people – seem too good to be true. They might be 'art-directed' in his head but they are genuinely real moments that are the essence of pure street photography. Advertising agencies and design groups know this too and Stuart has undertaken assignments for them all around the world.

His heroes in photography are numerous: Henri Cartier-Bresson, Robert Frank, Joel Meyerowitz, Garry Winogrand, Tony Ray-Jones and Lee Friedlander

should be noted, but Stuart has often cited attending a workshop by Magnum's Leonard Freed in 1998 as significant. It was there that he started to see more clearly and the obsession took grip. First it was black-and-white photography but he found his true identity with colour. This is not an uncommon 'progression' but you sense the comfort in Stuart's style with colour. His world needs to be colourful.

When asked what advice he would give to someone starting street photography, Stuart summed up his philosophy as follows:

'BUY A GOOD PAIR OF COMFORTABLE SHOES. HAVE A CAMERA AROUND YOUR NECK AT ALL TIMES, KEEP YOUR ELBOWS IN, BE PATIENT, OPTIMISTIC AND DON'T FORGET TO SMILE.'

This is signature Matt Stuart; being in the right place at the right time, in New York, 2009. You simply cannot imagine such a shot, that's what makes it so special. When he moved off, the cop would have suddenly become clean-shaven

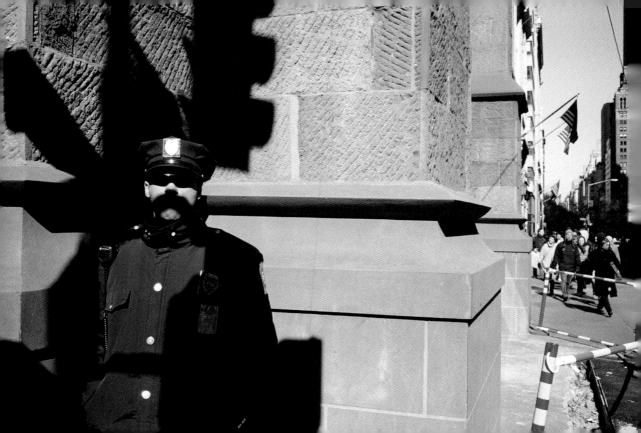

4 LINING UP

There is always an alternative view:
if two people can become one and baffle
the viewer then the photograph works.

I have often thought that the obsessive photographic eye eventually develops an element of autism – in which everything visual is processed slightly differently from the mainstream – so that, for example, elements can be satisfyingly lined up. A strong element of street photography is making things fit, almost like the pleasing joints in carpentry or a jigsaw. This 'fit' is an exercise in some respects, but, if done well, you literally cannot see the join.

One of the satisfactions of observing people on the street is their body language. An example of exploring this is by observing two people who are absorbed in each other's company, because from different angles they are 'joined' and can fleetingly become one. This creates an alternative or sideways view: it is a visual trick that can prompt the viewer to look twice. If a photograph demands time to understand it, it is a photograph that works.

The photograph of the two men behind the telegraph pole works because they genuinely merge into a single standing figure, with the pole. This image required lots of very slight movements for everything to fit. I was hidden behind the pole, which gave me time to try minor adjustments.

However, with hindsight this photograph seems to be more of an exercise; it works but it probably lacks real punch. The Stockholm fit on the next page is far more effective.

IT IS AN INESCAPABLE TRUTH THAT SOME PHOTOGRAPHS WORK BETTER THAN OTHERS, YOU HAVE TO ACCEPT THIS. FEEDBACK HELPS; NO PHOTOGRAPHER IS COMPLETELY UNSWAYED BY OPINION, BUT YOU HAVE TO KNOW YOURSELF.

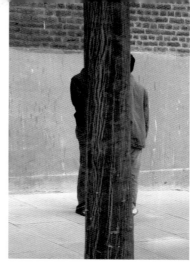
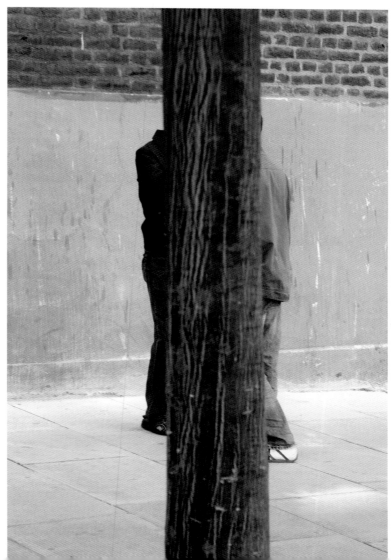

David Gibson, London; 2006

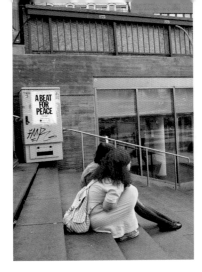
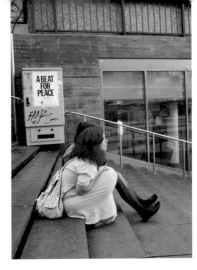

David Gibson, Stockholm; 2012

The sequence of three Stockholm photographs here shows the jigsaw coming together. The red hair of the woman in the foreground stood out but the two friends sitting on the steps were to my eye one entity. I quietly sat near them, took one shot and then quickly adjusted my position – moving one step down and then another so that from my angle the pieces in my composition 'fitted' together to make a visual illusion. Each image is only slightly different but only the final one works.

There was the possibility of a fourth shot as a friend approached the pair, but I instinctively knew that I would be pushing my luck if I tried to take more photographs. To take street photographs, you need to develop an acute awareness of when your imagined cloak of invisibility is about to slip. If you take too many photographs or do it in a clumsy way, the natural scene that you wish to photograph will disintegrate. There is a very fine line between the need to get a photograph and 'giving the game away' by getting caught. So much is dependent on the body language of the photographer; you need to pursue your subject as if you are not interested, when in reality you are very interested. Experience can teach you this, but it is also an attitude. I saw this moment in Stockholm and I wanted to get it absolutely right – there was only one fit – and this is not an uncommon feeling. Without sounding too absurd I hope, I would extend the analogy of the hunter and its prey. The cheetah hiding in the long grass is not seen and knows exactly what it is doing.

CONCLUSION

It's a strange thing to see two – or even three – people merging into one. You have to develop a particular taste for this absurdity, which is not for everyone's palate. Like other aspects in street photography it can be in your vocabulary for possible use. It's a trick but like any trick done well, the impact is immediate.

- Look at the photographs of Richard Kalvar, who frequently sees people and their shapes in fresh ways.
- Remember that people engaged in conversation will often be unaware of a photographer's interest in them.
- Lining people up can be helped by the background.
- Lining up – or merging – can also be linking colours.
- Likewise, black-and-white photography can absorb differences. A green top on a person appears darker, like a hedge; they too can become one.
- Parades are deliberate 'lining up' – think marching bands, the military, etc.
- People 'line up' best when they are stationary because you can move around them. Public squares are good for this.
- Animals – dogs and horses, for instance – line up well with humans.

MARIA PLOTNIKOVA

born 1984, Moscow. www.mariaplotnikova.com

The photo is a celebration of bold red but it's also charming and a little mysterious. It's a simple juxtaposition but it works so well.

Maria Plotnikova makes an interesting observation about the paucity of female street photographers in Russia that can probably be applied more widely. Female photographers, she thinks, prefer 'guaranteed' trends in photography, such as portrait, documentary, wedding or even sports photography. She adds that, with time, women will make their mark on street photography as they have in documentary work.

Plotnikova is a thoughtful photographer who draws on a wide range of influences; she studied philology – a combination of literary criticism, history and linguistics – with an emphasis on Russian literature and language. She cites this as a major influence and suggests that Russian culture is built on verbal foundations, which gives primacy to the word over visual language. A Russian apartment might be 'visually primitive' while home to a library of many books. Her view is that 'we believe more deeply through the word than through the picture'. This is an interesting conundrum but Plotnikova strongly believes that Russian photography is therefore driven by an overabundance of information and narrative.

She herself has a background in documentary and especially sports photography. She likes all sports and is

a fan of the Russian football team, which she describes as a 'very sad passion'. Plotnikova also notes the relationship between sports and street photography, in the 'decisive moment' of hitting the target.

Plotnikova is a member of Street Photographers Collective, which she joined in 2012, and she cites members of other collectives as influential, including Jesse Marlow, Nils Jorgensen and Maciej Dakowicz, but she reserves special praise for her 'virtual teacher', Gueorgui Pinkhassov. Alex Webb and Harry Gruyaert's use of colour has also been an influence on Plotnikova's work.

Plotnikova is sensitive to colour, particularly as she comes from a relatively 'grey' place dictated by plain visual taste but also climate. Intriguingly, since 2010 she has been living in South America, in Buenos Aires and now São Paulo. She thought at first that she would 'go mad from the diversity of colours and the light' but yet again this has provided her with more studies and influences. She is now well versed in South American

photography, citing Sebastião Salgado, Sara Facio and Magnum member Alessandra Sanguinetti. The latter you sense connects with a very particular feminine sensitivity.

Plotnikova emerged and gained confidence from the Flickr world of street photography – she still regularly checks in – but has since continued to learn beyond that. Her wide interests are reassuring, in that there is always something new to discover, especially when you live away from your home country.

South and Latin American colour dominate her photographs here. The girl wearing a red top complements the umbrella in her photo from Cuba, 2008. The action shot of little Lionel Messi running on an Argentine beach, 2010, is perfectly framed.

This is perfectly framed, indeed a whole series of lines and colour with the little boy caught exactly at the right moment. His joy at kicking the football is infectious.

2 QUIET

Although cities are crowded with people, photography is a reflective and calming way of seeking quiet amid the noise.

Some photographs shout loudly; they draw our attention and make an instant impact. The alternative is the quiet photograph: fewer people, more space and, in a sense, more time. Quiet photographs are slow photographs. You give time to the photograph because it has depth. Busy and quiet are not necessarily polar opposites, but it is worthwhile to recognise how a photograph works.

Photographs suggest, and it is up to the viewer to engage and make their own interpretation. Attributes of the quiet photograph are that it is calm, modest, measured and has grace and economy. You could add other attributes: quiet photographs can be spiritual, sad, gentle or comforting, however, all these aspects are fluid. There are also other, as yet unthought or unexpected, attributes that are unique to a particular photograph.

There might even be an unexplored question regarding gender: for example, do female photographers take quieter photographs? Street photography – so far – is largely the preserve of the male and perhaps the female aesthetic is a little less boisterous at times.

There is a beautifully considered anthology called *Hope Photographs* (1998) that offers yet another category of what a photograph might suggest. Many of the photographs in this book are calm and poignant, although hope is not exclusively quiet. A more uniformly quiet book is *To Sleep, Perchance to Dream* (1997) by Ferdinando Scianna. Always fascinated by the sight of 'figures wrapped in sleep', Scianna gathered a collection of pictures alongside evocative quotes from Shakespeare on a universal theme. The book is soothing and emphasises how well quiet photographs can collaborate with text.

'WHEN PEOPLE LOOK AT MY PICTURES I WANT THEM TO FEEL THE WAY THEY DO WHEN THEY WANT TO READ A LINE OF A POEM TWICE.'

ROBERT FRANK

Quiet photographs lend themselves to having a title, but an ill-thought-out title can narrow the possibilities of the image. A good title should naturally aid our appreciation of the image and the intent of the photographer. Quiet can evoke a mood and thus a title: as with book covers, the right photograph suggests something 'inside'. It is worth going into a bookstore and looking at the carefully chosen covers in the fiction section. Often they are contemplative,

▮ PROJECTS

*WAITING	page 80
*FOLLOWING	page 86
*BEHIND	page 92
*LOOKING DOWN	page 98

David Gibson, Perugia, Italy, 1992

and the people depicted on them are somewhat anonymous. These cover images are nearly always sourced from picture libraries and again it is worth researching the styles that these libraries offer. There is a demand for quiet – and abstract – photographs, and many photographers shoot specifically for picture libraries.

Sebastião Salgado's photographs have always been intensely epic, almost biblical in their scale. His *Workers* series was suitably industrial and in his recent eight-year *Genesis* project, the scale remains but the photographs are quieter and less crowded. They are about remote communities and a concern for nature, a quiet protest about the damage that we do to our planet.

Rural streets – roads without houses – are quiet. Rural communities such as the Christian Mennonites cling to a different way of life. They do not shun technology but there is a strong emphasis on peace and quiet. Magnum photographer Larry Towell has extensively documented their way of life in Canada and Mexico. His beautifully composed photographs evoke the simplicity and quietude of their lives. The theme of childhood is prominent and you can strongly sense Towell's sincerity and respect for Mennonite traditions.

Nils Jorgensen (page 90) seeks the quieter margins of the streets. In his work there are typically fewer people, sometimes just a singular graphic figure against a suitable background or various quiet echoes; occasionally the echoes are just small splashes of colour. Like many street photographers, the colour yellow is common in his photographs because it is everywhere in street markings. Yellow is quieter than red.

Arguably colour is louder than black-and-white, especially primary colours, which can be distracting. It is significant that Henri Cartier-Bresson only reluctantly worked with colour on assignments because he felt so strongly about its inherent difficulties. He had a distinct philosophy about what photography should be. However, you need only consider the early colour work of Saul Leiter to recognise that quiet need not be exclusive to monochrome. Overanalysing the merits of the two options can be a distraction in itself. What is important is the intent of the photographer. It is better to consider the mood of a photographer's work, whether it leans more to busy, quiet or abstract rather than the actual palette.

Quiet is good for the soul and it is interesting to observe the work of certain photographers. The renowned war photographer Don McCullin covered noisy and bloody war zones throughout the world over several decades, including in Lebanon, Northern Ireland and Vietnam. What he primarily sought in his work was to emphasise the quiet dignity of people amid the inhumanity and madness of war. Today he seeks solace by incessantly photographing the rural landscape in his adopted Somerset. These black-and-white photographs are all the more powerful and redemptive when you consider his experiences in war zones. Don McCullin is a quiet and dignified photographer who, by his own admission, was transfixed by the adrenaline rush of war.

The ultimate quiet photographer is Vivian Maier; indeed, she was virtually unknown during her lifetime. There has been much conjecture about how and why this came about; was she content not to seek an audience, did she perhaps lack ambition or confidence, or was this more a reflection of women's roles in society during her formative years? She worked as a nanny for a family in Chicago for much of her working life yet obsessively documented life on the streets. It seems that she wanted to be left alone although quite possibly like many photographers she experienced frustration and did not, for example, have the money to process much of her later work. Her 'quietness' – since her discovery shortly after her death in 2009 – is of a different order, but in their 'modesty' her photographs do have a quiet dignity. Her street photographs, some of which can be considered street portraits, are not exclusively quiet. She photographed on busy streets, but her silent approach has been rediscovered in the Internet age.

It is misleading to try and suggest where quiet photographs might be found. Of course, there are emptier parts of a city and at night there is stillness in some places, but quiet photographs really start with the mind and the eye of the photographer, and what they seek in their pictures. The photographer highlights what he or she wants to see and crucially excludes what is uninteresting to them.

Photographers eventually take photographs subconsciously; it becomes a prolonged personality test that reveals aspects of who they are. In theory the more extrovert are drawn to the busy streets while the quiet photographer prefers space; they do not want to be hemmed in by crowds.

Street photographers wander; they move in and out of busy and quiet. Most photographers instinctively gravitate towards busy streets because there might be 'something going on', but how many photographers have taken a better photograph on the way home from a busy event? They have been fired up or frustrated by the crowds, but with their eye suitably primed, they have got something worthwhile afterwards.

Quiet photographs are reassuring. They are like parks in a busy city.

Vivian Maier, Florida; 1957

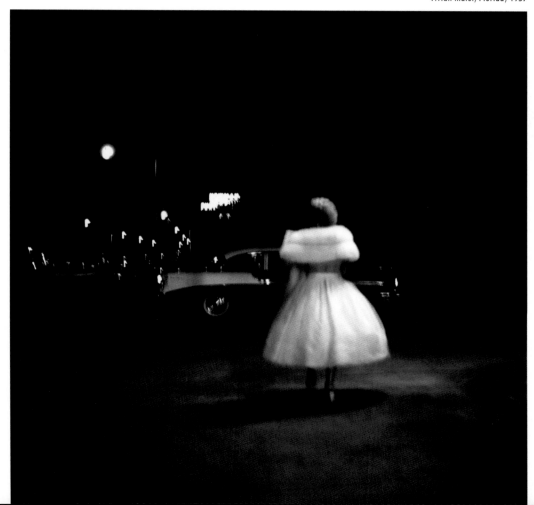

MEREL SCHONEVELD

born 1983, Muscat, Oman. www.merelschoneveld.nl

Merel Schoneveld, who lives in The Hague, Netherlands, has been taking street photographs since 2016 – a ridiculously short amount of time to have acquired such a significant body of work. She seems to have arrived fully formed: a natural talent who has found her calling.

Take one of her recent photographs – one of several that could be shown here – of Korean naval officers bunched up on the deck of a ship. It is not one of her chosen best, so perhaps she underestimates its power to spark the imagination. The men look high-ranking, yet wait politely for an even more important person to descend the gangway. It seems an historical event captured by Marc Riboud or Henri Cartier-Bresson in the 1960s. The scene is strange and beguiling.

The photograph here, taken in Belgium, is equally enigmatic. The scene is dreamy, even sultry. It seems a hot night. The contemplative cigarette suggests mystery – the hand belongs to Schoneveld but, as with the expectant naval men, we forget her presence. Who is the man in the street below? Is he waiting for someone? Perhaps the secret onlooker is somehow connected to him. The photograph is a short story – we want to know more.

There is a mix of purity and maturity in Schoneveld's work. For her, it is a new-found love and it seems invasive to ask who her photographic inspirations are. For the record, she cites Henry Cartier-Bresson, Lee Friedlander, Martin Parr, Josef Koudelka and Vivian Maier. But perhaps her calling is independent: she is self-taught, free and fuelled by an endless curiosity. She loses herself within it, a familiar immersion felt by many photographers. She forgets, in her words, 'to eat, drink, or go to the toilet' adding:

'WHEN I GET HOME I UPLOAD THE PHOTOS ... AND THEN USUALLY STAY THERE FOR HOURS, WITH MY COAT AND SHOES ON. I FORGET THE TIME AND EVERYTHING AROUND ME...'

This timeless, enigmatic scene captures an air of mystery. It could be linked to the past – only the partially shown signage on the boutique brings the photo up to date.

It's a refreshing scenario, and one you sense that will last. Schoneveld posts every day on Instagram and it's no coincidence that she has more than 20,000 followers. People pick up on her sincerity and enthusiasm. And more to the point, her photographs are consistently good, carefully composed and free of the cloying copy-cat syndrome that creeps into the work of many fledgling street photographers. All her photographs are black and white, there is no hesitation, but each new photograph to the world instantly looks precious.

WAITING

Backgrounds are a beginning; an interesting background in texture, words or shape can be half of a photograph. Then we wait.

What I call 'waited for' – or 'staked out' – photographs can be clichéd, in which the juxtaposition becomes too formulaic; it might literally be the 'oldest trick in the book'. Photographers take clever photographs employing this 'technique' but the better results are those where you cannot first see the method; it should look as if the photographer naturally came upon the scene complete. It might be a paradox; you want the perfect picture but you don't want it to look too perfect.

Imperfections are at the heart of street photography; however, backgrounds do offer a little more control for the photographer. There is an element of the scene being preconceived in the photographer's head but ideally not completely. Find an interesting background and imagine the 'perfect casting' – the right person to walk into the scene – but be open to what might actually transpire.

The first of the two 'cloud' series here is an example of being open to possibilities. The obvious cloud shape on boarding in a London street immediately struck me. It was raining and people were passing by with umbrellas. I imagined a little girl with red Wellington boots and a red umbrella passing under the cloud. It did not happen and I settled for a drably clothed man of the 'wrong' height, who merges more with the cloud rather than passing underneath it. The scene needs more colour, but the other imperfections work; people have commented that the cloud stain is more like smoke coming from his umbrella. The other two photos in this series are clearly warm-ups but this was not a long stake out. Sometimes if something does not come naturally it is better not to force it.

This straining is apparent in the other cloud series where, having chanced upon the cloud idea, I saw something similar in Stockholm: a wall on which the plaster had eroded – to my amazement – suggested big fluffy white clouds. It was a busy street, again it was raining and people were passing in front of the 'clouds', but this was a much longer wait and subsequently became overworked. The background was not so simple; there was more than one 'cloud' and the whole scene required more orchestration. In other words, the odds were stacked against me. What did I really hope for? Perhaps two or three people in unison passing in front of clouds? The slight desperation is evident in the lengthy series of shots. Some are horizontal, some are vertical and nothing looks quite natural. It was one of those days when, in the words of Henri Cartier-Bresson, I was guilty of wanting. The chosen image of the woman with the white boots works to an extent, although it does not work as naturally as the London shot.

CONCLUSION

I cannot emphasise enough how the natural and unforced element of waited photographs should be prioritised. The combination of patience and luck is at the heart of street photography. You tend to get what you deserve and sometimes it is just not meant to happen and you move on. And there is a moment when it does not feel right waiting any longer; in a sense you wear out your welcome.

David Gibson, London; 2008

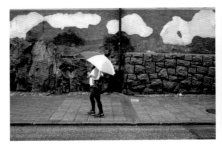

▷ **3A**

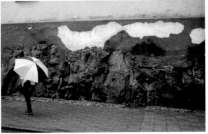

▷ **4A**

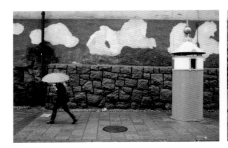

▷ **5A**

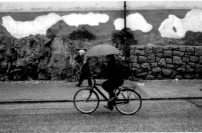

▷ **6A**

TIPS

- Wait a while but not too long; if the background is good, you can always return with fresh hope.

- When you 'set up' the photograph – in your head – and the subject is walking towards the scene, wait until the last moment because if they see you want to take a photograph they will either wait, or will even walk behind you.

- Know what you want – particularly with one person – try and get it with one shot.

- Some backgrounds involve sunlight and shadows, which are constantly changing. This is another form of waiting; the shadows could be significant at certain times of day.

- To use backgrounds effectively it is usually best to photograph people with the background square on, not from an angle.

- Always do a test shot (if digital) of just the background to get the exposure right.

- But try to focus on the person, or people, rather than the background. The distance might be small but it could show.

- Know your favourite type of backgrounds; sometimes you can return.

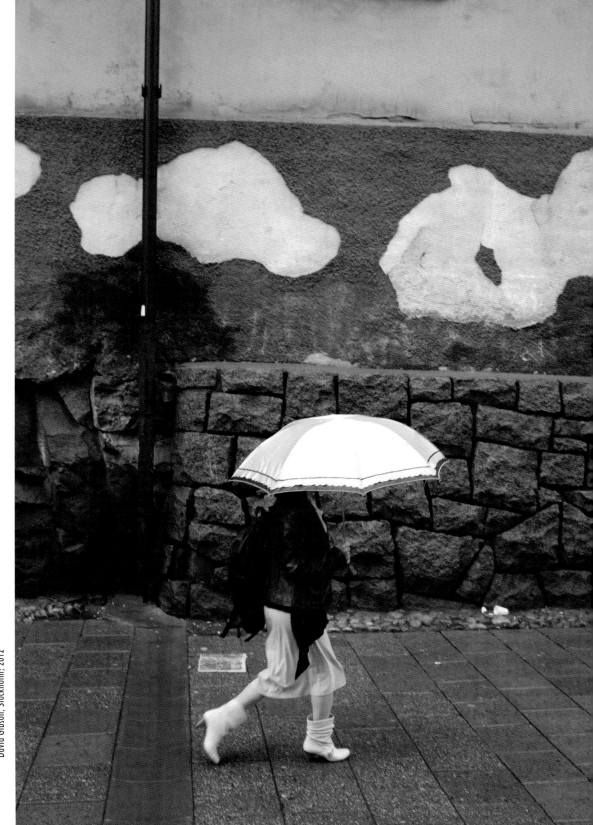

BLAKE ANDREWS

You see the white legs first and then look harder into the darkness for a human outline. It's an illusion, the difference between what is seen and what the camera tells.

born 1968, California. www.blakeandrewsphoto.com

Blake Andrews lives in a place that suits his forensic eye – and his sense of humour. Eugene, Oregon seems to have welcomed a small advance party of aliens who haven't quite blended in. Then again, the default setting for many street photographers is a strong suspicion that things are a little weird.

Andrews describes himself as a 'volume shooter'; he shoots every day, 'sometimes just a few frames, sometimes several rolls'. He has been advised that his website has too many pages but this is an honest reflection of his photography. You need only read his 'guiding principles' to get a flavour:

1. Camera in hand always, unless asleep in bed.
2. Film is cheap.
3. Digital looks cheap.
4. Reality is stronger than imagination.
5. Form subjugates essence, yet requires it.
6. Bystanders will quickly forget you, but a good photo lasts forever.
7. Light should illuminate the subject matter, but not be the subject matter.
8. Don't fight light. You will always lose.
9. Use right brain when shooting, left brain when looking over contact sheets. Paraphrased, this becomes …
10. shoot first, ask questions later.

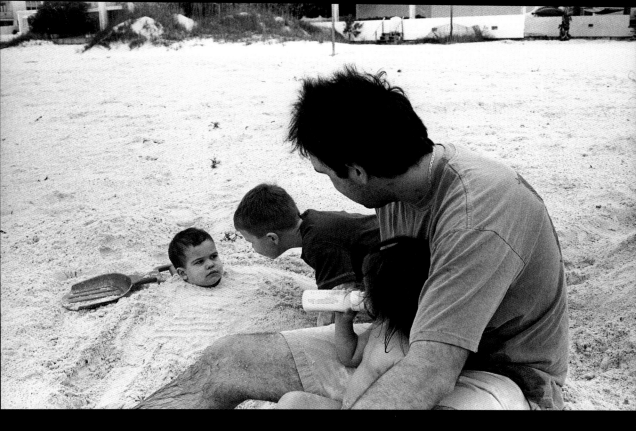

Andrews takes finely tuned black-and-white photographs so subtle that you need to double-check that you haven't missed something. This is a rare quality. They are a quiet homage to the weird, and often feature children. He has three children of his own and obviously likes them. He sometimes gently depicts scenes of play but he equally delights in the macabre.

Through Blake's eyes the beach scene above, taken in Florida in 2008, is a little sinister. The child is buried up to his neck in sand and by the look on his face he is being interrogated and systematically tortured. Things are perhaps not what they seem.

The 'disappearing woman' photograph, taken in Portland, Oregon in 2010 is a cleverly seen moment; it is also timeless. There is no contemporary clutter and you have to do a double take on the legs. When other photographers respond to this photograph, they wish that they had taken it.

His influences are many; like some obsessive working in a vinyl record store he knows about the most obscure artists. This obsession is channelled into his widely popular blog, which is one of the most respected in the photographic community. He employs quirky charts to illustrate different photographic trends and interviews photographers. He was a dedicated member of the Portland Grid Project, which documented the city through photography, and in 2008 he founded the spin-off Eugene Grid Project. The word 'grid' is telling because everything he does seems initially complex. He is a photographic DJ with an eclectic playlist.

You could attempt to describe Andrews' work as a hybrid of Richard Kalvar, Lee Friedlander and Henri Cartier-Bresson but that wouldn't really do it justice. His style is both subtle and original.

A normal family beach scene. Or is it? This delicious dark possibility is what the photographer has seen.

PROJECT **6** FOLLOWING

It is very natural to follow an interesting person, who might suddenly walk past the perfect background, to make a picture complete.

Taking 'waited' photographs from a fixed position can obviously be reversed; it still involves a background and a moving subject combining to make a photograph complete. The difference with the 'followed' approach is that the photographer is also likely to be moving. Everything is quicker and it is not uncommon to require a sprint to get in position.

Photographers in the studio prefer to work with uncluttered backgrounds because they do not want distractions. Subjects are sometimes depicted as seemingly floating in space. On the street where everything is happenstance, backgrounds can work in tandem with the subject. The bigger ambition therefore – achieved with luck and awareness – is to get an almost unbelievable background. The man carrying mattresses on his head who suddenly came out of a store in London's Regent Street was a good start; that alone is a reasonable capture, but what lifts the photograph is the background. The woman in the shop window display seemingly balances on the end of the mattresses. The man only walked a short distance but the jigsaw fits in the middle frame (main image).

The 'pursuit' of the woman with the striped dress on page 88 lasted longer, although still only a few minutes. I saw her dress and immediately thought zebra or pedestrian crossing, because at some point, with luck, she would surely walk across one. The idea is to keep everything simple; there are only two factors in the photograph: the two sets of stripes. A vertical shot naturally worked best, while the man with the mattresses suggested a horizontal view. The shape at the centre of a scene should naturally suggest the format.

SOMEONE SUDDENLY EMERGING CLOSE BY CAN DRAW YOUR ATTENTION – THEY LOOK INTERESTING, OR THEY ARE CARRYING SOMETHING UNUSUAL, AND YOUR INSTINCT IS TO FOLLOW THEM. IT COULD BE CALLED THE JIGSAW APPROACH: YOU ARE AWARE OF WHERE A PIECE SHOULD GO AND SUDDENLY YOU HAVE THE MISSING PIECE IN YOUR SIGHT.

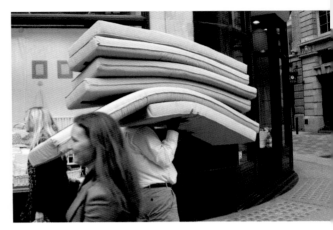

David Gibson, London; 2010

Safety helmets
and boots
must be worn
at all times

LEFT

LOOK

David Gibson, London; 2006

The last two photographs here illustrate a final fit that never quite happened. They were taken in Cambridge and London respectively a few years apart. Individually each of these street photographs has merit but it does not take much imagination to see a far better photograph if they were combined. The scaffolding 'erection' specialists and the man with the low-slung guitar walking towards it are two elements that combined could equally make a waited photograph, which would have been extraordinarily lucky. 'Missing' such a photograph is a reminder that luck does not always happen and it should be considered all the more precious when it does. We should always be prepared to follow possibilities.

CONCLUSION

Following people should only be done with a view to taking a few photographs fairly quickly; it is not realistic – and it is strange – to follow someone for more than, say, five minutes. Photographs tend to come together fairly quickly or not at all and it is best to accept this. And this philosophy applies to much else in street photography: you should be receptive to what occurs naturally, you cannot force something to happen.

- Follow but anticipate; look ahead to where a background might complete a photograph.
- Think jigsaw; the person might at some point fit the background.
- Be ready and have camera settings set correctly especially the shutter speed and the ISO setting.
- Following people is following shapes and/or colour.
- On sunny days, follow the shadows of people too.
- Sometimes an anonymous background, a wall for instance, is enough so that the emphasis can be on the subject.

id Gibson, Cambridge; 2009

David Gibson, London; 2006

NILS JORGENSEN

born 1958, Hørup, Denmark. www.nilsjorgensen.com

Nils Jorgensen appears to be the quintessential quiet photographer. He is quiet, his photographs are quiet, but this disguises his tenacity when it comes to taking photographs. He is always taking photographs; indeed, he takes photographs on the way to taking photographs. His day job as a press photographer, for many years with Rex Features and more recently as a freelancer, has never dulled his love for street photography. He has often bemoaned how this strange branch of photography was never understood by most of his press colleagues. It is not news and it features ordinary people or bits of people, or just as likely a cat in a window or a pair of shoes in a box. Jorgensen's strange photographs of nothing in particular have acted as an antidote to the pursuit of celebrities and the incessant rush of news pictures.

His street photography is slower and the lack of urgency means that he often sits on photographs for a long time, sometimes years. He lets them marinate and he comes back to them with a fresh eye. Some photographers do this; they like to forget.

In his press work, Jorgensen particularly enjoys art openings where his street eye picks out juxtapositions and oddities. He has a close affinity with art as his mother is a keen painter, and Lowry – a street painter – is one of his favourite artists. Jorgensen has eclectic tastes that encompass The Clash and the poetry of Philip Larkin.

His obsession with photography began with one of his father's *Time-Life Photography* yearbooks, especially one that featured Paul Strand, Diane Arbus, André Kertész, Elliott Erwitt and Tony Ray-Jones. Jorgensen's father, a doctor, was an amateur photographer and in 1976 gave Nils one of his old Leica cameras and that was the beginning.

For years Jorgensen drove everywhere, stopping the car briefly to snatch a photograph or even taking the trouble to park it and return on foot to something that had caught his eye. Recently he has used public transport in London but the prolific picture-taking has continued. Now there are more photographs of people on trains or life seen on and from the top deck of a bus. His territory is the margins of life. This is the real news for him.

And he gets 'lucky' – and what better example of luck visiting the prepared than Jorgensen's grabbed long-distance shot taken at London's Tate Modern in 2002. Remarkably the flash from someone taking a photograph went off at the same time. Nothing can really prepare you for such a possibility, but you recognise it, with a quiet nod to the god of photography somewhere in the sky.

A strange and miraculous photograph, which takes a while to figure out because almost everyone is in darkened light except for one colourful figure that is lit by flash. The whole scene is instinctively well composed, but allows for the serendipity of luck.

7

BEHIND

Photographing people from behind is natural;
it allows the photographer more freedom, which
makes the viewer's imagination work harder.

The conventional view is that portraits should always show the face; it would be odd for a studio photographer to focus on the backs of heads, for example. On the street this notion is largely undone because life on the street is unrehearsed, whereas in the studio the sitter is prepared and consciously offers a performance towards the camera. Indeed, the photographer will also direct them.

Street portraits are popular, too, but with street photography there is no interaction and this gives the photographer quite literally many more angles. There is a long tradition of photographing people from behind; André Kertész's shot of a man seemingly looking at a broken bench immediately comes to mind. This photograph is packed with possible interpretations. The photographer is unseen by the subject, which perhaps made the photograph more possible.

Couples on the street attract photographers because, amongst other reasons, they are often engrossed in each other and thus less alert to a photographer's interest. A good example is the monochrome photograph here of the couple entwined on a London bridge; they are merging, indeed she is almost buried in his embrace. This photograph came complete; there was no waiting and it was just suddenly seen. The view from behind *is* the photograph; there is no other angle. It is not a difficult photograph to take; the central theme of the photograph is obviously the three legs, which required a tight framing with no distractions around the edges. You just need to be alert to such gifts and to be fairly quick. With the photograph of the couple on the right, there is no long sequence. The contact sheet does not reveal many alternatives because each scene is still. I had time to adjust my vantage point by moving a little closer. Ten seconds in street photography is a luxury and it happens more with photographs taken from behind.

THIS VANTAGE IS NOT NECESSARILY AN EASIER OPTION OR IN SOME WAY COWARDLY; IT SIMPLY ALLOWS THE PHOTOGRAPHER TO WORK MORE FREELY. SHOWING LESS REVEALS MORE.

This father and son photograph on the promenade in Blackpool is a quiet moment. We do not need to see their faces; the photograph is more poignant from behind and crucially the uncluttered space around them emphasises the protective arm of the father.

CONCLUSION

It is in no way feeble or cowardly to photograph people from behind; it is considerably easier, admittedly, but the final result can be more compelling and imaginative than the conventional front view. Less is often more and besides we are conditioned to read character from behind; our imagination is better than reality quite often.

- It is not furtive or strange to photograph people from behind.
- It is simply easier to photograph people from behind; take advantage of this.
- Watch from behind how people clasp their hands; it's an endlessly rich subject.
- Remember that people are vertical, so a vertical – upright – framing will usually be best.
- Shapes and body language are more pronounced from behind.
- Move close to fill up the frame, as edges can be distracting.

David Gibson, Blackpool, UK; 1996

MARC RIBOUD

born 1923, Lyon, France. www.marcriboud.com

Marc Riboud's photographs are probably better known than his name. In a world in which the word 'iconic' is overused, Riboud can genuinely have the term attached to several of his photographs.

'Iconic' is a lazy word, and what does it mean exactly? Perhaps it describes an association with an historic event, nostalgia, or some indefinable resonance. Riboud's work encompasses all of these together with an underlying sense of grace and dignity. He is primarily a documentary photographer but the term 'humanistic photographer' is more telling. Like many of his Magnum colleagues, he took photographs on the street, usually while on assignment but equally for the sheer pleasure. The publisher Robert Delpire has described Riboud as 'a humanist who loves life'; certainly pleasure and passion are part of Riboud's philosophy, as he clearly states:

'A CAMERA IS EASY TO USE, BUT PROPER USE OF THE EYES REQUIRES A LONG, LONG APPRENTICESHIP OFTEN CAPPED WITH GREAT PLEASURE.'

Riboud's long photographic life has taken him all over a changing world. His 1967 photograph taken at a Washington DC anti-war protest of a woman placing a flower on the barrel of a rifle is one of the most powerful photographs associated with the Vietnam War.

A truly 'iconic' image is the ballet-like pose of the man painting the Eiffel Tower in Paris in 1953. It is graceful, elegant, beautifully composed and will continue to be seen for a long, long time.

There are several retrospective books of Riboud's work but a largely overlooked book is his *Three Banners of China* (1966). He was one of the first European photographers to be allowed into China and this book still has that exclusive, exotic feel.

When you look at his body of work, what shines through is how effortlessly free it appears to be of visible technique. His work is of a different order, alongside that of his colleague Cartier-Bresson. There are a few quiet juxtapositions, echoes and always careful composition, but the only real technique is his humanity seen through a graceful eye.

The photograph by Riboud on page 38 was taken in Istanbul in 1955, and was given the caption: 'The photographer operates with a tripod and will deliver his photographs three days later.' There is one kindly face visible but you suspect that the photographer is a kind man, too. The photograph is so simple; there is no modern clutter and everything about the scene is modest. His wise words are worth remembering:

'SURPRISES OF EVERY KIND LIE IN WAIT FOR THE PHOTOGRAPHER. THEY OPEN THE EYES AND QUICKEN THE HEARTBEAT OF THOSE WITH A PASSION FOR LOOKING.'

Why did the tortoise cross the road? Because it had time. Such an unusual and charming photograph, taken near Van, Turkey, in 1955.

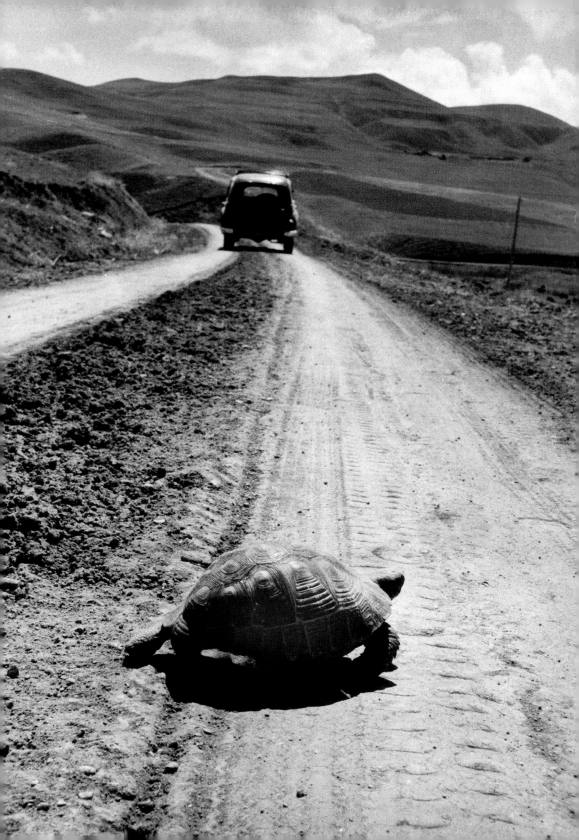

8 LOOKING DOWN

Where we take photographs from is as important
as what we photograph: different perspectives
on the street are vital.

We should think of the city as layered: upwards there is sky and building tops, then there is head height and then the ground we walk upon. In nearly all cities there are also streets below our feet – walkways and bridges from which to view more layers below. Photographs can be taken from buildings and there is also the upper deck of a double-decker bus for another bird's-eye view. The best analogy for finding the right perspective is a sniper looking for the perfect vantage point.

Taking photographs from above naturally halts our wandering; we become still and more in tune with what is below us. We have time to observe and we are not seen. It is easy to overlook how instinctively so many photographers have done this. André Kertész delighted in the scale and quiet afforded by distance. His iconic, snowbound Washington Square shot at night from his apartment window in 1954 is typical. The square is empty, only the street lamps announce their presence, and the mood is reflective. Kertész took the photograph when he was resting, not in the throng of a busy daytime street.

This resting motif is a vital one because we are open to what plays out below. The flat ground or gradient becomes the background and with this view we have more control. We do not have to consider the skyline, which can be a distraction with uneven light and lines; there is no top or bottom and everything is even. It is like chess – we need to look from above to see what move is best.

I have a particular fondness for finding higher vantage points and one such place is above Trafalgar Square in London, which is typical of many public city spaces in that it can be looked down upon from the street. It is a place to stop; sometimes the more interesting photographs are to be taken looking down into the square as opposed to being in the square.

The Trafalgar Square sequence here is taken a short height above some benches. I had time to frame these shots, to get the two legs from two people seated there to appear as one. The little girl moving around provided the variation. The strongest in the sequence is the main one with just the feet, because it asks more questions and provides a double-take moment.

The other set on pages 100–101 are taken from Bukit Bintang Monorail station in Kuala Lumpur, Malaysia. The distance was longer and it was more of a concentrated wait; the bold yellow arrows fascinated me and this was the fixed starting point. Kuala Lumpur is a layered city, with the monorail itself and raised walkways between shopping malls. Traffic dominates and by necessity pedestrians are often above the street.

The woman with the red hijab echoes the traffic cones but it is the three vertical shots of the woman in the red top carrying two yellow shopping bags that ultimately work, as everything is pleasingly laid out.

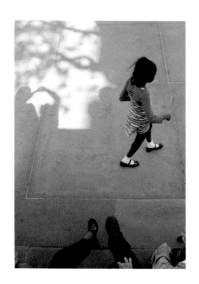
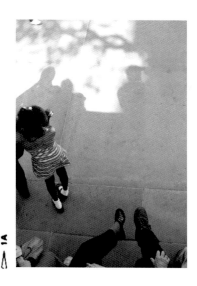

David Gibson, London; 2010

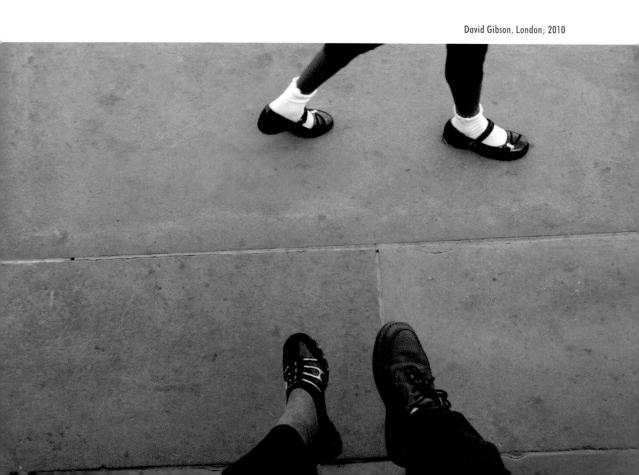

▷ 5A

▷ 6A

▷ 7A

▷ 8A

CONCLUSION

When we look down in a busy city we are removed from the fray. Just get on a double-decker bus, for instance, to watch the world go by. Suddenly we are above and can observe completely unnoticed. And this is an ideal that we should occasionally seek; we should look up to find places in which to look down. It's an intriguing game because many cities – not just Asian ones – have unexpected raised walkways or vantage points.

- Even our height is a vantage point; look at the street at your feet.
- Take photographs looking up too; the sky and buildings can be fascinating.
- Look for higher vantage points, to look down upon street life. In some cities, it might be a double-decker bus; in others, a road bridge or buildings.
- Think 'chessboard framing' – a game unfolding with every square vital.
- But appreciate empty space when looking down – it adds to a scene.
- Know that from a higher vantage point, you are given time and can work unnoticed.

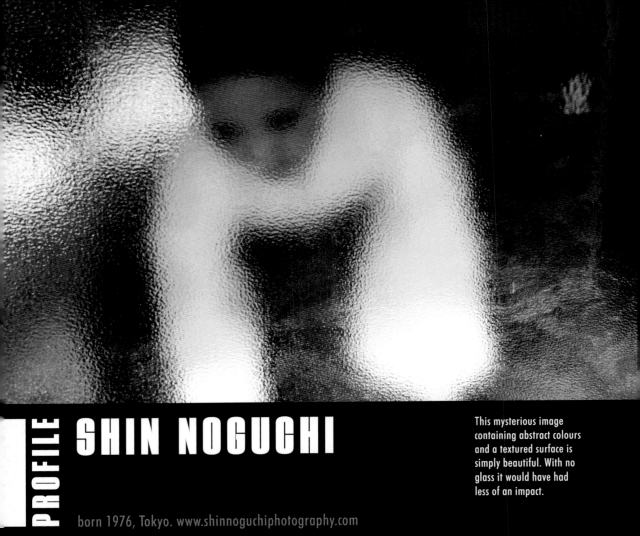

SHIN NOGUCHI

This mysterious image containing abstract colours and a textured surface is simply beautiful. With no glass it would have had less of an impact.

born 1976, Tokyo. www.shinnoguchiphotography.com

Shin Noguchi describes himself as a jazz-loving street photographer, based in Kamakura and Tokyo, Japan. What is it about jazz and photography? Is it some sort of sideways take on everything and not necessarily playing the melody straight? Noguchi singles out the jazz trumpet player, Clifford Brown, who died aged twenty-five in a car accident leaving behind only four years' worth of recordings.

Noguchi readily admits to a hero worship of Henri Cartier-Bresson and there is certainly a similar tidiness in Noguchi's best work, as opposed to the often chaotic approach of Daido Moriyama, which seems so imitated in Asia. Noguchi is more attuned to the work of Ihei Kimura, which he describes as 'overflowing with beauty and humanism' and you can see this ambition in Noguchi's work too. Perhaps there is something poetic about Noguchi's sensibility, alongside his liking for graphic lines, space, elegant shapes and a little surrealism.

Intriguingly, in two of his projects, *Sweet Dreams* – on people sleeping – and *Umbrella*, he mixes black-and-white and colour together, and it works. The consistency of the themes overcomes a usually very tricky dilemma. Ordinarily it is not a good idea to mix colour with monochrome in a single project; very few photographers do.

He has flitted backwards and forwards between colour and black-and-white, but as with many photographers who began in monochrome he is starting to find his true vision in colour. Noguchi was always interested in the photographers from Magnum – that was his beginning – but the true momentum for his street photography came from the anthology, *Street Photography Now* (2010) and the subsequent online project that sprang from that book.

You might describe Noguchi as an emerging photographer. Everybody has to start somewhere yet he has amassed a strong body of work over just a few years. He seems modest about his output, but he aligns himself firmly with the new 'online generation' of street photographers who are all active on Flickr and Facebook and look towards the ever-increasing number of street photography collectives for inspiration.

Significantly, in 2012 Noguchi joined the collective, Street Photographers, which has one of the biggest online followings. He was also recently one of the finalists for the IPA Street Photography Asia Award

Looking at a photographer's work on Flickr can be revealing – and sometimes disappointing; because photographers test photographs there, they are a little experimental in what they share. Noguchi's Flickr stream reveals some of his fascinations: people carrying things and looking odd, the colour yellow, deep shadows on bright streets and people layered behind glass or reflections.

In the photo above left, the black-eyed woman seemingly wearing a kimono is sparingly beautiful, reduced to shapes of colour behind the mottled glass. In the other photograph of a dog in a car, the colours leap out. This one is about eyes as well, and the colour yellow, in bold repetition, but it's also a slightly surreal moment. It captures a dog with attitude, which is always good to photograph.

Two bright yellows coming together is so simple but this fun slice of life on the street is really all about the quizzical look of the dog.

ABSTRACT

The abstract can be part of street photography; it offers an alternative direction within art and a welcome break from seeing conventionally.

Abstract is not a word normally associated with street photography or indeed photography generally. It is rarely accorded a separate category, possibly because the term is more firmly associated as a genre within art. Mark Rothko, for example, is clearly understood to be an abstract expressionist painter. Perhaps photography can never be completely free to achieve anything comparable because ultimately it records a reality. Photography is creative – it is an artistic tool – and it sees broadly but it cannot entirely escape its inherent function to record.

The US photographer Aaron Siskind took 'abstractlike' photographs; his peeling paint series are abstract but they are also photographs of a surface. Whatever the surface, whether it is a distressed wall or even human hair, it will still prompt most people to wonder what the photograph shows. In fact to not know what the 'subject' is, lessens the impact. This may be the attraction of abstract photography – to disguise and prompt questions – and it seems all the more clever when it creates 'art' out of something that does not function as art.

I have always had a strong affinity with abstract photography, as a means of experimentation and a much-needed escape from what I normally do. Taking 'conventional' street photographs has never been enough, and I have sought inspiration from art almost as much as photography. It would be unusual and limiting for any photographer not to look at art. You do not need to delve too deeply into the lives of some of the so-called master photographers to discover their artistic connections.

When street photographers cite their influences, many routinely mention Henri Cartier-Bresson or Alex Webb. A better question to pose to a photographer is not who are the photographers who have influenced you the most, but who are the artists?

Some photographers have also been accomplished artists. Cartier-Bresson virtually gave up photography to return to his painting. Others, such as Saul Leiter, have kept their photography and art running simultaneously. The shared theme is creative energy, which does not always come out in one particular medium. You could argue that various creative outlets are vital and that repetition potentially dulls any artist's output.

The history of photography is littered with photographers who have tried to 'escape' the restrictions of what they have become known for. Walker Evans established his reputation during the Great Depression era of 1930s America when he documented the poverty and conditions of the time for the Farm Security Administration (FSA). In his old age, in the early 1970s, he playfully engaged with the then new Polaroid camera and his photographs are very different, both experimental and a little abstract.

▌PROJECTS

*BLURRED page 108
*LAYERS page 114
*SHADOWS page 120
*REFLECTIONS page 126
*DOUBLES page 132

I have always admired the Italian photographer Mario Giacomelli, whose work clearly leans towards art and abstraction. His trademark high-contrast prints provided his escape, though far less consciously, because he did not have a background in photography and was not aware of the supposed rules. He photographed the streets of Scanno in Italy, an almost fairy-tale village that in the late 1950s remained untouched by the uniformity of the modern world. Giacomelli seldom travelled outside of Italy to take photographs; he did not need to, which somehow makes his work all the more complete. The artist Lucian Freud once said that he much preferred to 'travel downwards', which seems an apt description of Giacomelli's singular approach.

Giacomelli, whose era was decidedly pre-digital, is known for his abstractlike images of priests playing in the snow. The series *Little Priests* (1961–63) is both poetic and graphic – the black figures of the young priests seemingly float in the white landscape; nothing is in sharp focus and the effect remains strikingly refreshing. Everything about Giacomelli is, in fact, refreshing; he was first a painter, he did not engage with photography until he was about thirty, and he seems to have had little interest in financial gain. He made photographs for himself. The very best artists often defy the expected rules.

It seems nonsense, therefore, that every photograph should be taken at $\frac{1}{250}$ of a second. Then there is the eternal question of depth of field. W. Eugene Smith, the great US photojournalist and humanist photographer, put the question of depth of field firmly to rest: 'What use is having a great depth of field, if there is not an adequate depth of feeling?'

Shutter speeds – slow shutter speeds – are a parallel universe: what if you took photographs for seven days, employing a different shutter speed each day? Things would look a little different. They might look like mistakes requiring instant deletion, but what if some kernel of an idea emerged, something unexpected? The possibilities lie in the meaning of the word 'abstract' itself: theoretical, hypothetical, unreal, spiritual, vague, conceptual, imaginary, indefinite, profound, philosophical.

The desire to explore should not be dictated by advances in digital technology whereby cameras can now shoot in high-definition in very low light. High-definition fulfills a need, but it is often the antithesis of abstract photography. It might be clearer, but it does not necessarily say more.

Abstract photography should be therapeutic, a means to redefine and challenge conventional photography. It should have soul, but these ideals do not chime with all photographers. In the wrong hands, attempting abstract photography can be a redundant path because it becomes visible experimentation with no heart. This is how it should be; after all, you could argue that Cartier-Bresson or Sebastião Salgado stuck with one tried-and-tested style that worked for them.

The D-day beach landing photographs by Robert Capa from 1944 are blurred. Circumstances obviously prevailed – it is some feat to take photographs in a battle – and tragically, some film was later destroyed by mistake. Some of the images that survived are enticingly blurred and add a creative edge to an already intensely poignant set of historical pictures. Suddenly, in the motion, everything seems even more vital.

Robert Capa was a straightforward photojournalist and a very powerful one because he covered such important events. His fellow Magnum photographer, Werner Bischof, who died young in 1954 – the same year as Capa – was quite different. He had the same concerns for humanity but his approach was far more experimental, perhaps even poetic. Bischof was an accomplished sketcher, and his early photography was full of experimentation with studio lighting on nudes and still lifes. Given a subject, he would as easily do a sketch as photograph it.

It must be stressed that this branch of photography is not for everyone. Some photographers stick to what they know, they play to their strengths because, quite literally, their expression is focused. Returning

to Cartier-Bresson for example; it is hard to imagine him deliberately shaking the camera or using very slow shutter speeds as it would spoil the picture and confuse our appreciation of his carefully constructed body of work. His photography always leaned more towards the surreal rather than abstract.

On the other hand, for photographers such as Mario Giacomelli or Ernst Haas, abstraction either slight or profound was essential to their way of seeing the world around them. Conventional photography for many has its limits that can only remind us of the futility of supposed rules. Photographers make their own rules.

Mario Giacomelli, Scanno, Italy; 1957

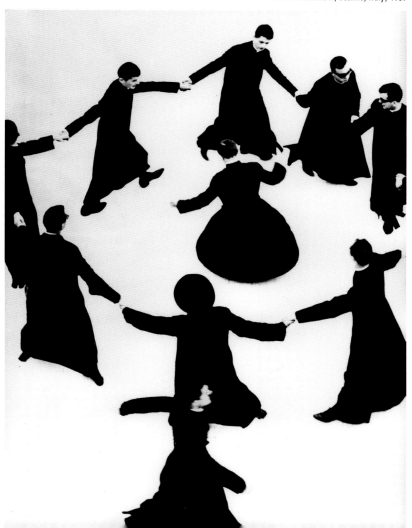

9 BLURRED

Deliberate experimentation in photography opens up the possibility of an escape hatch. Blur need not be a mistake.

Many photographers prefer the pin-sharp or high-definition world of photography; the word 'blurred' can be associated with having made a mistake. There are degrees of blurred – and out of focus – and sometimes it is a mistake, but when it is done deliberately it can open up a whole new world on the street.

We should also consider movement in this context, and again there are degrees of movement too. When does movement become abstract? There is a famous blurred photograph of a pedestrian's foot from 1950 by Otto Steinert that is so deceptively simple, yet abstract and surreal. It is a reminder of how differently the street can be seen.

Swiss photographer Ernst Haas was a pioneer of colour and abstract photography in the 1960s; he was a documentary photographer whose work became fine art in galleries. He broke new ground with shallow depth of field, selective focus and blurred motion. His photograph of a bullfighter in Pamplona, Spain, in 1956 looks like a painting and is still a revelation.

Raghu Rai's epic black-and-white photograph of Mumbai Railway Station (page 10) shows two men reading newspapers who are in focus but a sea of flowing movement surrounds them. The technical details are not known, but you would hazard a guess that it was taken at around ¼ of a second.

Sometimes when I am out, I will occasionally visit this other world of photography, which all comes out of the same camera. The shutter speed on the camera determines this; it is usually set at ½₅₀, which can cope with normal walking movement, but altering the film speed (ISO) together with a shutter speed of, say, ⅛, changes everything. And there are many more variations.

I HAVE FOUND TAKING BLURRED PHOTOGRAPHS A RELIEF AND A COUNTERBALANCE TO MY MORE CONVENTIONAL PHOTOGRAPHY.

The photographs here are a selection of these controlled experimentations. This short series of a traditional Korean musician was taken looking down onto the floor of the Great Court in London's British Museum. She was stationary – I wanted her more or less in focus – but with blurred people passing by, it is almost as if she is the pied piper. The shutter speed here was ⅛.

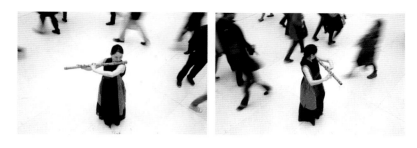

⊳ 1A ⊳ 2A

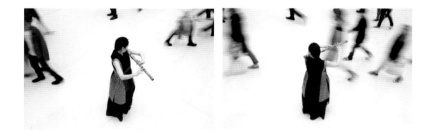

⊳ 3A ⊳ 4A

David Gibson, London; 2013

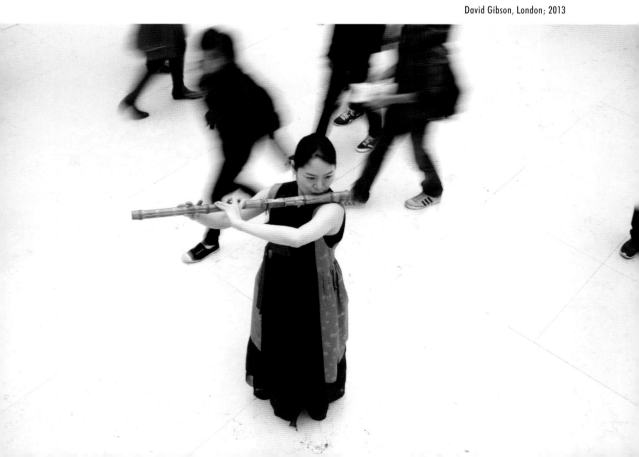

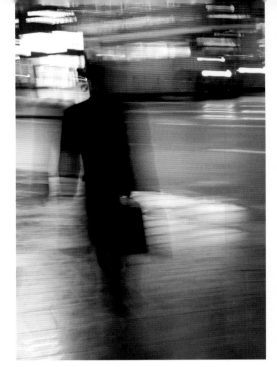
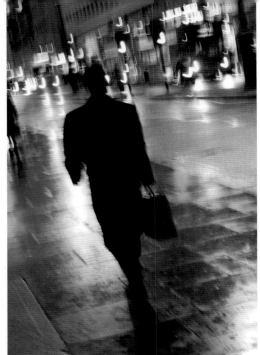

The blurred, black-coated man with hat and briefcase taken at night is a combination of a slow shutter speed and shaking the camera to create a slightly streaked effect. It was a wet night with lots of saturated colours reflected on the ground, and this man, looking elegant in a black hat, was an opportunity to capture a mood and shape. Sometimes it is just the shape that draws you.

YOU NEED SOMETHING BOLD TO STAND OUT IN THE BLURS AND STREAKS OF COLOUR.

CONCLUSION

We are forever moving towards 'better quality' in photography, but the soul of photography is hopefully unchanged. It is like painting; the canvas and brushes are basically the same as one hundred years ago. The pin-sharp world of street photography is like high-definition television; what ultimately matters is the quality of the show.

- Experiment: do not think of blur as a mistake but something creative.
- Photograph the street at various slower shutter speeds – for instance, shoot only at ⅛ of a second for a concentrated period.
- Take photographs from a fixed point; let the movement of the people create the blur.
- Shake the camera upwards or sidewards to create blur that might be streaked.
- Know the kind of bold shapes, not just people, that work when blurred.
- Look at the photographs of Ernst Haas, a pioneer of abstract colour that was fine art.
- Delight in primary colours when taking blurred shots.
- Look at art, especially abstract and impressionistic. Let it influence your photography.

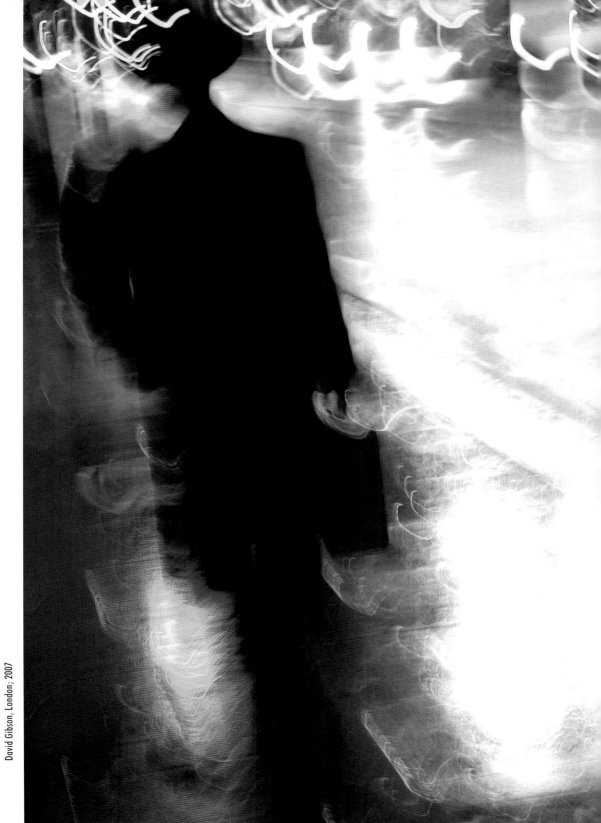

GUEORGUI PINKHASSOV

born 1952, Moscow. www.instagram.com/pinkhassov

Flicking through the pages of a photographer's book, you sometimes keep coming back to a few images that have startled and inspired you. There are many words that describe this moment; in his book *Camera Lucida* (1980) Roland Barthes notably called it a 'punctum' – something that pricks your consciousness. But this feeling is also an affirmation of something special that can still surprise. Gueorgui Pinkhassov's photographs do this.

Part of this pleasure is probably that Pinkhassov is a relatively obscure photographer. Although he is a member of Magnum, he is not that well known. Sebastião Salgado, Alex Webb and Martin Parr, for example, all have a higher profile.

Some of Pinkhassov's 'punctum' photographs are in the book *Sightwalk* (1998), which is distinctive in itself with its Japanese binding and paper. What is it, though, that makes Pinkhassov's work so different? He has an acute awareness of light, colour and distortion; he is drawn to the muted and the unusual. He seemingly has his own special time and place to photograph.

You could describe it as a murky world in which he avoids normal daylight; night or twilight is better, or a daylight that is muted or not wholly seen. He has his own light; perhaps it could be said he takes indoor pictures outside. His early background as a film cameraman might explain this, but it is commendable that Magnum should want to embrace such a unique vision. Magnum's ethos focused initially on important photojournalism, yet it also encompasses a broader appreciation of abstract artistic vision too.

Another aspect of Pinkhassov's work is his unusual framing and his liking for layers, through windows in particular, as if he wants to abstract the world around him. It is very difficult to pin Pinkhassov down, and his own words seem to confirm that:

Pinkhassov sees unusual beauty. The evocative light and reflections present the girl very differently. The photograph is literally quite reflective.

'THE POWER OF OUR MUSE LIES IN HER MEANINGLESSNESS. EVEN THE STYLE CAN TURN ONE INTO A SLAVE IF ONE DOES NOT RUN AWAY FROM IT, AND THEN ONE IS DOOMED TO REPEAT ONESELF. THE ONLY THING THAT COUNTS IS CURIOSITY. IT WILL EXPRESS ITSELF LESS IN THE FEAR OF DOING THE SAME THING OVER AGAIN THAN IN THE DESIRE NOT TO GO WHERE ONE HAS ALREADY BEEN.'

The photograph of the women at the Tokyo metro station, taken in 1996, is typical of his layered, abstract pictures; the colours and speckled reflections are absolutely beautiful.

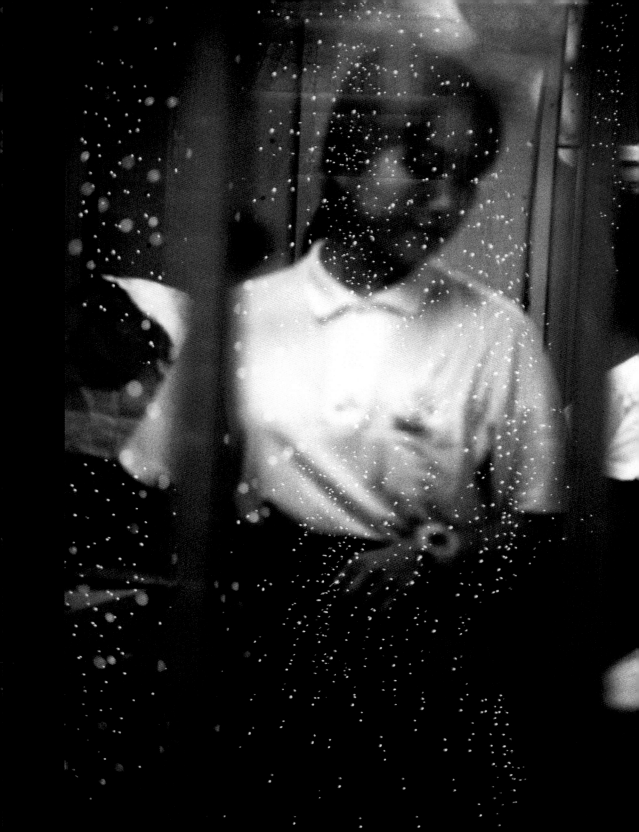

10 LAYERS

Taking photographs through things, such as glass or material, adds a natural artistic layer. Suddenly there is another meaning.

Camera equipment has always offered layers in the form of filters on lenses that can be added for artistic effect, but more interesting filters are those naturally found on the street. As with perspective and with finding a higher vantage point, it is worth seeking 'street filters' through which to take photographs. These can be myriad: glass, preferably dirty, wet or frosted; wire mesh fencing; and all kinds of material or liquid. Even plain glass adds a slight layer, and you could even add bright sunlight to the list. Photographing into the sun might capture shafts of light streaming down but this again breaks things up

and provides a layer effect. The normal technical rules might curtail such experimentation, but equally there are no limits to possibilities. You can even 'remove' a layer by shooting faint, low-key photographs. We should not necessarily consider layers as adding density.

A photograph by André Kertész taken in Martinique in 1972 is a half-layered photograph; a man silhouetted behind glass is one half, the rest is lines, sky and horizon, but the two halves work together to create a surprising image. Kertész's background was rooted in surrealism and he experimented with distorted imagery during his long career.

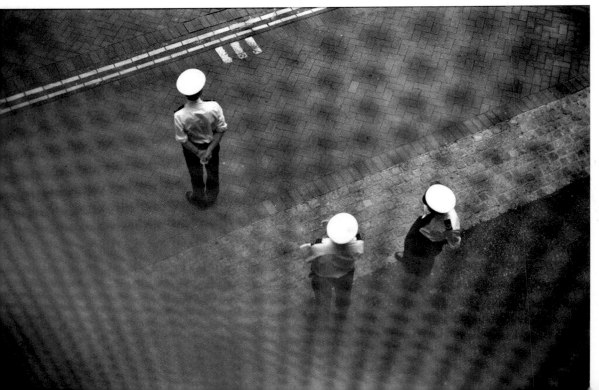

David Gibson, London,: 1995

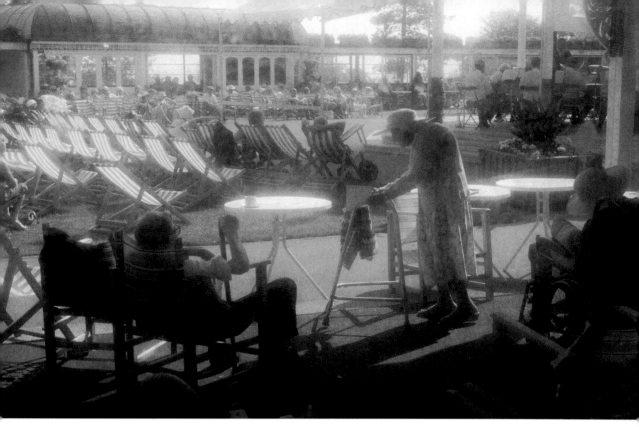

David Gibson, Westcliff-on-Sea, UK; 1994

Glass is one of the most common layers; usually windows of some kind. Michael Wolf's series *Tokyo Compression* shoots commuters seemingly trapped behind the glass windows of subway trains. Their discomfort, dignity and strange beauty are frozen in the photographs. These could be described as layered street portraits.

Layers iron out normal distractions, they can add texture and mood, and like a veil may suggest mystery. The layer can sometimes also be a screen allowing the photographer to work unseen, and as with looking-down photographs it allows time to compose.

The photograph above, which I call *Heaven*, was taken in 1994 at an old bandstand and shot through a dirty window; there is a heaven-like mood to it. The exposure is a little uneven and the contrast is quite high, which blasts out some of the detail in the background, so that the shape of the elderly people in the foreground stands out.

The photograph below left, again taken on black-and-white film, was captured looking down from a station walkway, but this time through a mesh fence. The texture is more pronounced; the crisscrossed pattern is the filter, which highlights the starkly lit white hats belonging to the three security guards. It is a photograph about hats, mood, shapes, lines and ultimately texture.

David Gibson, Bangkok; 2013

The final example is a series taken in Bangkok, this time in digital colour but with exactly the same concept. Taken from a walkway through frosted and scratched glass, the focus is not on people but the colourful Bangkok taxis. The pleasure is simply the bright colours, which became abstracted through the layer of glass. It is worth acknowledging that in such situations the glass layer throws out what might be considered the 'correct' colour. Suddenly we are excused from having to present the expected colours that we see on the street and we can experiment a little. The colour balance in this series can be varied and none would be wrong.

CONCLUSION

The main point about photographing through layers is that no one is concerned with the method, however odd it might seem at the time; it is only the effect in the final photograph that counts. The maxim must be: think differently; look for different ways to approach photographing on the street.

- Take photographs through layers (with the advantage of concealing yourself).
- Consider 'layers' in the air, such as mist, fog, snow, steam, smoke and heavy rain. They can soften or abstract a subject, making it quite different.
- Experiment: use different camera filters, but create your own 'filters' too. For example, at a cafe table, hold up a glass and photograph the street through it; in a flower market, pick up a fragment of see-through wrapping paper and use it as a filter: it's not a strange thing to do.
- Unclean or textured layers, such as a dirty window or mottled glass, are usually the most interesting.
- Focus on both the layer and the subject beyond.

JACK SIMON

born 1943, New York. www.jacksimonphotography.com

The bandwagon of street photography doesn't really need any more recruits, however there is delight every now and then when someone a little bit different gets involved. The addition of Jack Simon is testament to that – his whole ethos is intelligent and refreshing:

'I'VE WORKED AS A PSYCHIATRIST FOR THE LAST FORTY YEARS. EIGHT YEARS AGO I BECAME FASCINATED BY THE POSSIBILITIES OF PHOTOGRAPHY, TAUGHT MYSELF AND NOW RARELY GO ANYWHERE WITHOUT A CAMERA.'

What an intriguing idea – the worlds of photography and psychiatry colliding or colluding – but then street photography has always probed and revealed. Simon's website galleries list, amongst others, *Women on the Verge…* and *One Flew over the Cuckoo's Nest.* They seem to confirm a link with psychiatry until you realise that they are just films he likes.

In interviews Simon appears reticent to commit to definitions or absolute explanations about what he does. There remains an urge to link his psychiatry to his photography and he concedes that his years of observing people – the quirky and the offbeat in his office – have heightened his intuition. Outside of his workplace, though, you sense that his thought process is more abstract rather than neatly cognitive.

Strangely, the fashion and documentary photographer Paul Himmel comes to mind. He became disenchanted with photography and took his last photograph in 1967 after which he retrained as a psychotherapist. There is not necessarily a predictable timeline for when inspiration first appears or slips away.

Jack Simon's enthusiasm for street photography developed through his involvement with the Street Photography Now project, which began on Flickr in 2011. The group's origins lay in the book *Street Photography Now* (2010), which struck a chord with many potential street photographers around the world. Every week throughout 2011 the book's contributing photographers gave members of the project an instruction. Jack Simon was one of the joint winners for that first year, accelerating his confidence, which led almost inevitably to his becoming a member of Burn My Eye, one of the burgeoning number of new street collectives that emerged out of this online energy. Burn My Eye, whose original members include Zisis Kardianos, has become one of the most ambitious amongst the new wave of collectives.

Looking through Simon's work it is astonishing to realise that it has all been created in less than four years: the depth and originality suggests twice that time at least. There seems to be another layer in his work that is more original. He loves reflections and a certain ambiguity.

'Leaving Japan', taken in Tokyo, 2008, might almost – after just a few years – be his signature style.

Jack Simon has this photograph for life; it's one of those surreal and beautiful images that will continually nudge him and resonate with others. His luck and vision came together that day and secured his late ambition with photography.

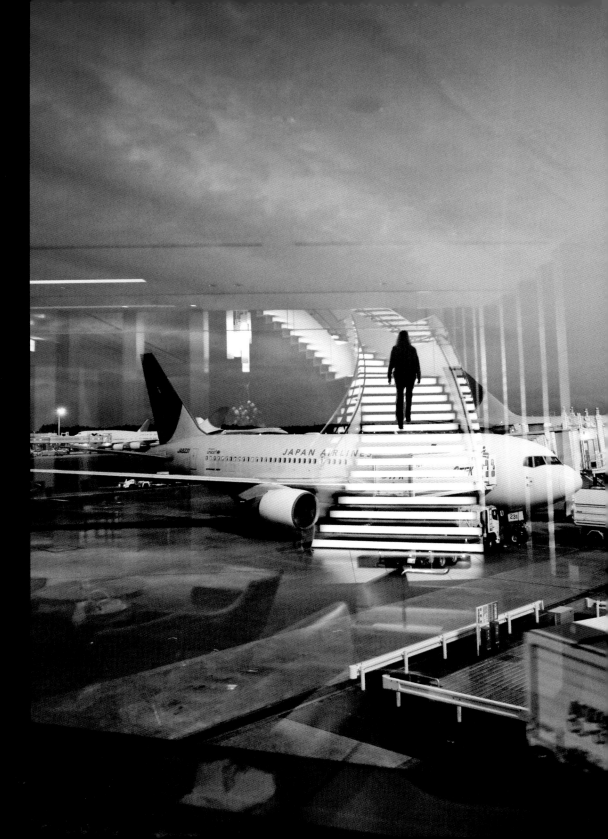

SHADOWS

Shadows on the street are conducive to being photographed; treat them as an opportunity to explore another world.

Shadows are an important part of photography. Indeed, the very concept of photography was born out of the desire to 'fix the shadow' in the early nineteenth century.

Shadows of people on the street can be approached as something quite literal or as another 'shadowy world'. Sometimes shadows are passive but they can be the reason for the photograph. Photographers chase shadows because they distort and they create atmosphere, patterns and surprise. Shadows in colour or black-and-white are always dark, they add balance and intriguingly photographers have their own shadow to enjoy. It is a constant and likeable companion. Often they cannot get 'out of the picture' and that can also be good.

There are shadows of people and there are shadows on people. Shadows are not there every day and when they are, they change and move. There is nothing quite like a late afternoon in autumn for long shadows in the city. On a bright day many photographers wait for the shadows to get long; they do not like the sun to be directly overhead.

A photographer in Athens once told me about his '18:38' photograph: every day at about that time a shadow was fixed at a particular point, which in conjunction with something already there could make a great photograph. This 'sundial' approach can be vital and it is worth noting the times and movements of shadows.

All the best photographers have at some point photographed their own shadow, almost like a signature. Elliott Erwitt's typically wry take is of his shadow on grass lined up so that his eyes are daisies. It's obvious and simple, but it's enjoyable.

My 'self-portrait' photograph here is a celebration of long shadows but also the scene, which was a small landscaped green with a lake outside the Museum of Modern Art in Edinburgh. Again it's simple but quite dramatic. There is also that familiar self-photographing shape with the arch of the arm that appears only in vertical photographs.

In the image on page 122 the shadow of the woman with the distorted hips is different and could be classified as an event photograph, although it avoids the event. It was taken at an S&M protest in London in 1996. The photograph is not really about the woman but the surprise and drama of her shadow. This scene naturally suggested a horizontal shape because of the left and right elements in the picture.

The third shadow photograph on page 123 is an example of the benefit of sometimes turning a shadow picture upside down. Shadows often suggest this; it cannot really be done with other types of photographs. Shadows have different rules. It was taken in the centre of Barcelona and shows a little girl carrying a small horse-like balloon. The long shadows distort the perspective and turning it upside down adds further drama.

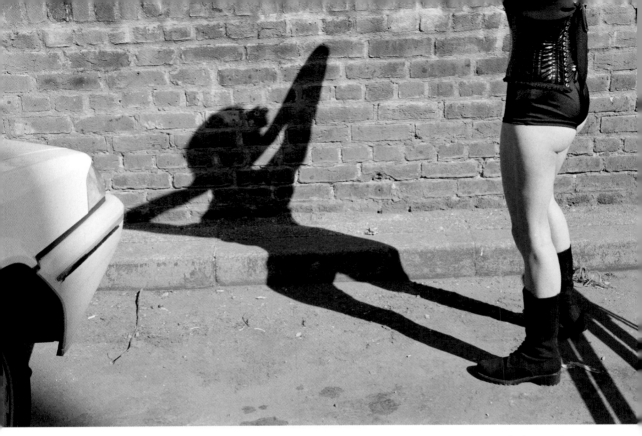

David Gibson, London; 1996

CONCLUSION

In bright light or sunshine shadows accompany
everything – people, buildings, objects – and they also
move. They really are an important element for street
photographers and should never be ignored or taken
for granted. Sometimes the shadow is better than
the thing or person that casts the shadow. We should
celebrate shadows on the street and not just have them
as incidental in the frame; they should leap out.

- Think 'sundial' because shadows move throughout the
 day; there might be one short opportunity to take a
 dramatic shadow photograph.
- In autumn, chase long shadows in late afternoon.
- Splashes of bright colour around shadows can add drama.
- Photograph your own shadow in all sorts of situations;
 alone but also imposed upon quiet or busy scenes.
- The shadows of a photographer is a special shape,
 especially when taken vertically.
- Shadows distort what people look like; photograph that.
- Consider the upside-down approach to shadows.

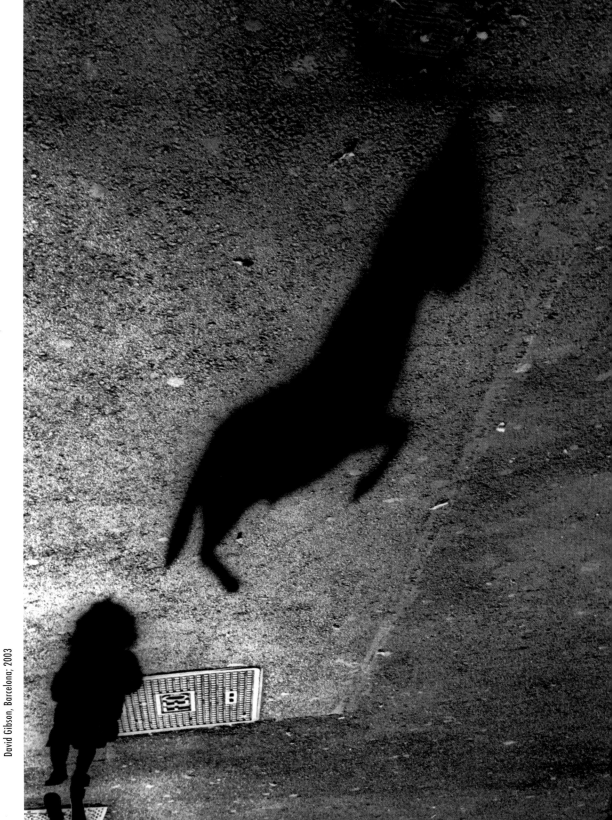

David Gibson, Barcelona; 2003

MELISSA BREYER

born California. www.melissabreyer.com

On her website, Melissa Breyer describes her work as 'an ongoing project of photography on the sly'. She has the unique ability to document the city, capturing fleeting moments among the hustle and bustle of urban life. Her inspiration lies in:

'THE BEAUTIFUL MASH-UP OF NON-FICTION AND FICTION THAT CANDID PHOTOGRAPHY HAS TO OFFER; THE NON-FICTION IN THE FRACTION OF A SECOND THAT THE PHOTO WAS TAKEN, THE FICTION THAT FOLLOWS AS EACH VIEWER SEES THE PHOTO AND CREATES THEIR OWN STORY.'

Breyer's photographs are quiet, contemplative and often abstracted through light or reflections. One particular photograph confirms her ethos; looking down upon the concourse at Grand Central Station, the shot is centred by a lone man in focus surrounded by the blurred movement of others. Of course, here Breyer is referencing Paul Himmel's iconic photograph from the 1950s.

Perhaps there is something film noir about her approach; some of her work evokes opening film scenes that are slightly melancholic, setting the mood for what might follow. You might add aloneness, elegance, perhaps even nostalgia evoked through shaded light.

You sense that Breyer could pull off a good fashion shoot – maybe she has – because men's hats and high-heels feature now and then. One high-heeled pair of legs ascends a marble staircase, its close-up cropped by light and shade. The result is understated and exquisite.

It is no surprise to discover Breyer's feelings for words. She writes as she takes photographs, with sensitivity. She describes New York, as:

To Breyer, this scene is reminiscent of rainy nights in Gotham – dark and lonely, yet beautiful and magic.

'A BEAUTIFUL WILD ANIMAL THAT REFUSES TO BE TAMED. AND THAT'S THE STAGE FOR MY PHOTOS. ELEGANT SKY-SCRAPING ARCHITECTURE AND MANSIONS MIXED WITH THE MUDDY AND MUNDANE; MIST AND GLINTING RAIN, SLY SUNLIGHT AND DEEP MISCHIEVOUS SHADOWS, GLASS EVERYWHERE THAT REFLECTS IMPOSSIBLY SURREAL WORLDS – AND HOLDING IT ALL TOGETHER, THE CITY'S INHABITANTS, WITH ALL THEIR STORIES, IN ALL THEIR ANGST AND BEAUTY.'

On this particular photograph, she adds:

'THE PLAY OF REFLECTIONS ON THE SIGN WITH THE WOMAN REALLY CAUGHT MY EYE AND I WAS FRAMING IT IN MY VIEWFINDER JUST FOR KICKS, AND THEN THE MAN STROLLED IN, WITH HIS LIT CIGARETTE, LOOKING PERFECT FOR THE PART.'

The key word about Breyer is enigmatic – that's abstraction – and it's deliberate, her desired face to the world. Just like this play of seen and half-seen faces.

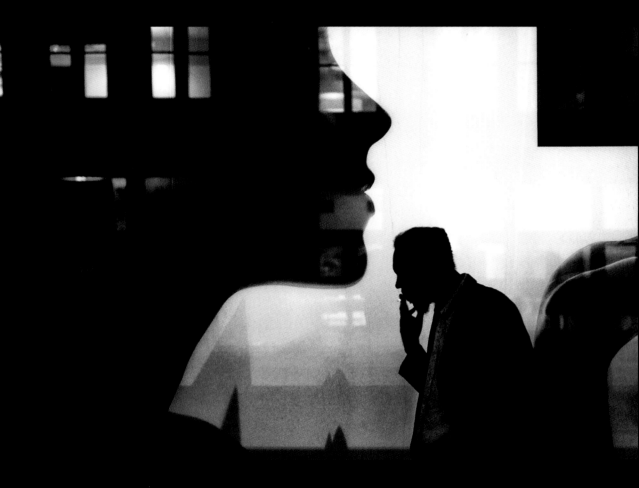

PROJECT

12

REFLECTIONS

Reflections on the street give back to us another
view; they break up normality and have the
ability to charm us.

Like shadows, reflections are a common concept
in photography. The mechanics of traditional
photography are based upon mirrors – in the camera
and the lens – and outside on the street there are all
sorts of reflective surfaces: glass in windows or even in
sunglasses, water or any kind of liquid, anything glossy,
such as paint or metal…the list seems endless. We take
many for granted.

Reflections can confuse and delight. The complex
reflection in Louis Faurer's Times Square photograph
from 1960 is like a short film. A young boy looking
cold or apprehensive seems to be reflected in a shop
window; there is also the busy street and another
reflection of a bride and groom. You keep looking
and you want to understand.

In cities at certain times on sunny days, office block
windows cast a series of light abstract squares across a
street. This alone is a modern phenomenon and worth
a series of photographs. Somebody somewhere will
have done it.

Weather is a factor; on rainy days colours on the
street can become saturated and the wet surfaces
almost prismatic. How many times have you seen a
small oil spill on a wet road that becomes a beautiful
rainbow mess of reflected colours?

My Piccadilly Circus photograph here was taken
on a wet day; without the wet there would be no
photograph. It is an abstract collection of colourful
road markings and at the centre is a man framed in
red. This was exactly what I saw, but in Photoshop
I have turned the saturation and the contrast levels up
a bit – not too much, just enough to lift the image.

A similar photograph was taken in Trafalgar Square
in London, again on a wet day, but this time the final
image has been turned upside down. The reflections of
people appear the wrong way up when you see them,
but turning the photograph upside down 'corrects'
this. This photograph is all about the colours saturated
by the rain and the shapes. People with umbrellas are a
classic subject for reflections.

This is another example of a photograph moving
towards the painterly where outlines are rounded and
the overall effect is a little impressionistic. It is no
coincidence that my interest in art surfaces in some of
my work.

The pleasure of reflections – as with shadows – is
that they offer virtually an alternative world for
the street photographer, which, crucially, does not
involve pointing the camera directly at people. This
is sometimes a relief because it is easier and it gives
you more time. However, that is not the main reason
for considering reflections and nor should they be
consigned to the realm of what the 'amateur' might
do. There are nice reflections of boats on rivers, for
example, but the street offers something a little grittier.
It is the same technique, but far more interesting.

David Gibson, London; 2005

CONCLUSION

Reflections are not a photographic cliché because it depends entirely on what is reflected rather than the technique. The results can be both startling and original. Reflections are like shadows; we should be acutely aware of them.

- Become aware of reflections generally – in windows or puddles - anything that reflects the street.
- Photograph your own reflection in mirrors and shop windows. Vivian Maier did a whole book of reflected self-portraits.
- Consider unusual surfaces, both wet and dry. Glossy paint on boards surrounding building sites, for instance, are a potentially good source for abstract reflections.
- A mirror, such as in an antiques market, is a frame. Fill it up. Likewise, a set of mirrors presents a challenge; one or more occupied can make a photograph.
- Know that rain intensifies reflections – it saturates colours – on the street.
- Reflections, like shadows, sometimes work better flipped.

David Gibson, London; 2007

TRENT PARKE

born 1971, Newcastle, Australia. www.magnumphotos.com/photographer/trent-parke/

To describe Trent Parke as a documentary, fine art or street photographer is too simplistic. He is a member of Magnum, his work sells off gallery walls and his territory is often the street, but that also does not really get to the heart of what he is.

Parke has a strong emotional connection to Australia, he lives absolutely in the now and he digs deep with an intensity that puts other photographers to shame. Parke is not an ordinary photographer; even within Magnum, you suspect he is a little unique. He is obsessive and restless – there are no half-measures – being in the zone, as he terms it, matters.

He has produced several books, most notably *Dream/Life* (1999) and *Minutes to Midnight* (2013), which reveal the familiar Parke style: razor-sharp observations in black and white, mixed with an unworldly appreciation of the Australian light, whether in the city or the bush. In *Dream/Life*, which is devoted to Sydney, we do not see that city with its expected colour; the shimmering blue of the harbour, for example, is dark and brooding in his pictures. Dark skies prevail throughout in possibly an allusion to childhood and lost innocence. Parke has often cited the sudden death of his mother when he was young as pivotal.

Dream/Life is a driven reflection on Parke's state of mind when he first left his hometown of Newcastle in New South Wales. His ghostly vision transforms Sydney into something unexpected and undoubtedly makes it one of the great photography books. This is not said lightly, because it is every bit as good as Robert Frank's *The Americans* (1958).

Parke considers himself to be primarily a storyteller and books are an essential part of that process; he does not like 'one-liners' in photography. After each story he quickly and ruthlessly moves on; he is only interested in immersing himself in the present. He goes about this quietly; he is reassuringly above, or beyond, the world of social media.

Parke has little interest in conventional fame. He was good enough at cricket for it to have been considered a career option at one point and he later toured (as a photographer) with the Australian cricket team; he had come up through the same youth ranks as some of the well-known players. He mentions his unease at seeing that fishbowl world up-close, concluding 'give me an anonymous street corner any day.'

Parke has interpreted both the city and country towns in colour, employing larger format cameras. But it's the same intense reaction to the Australian light, with the colours deep and rich.

Here, *White Man* shows that reality is probably the noise of traffic, but the imagination conjures up the sounds of the deep forest. The building looks incongruous but we dwell upon the dramatic misty light. It might be smoke or a plaza being steamed cleaned. It's better not to know. What matters is Parke's unique vision, his ability to see a different reality.

White man is quintessential Parke from his early black and white days. Taken in the heart of Sydney, the business man seems transported to a tropical rainforest.

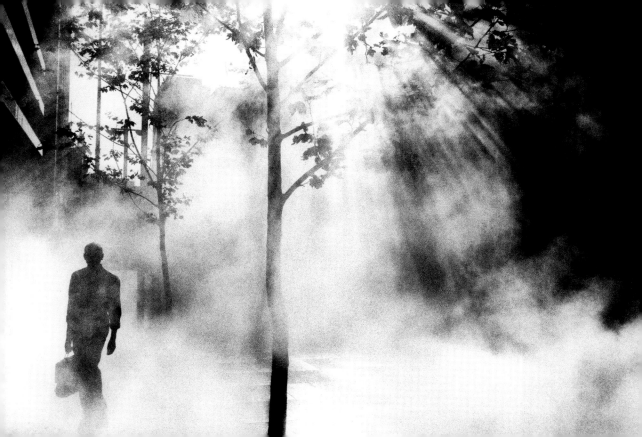

13 DOUBLES

If you are walking next to a glass building,
or any surface that reflects, hug its contours
to see the doubling-up potential of the street.

Another type of reflection is the mirror or kaleidoscope effect, what might be called simply 'doubling up'. It is a technique that I have always instinctively used because you cannot always chase the obvious in street photography. You have to look up and down, seek different perspectives from which to shoot and generally search out alternatives.

We are surrounded by surfaces and buildings that are not always opaque backgrounds that stop dead, as it were, for photographs. They can be transparent or half transparent. More significantly, they can reflect back, distort and surprise. We do not always look at this parallel world because we know that it is not real, we take it for granted; but remember the imagination of children and how naturally fascinated they can be when noticing their reflection on the street and how they'll spontaneously play with it. This is what street photographers do; they understand more than the child but they seek to play with their surroundings.

Using reflections to split photographs in half – with one half mimicking the other in reverse – is a trick favoured by many photographers because it can be ingenuous and a little surreal. At ground level you have to position yourself tight against the reflection, so that the split is roughly in the middle. This 'doubling-up' series (opposite) was taken from a high perspective in Bangkok; it continues the high perspective concept, but the main intrigue here was the cleaner by the side of the glass building. With her blue top, blue bucket and mop, she is central to the series of photographs.

I was struck by her reflected doubling-up shape in the glass wall. Immediately there was a central

symmetry that might be added to by the people passing by. I had time and was unseen – always a good combination – and was keen to fill out the corners of the frame, so that everything was balanced but provided a pleasing kaleidoscope shape.

I took 20 frames, which is a reasonable amount, feeling, as I often do, that I'd naturally exhausted most possibilities. How long to linger and at what point does it start to feel strained, with too many pictures? I think that there is some sort of internal nudge that comes into play, almost a reminder to not push your luck. Luck is precious and it should come naturally.

There was plenty of even daylight in this scene and because I wanted the passing figures to be sharp, I had the shutter speed of $\frac{1}{500}$ of a second.

The other short series on pages 134–135 was shot in London and taken at street level. I was interested in the man's reflection at a bus stop but was aware that it was not enough, it needed another element. I then saw the newspaper seller coming along. Everything was set up and I took just one vertical shot as he suddenly came into the frame. This was better; it was much more of a kaleidoscope.

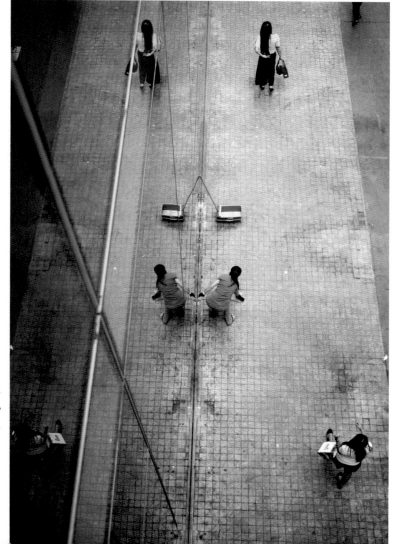

David Gibson, Bangkok; 2013

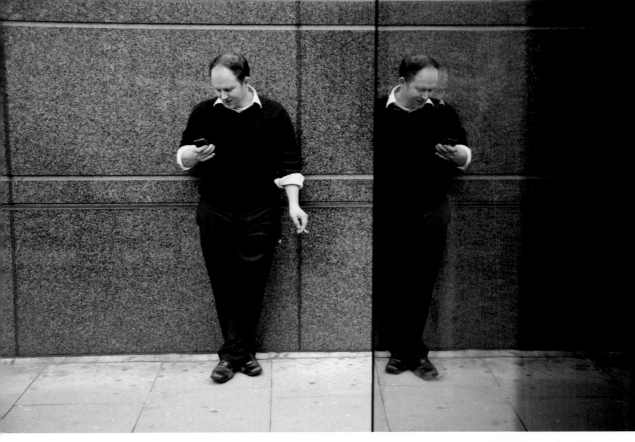

David Gibson, London; 2012

CONCLUSION

Doubling up is a great way to develop a good sense of composition and balance, although admittedly it could be viewed as an exercise. Too many photographs would potentially be bland, and that would prompt a challenge – to make each double photograph appear fresh. An awareness of this technique offers another avenue to explore and slows you down, because it often requires standing in one spot. To people passing by – who might be vital for your photograph – it can appear as if your focus is not on them but on some sort of reflection. It is easy to give this impression and then at the right moment swivel the frame to include them.

TIPS

- 'Hug' reflected walls or glass as you walk along; see the potential doubles.
- Stake out mirrored street corners for the kaleidoscopic effect, and catch people in double as they come past.
- 'Double' photographs work best as a 50/50 ratio/two halves in the frame.
- Have fun photographing animals – half a dog with half a human might be cartwheel of legs and arms!

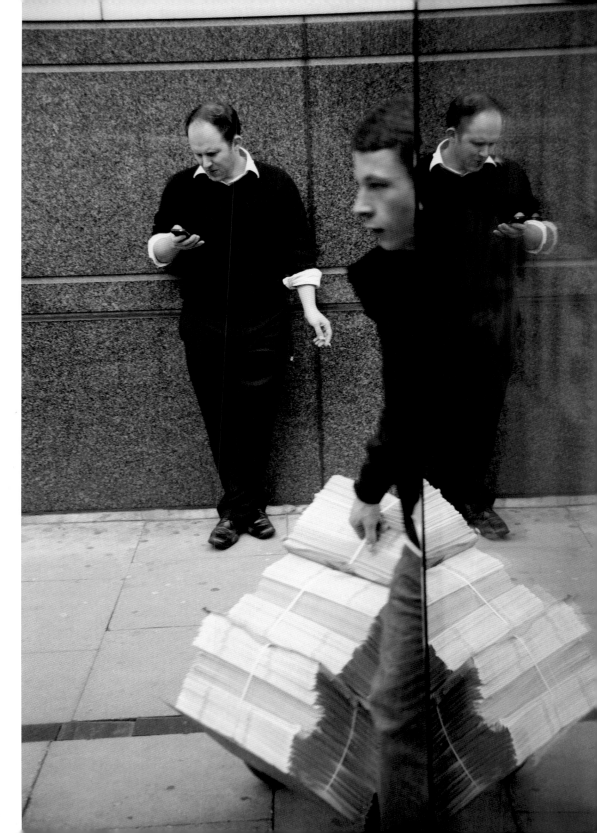

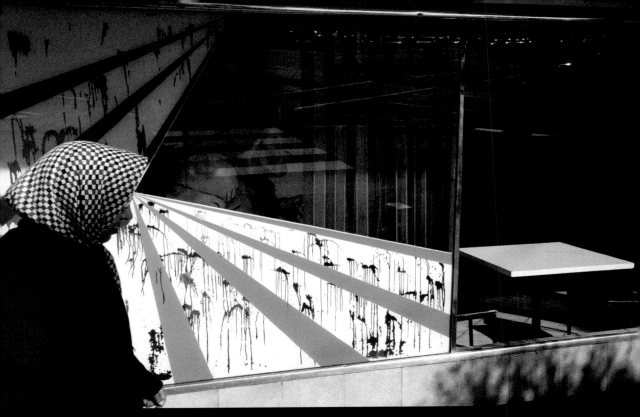

JESSE MARLOW

This is fun and so perfe[...]
seen and lined up. It's [...]
decisive moment on the [...]
streets of Melbourne.

born 1978, Melbourne. www.jessemarlow.com

Jesse Marlow is one of the most surprising photographers within the In-Public collective, which he joined in 2001. His folio of traditional black-and-white street photographs appeared to be his style with a leaning towards documentary projects, but a shift took place when he took up colour photography.

His normally peopled street scenes gradually gave way to a more primary coloured, abstract style. Suddenly there were fewer people and the focus was more on colours and shapes.

Photographers essentially have to grow; they might have a starting point where they absorb their first influences but eventually they find their own voice. Marlow has grown into his signature style, which has resonated within the street photography community. He is often name-checked and it is significant that In-Public has three of Australia's finest photographers in its ranks. Marlow, Trent Parke and Narelle Autio were all early members of In-Public. Marlow has always generously acknowledged the collective – especially in its frenzied early years – for its encouragement and for introducing him to the work of photographers such as Tony Ray-Jones.

Marlow's conventional start in photography drew inspiration from Henri Cartier-Bresson and Josef Kouldelka, but it was the colour work of Alex Webb

that provided the spark for a gradual change of direction. Marlow cites the opening photograph from Webb's *Hot Light/Half-Made Worlds* (1986) – of a man jumping and touching a wall – as being pivotal. Webb's intricate and busy images have continued to inform Marlow's approach, but intriguingly so has the Australian modernist painter Jeffrey Smart and the US realist painter Edward Hopper. Marlow also mentions his mother, who he watched when younger, working in the family clothing business, collecting and reinterpreting antique fabrics. An appreciation of colour and design was clearly instilled early on.

The real shift in Marlow's work, however, took place when he began to embrace colour photography. With these accumulated colour connections, he was less likely to cling, as some photographers do, to a black-and-white sensibility. He has produced several books, most notably a monochrome collection entitled *Wounded* (2005), during an obsessive period of photographing all kinds of human wounds covered in casts or bandages on the streets of his native Melbourne.

Marlow seems most proud of his book project, *Don't Just Tell Them, Show Them* (2014), in which his gathered coloured work is at its most mature and complex. Marlow likes visual puzzles and the chance to play around with perspective, which is clear in the two photographs here. The 'White Horse' is a Melbourne landmark, but caught here with a worker in the background it suddenly asks questions about the horse's size. The woman in a headscarf is another surprise; she seems to have some sort of super-power or x-ray vision. And yet – to tease expectations – and no doubt out of curiosity and an abiding first love, he still returns to black and white. We can't make absolute predictions as to where his palette will go; photographers ultimately decide such things for themselves.

It's a visual trick and no amount of looking will confirm the height of the horse. This plus wonderful light is why it works.

4 STILL

Street photography does not necessarily require people: evidence of people's lives, in all their curious forms, is just as poignant.

Ironically, perhaps the very first street photograph by Louis Daguerre in 1838 of a busy Paris boulevard is almost completely devoid of people. Due to the required long exposure of several minutes only one small figure is rendered – a man having his shoes cleaned, who was sufficiently still during the long exposure to be immortalised in the photograph.

It is a fascinating photograph that was carefully composed, but the eye is drawn to that one standing figure…That section of the photograph is often blown up to show the 'first man photographed' on the street.

However, the concern here is not with people but with *evidence* of people and objects and 'empty' streets. As ever there is some overlap, but it is helpful to try and make clear distinctions.

In reality many street photographers make little separation; certainly in the process of photographing as they move comfortably between peopled and non-peopled scenes. All that matters is that they have seen something interesting to photograph.

Mannequins are surely one of the best subjects ever for a street photographer. They are humans by proxy and they do not mind being photographed at all.

IT SHOULD BE REITERATED THAT STREET PHOTOGRAPHY DOES NOT NECESSARILY REQUIRE PEOPLE; THERE ARE ALWAYS OTHER VALID OPTIONS.

Often found in separate parts alongside other interesting artefacts, the possibilities are endless and it is not surprising that they have been a staple subject for so long. The eyes of any accomplished street photographer will inevitably fall upon mannequins. Just look at those collected by Magnum photographers over many years and you suddenly realise how vital and versatile mannequins can be for a street photographer. And they don't just stare out from shop windows; they can also interact with real people. They are one of the best props on the street.

■ PROJECTS

*EMPTY	page 142
*OBJECTS	page 146
*GRAPHIC	page 154

David Gibson, London; 2006

Bits of mannequins are sometimes thrown out like litter. Litter is not pretty but there is a point at which it can be different, say with empty boxes piled up. The shape might be a beginning for a photograph or generally as an idea for a project. Litter is a theme too; people leave litter on the street, so why not photograph it? Not all litter is dirty and unattractive.

It could be added that relentlessly photographing people, even when they are minimal elements in a photograph, can be overwhelming for both the viewer and the photographer. It is a question of pace; in a book, for example, still images without people allow breathing space.

STILL PHOTOGRAPHS ON THE PAGE OFFER PUNCTUATION. ON THE STREET THEY ARE LESS HURRIED AND SIMPLY EASIER TO DO. THEY ARE NOT ALWAYS EASIER TO SEE.

It is not uncommon for novices in street photography to consider taking pictures without people as lacking – in all respects. They are anxious about photographing people and turn the camera away, feeling cowardly and then that everything else they do subsequently is a compromise. This is really not the way to approach it; everybody is different and if you genuinely feel uncomfortable about photographing people, it will show and most likely compound the problem. It is like a very bad golf swing – you probably need to start again and consider what you really want to do. If you really want to photograph people, you have no alternative but to

completely change your mindset. Equally, however, for some people, photographing the streets does not mean a focus on people. They might have a fascination for graffiti, street art, or just curious found things, either temporary or fixed. You could define this as an interest in the design found on the street that we are surrounded by. Typography alone is a huge and varied subject to photograph on the street, as too is 'street furniture', which is a homely description for a litany of objects, including benches, bus stops, traffic lights, fountains, memorials, mail boxes and so on.

Milk bottles were once a fixture on the street – the glass variety delivered by a milkman from his milk float – and they meet the criteria of being an object and evidence; and when left for the milkman to collect, they are empty. They were taken for granted when they were everywhere in a city like London, but now, practically vanished from the street, they pronounce their absence merely by a picture reconsidering them. The US photographer Jonathan Bayer has photographed milk bottles since the 1970s, and in 2004 he produced virtually a requiem to the milk bottle, in his book *Bottle in the Smoke*. They are such ordinary objects but when collected in a book of photographs, you suddenly realise how surprisingly beautiful they are. They are never empty of meaning and a classic example of a forgotten street object.

Johanna Neurath (page 144) is a design director for a large publisher in London and she delights in finding 'design things' on the street. One of her specialities is to visit Columbia Road flower market in London's East End as it is winding down and photograph the mess of flowers left in the gutter. What she captures is a wonderful alternative to the formal beauty of flower arranging; her flowers, petals and leaves form temporary street arrangements that are quite compelling. They are also inspiring, especially to people who realise that you do not always have to photograph people.

Trees are also part of the lexicon; they line the street and are one of its most important fixtures. On

their own, the trunks can bend and curve like human figures. There is a 1953 photograph by Cartier-Bresson of curved trees along the bank of the Seine with just one very small seated figure, who seems almost incidental. The trees are like curved backs.

Cartier-Bresson did not always rely on human figures in his photographs; he was equally concerned with shapes. You might even claim that the shapes came first for Cartier-Bresson, although as people usually provided the more frequent shapes, he was always happy to use them.

You need only look through some of his books to see that geometry was really his subject. It can be seen in a sky of seagulls above the English Channel or in the eddy of a stream in Japan that strongly suggests the yin and yang motif; or even in his unmade bed with a newspaper taken in the 1960s. Cartier-Bresson did not need people, which is a surprising revelation to consider in his photography.

CHARACTER IS THE KEY WORD. IF A SPACE OR OBJECT HAS SOME SORT OF PRESENCE OR PERSONALITY, IT IS WORTH PHOTOGRAPHING.

Time is a factor in photography; an empty photograph can be filled up with time. In the first decades of photography in the nineteenth century the medium was not wholly capable of rendering people unless they were absolutely still for a long exposure. But this was not a deliberately photographed absence, although in the nineteenth century there was an absence of cars – now an integral part of contemporary life. Street photography can literally be jammed with cars that often don't improve a photograph. How often has a photographer seen something interesting only for a parked car to be in the way?

I was in Athens a few years ago and was taken to where Cartier-Bresson took one of his well-known photographs from 1953 – the two women echoed by two statues in the upper floor of a building (page 192). This building is perfectly preserved but on most days there is, ridiculously it seems, a car parked outside. You cannot in any way replicate Cartier-Bresson's photograph. The disruptive role of cars in street photography is decidedly underdiscussed. Old cars in Havana are subjects in themselves but the modern car fills up photographs. A street with parked cars is not properly empty.

It is interesting to trawl through some of the groups on Flickr that tackle the subject of empty streets. Some of the photographs are truly empty – of ambition or meaning – their only value is that they meet the brief. Unsurprisingly night is present in some images because night can fill up a photograph.

In daylight, is a sky with no clouds considered empty? Even the blue has a presence but is it worth photographing? An empty street can be made dramatic by the presence of clouds – odd-shaped clouds that might interplay with the shapes on the street. Street photographers should always consider the sky, and therefore the sunlight, because shadows and reflections can make a photograph less empty.

Empty chairs and benches on the street announce their presence because of their emptiness. Their function is always incomplete without people, so they are never completely empty when photographed. Chairs are objects, of course, and they furnish streets and public spaces; they might not initially be considered worth photographing but chairs can have character, like people. It is good to see the personality behind inanimate objects and remember that just like humans, they too have a story to tell.

EMPTY

Street photographs that are empty of people, cars or general clutter are not necessarily empty of mood or interest.

Empty is a spurious word when applied to street photography because it suggests something lacking – an empty street is supposedly always awaiting people to furnish it. Streets are functional, they require people, but their absence can actually be the photograph. Photographing absence is a great subject, as long as you can feel the absence.

The important question is: how deliberate is the intention to photograph the absence? The Düsseldorf School of Photography in the mid 1970s espoused a 'new objectivity' towards photography by minimising the appearance of the human figure. Arguably, those bland photographs are deliberately empty; they are empty of hope. However, the meaning of street photography, even without people, is always to have at least some soul and never be completely empty.

The concern here is with the emptiness that stirs the imagination, that suggests something, and is not a lazy photograph of nothing in particular.

My photograph of a cobbled street in Glasgow at night is virtually empty – just one car and no people – but it is filled with reflected light and mood. To me it also strongly evokes the work of Bill Brandt because it has something of his dark, heavy style; it might even echo one of his actual photographs. Photographers have their heads full of images from other photographers and every now and then one of them unexpectedly pops out. Would the photograph be lifted by a single dark figure walking across the scene, an elegant man with a hat? Or a cat, or a pigeon in full flight? Quite possibly it would.

Perhaps the true question revolves around how comfortable we are with emptiness. We expect a street at night to be empty; the emptiness would be more pronounced in daylight but ultimately the photograph is as much about lines as mood. The photograph is full of time as well; it initially seems timeless until you truly consider the car. Without the car it could be the 1930s; that's what stirs the imagination.

CONCLUSION

Empty is such a slippery concept and perhaps the real debate is what is comfortable in a photograph. How comfortable is the photographer – and the viewer – with space or blandness? It is how we understand and approach emptiness that matters – and crucially how deliberate this is. Doing things deliberately with a clear understanding of our motives always makes for stronger, or at least more interesting work.

- Landscape photography is not 'empty,' the street is the same.
- Light is a subject; on an empty street it is enough.
- Photograph the emptiness of the night.
- Take the theme of empty as a project. Photograph empty buildings, streets, boxes of any kind, shops, etc.
- Photograph minimal evidence of people on the streets.
- Remove clutter from your photographs; understand the process of boiling down your images to the absolute minimum.
- Experiment with composition – with a person or object in the corner – surrounded by space.

JOHANNA NEURATH

born 1963, London. www.flickr.com/photos/johanna

> Looking down at the ordinary or neglected can certainly be rewarding; like bold art framed in the gutter on the street.

Johanna Neurath describes herself as 'a bibliophile and image junkie'. The daughter of a prominent worldwide publisher, she has design in her blood; she has risen to become head of design at an independent art book publisher after many years dealing with picture editing, typography and jacket design.

Having been immersed in design and art for so long, it is inevitable that she should 'sketch' with her camera. With the rise of online photo-sharing sites such as Flickr – to which she was a passionate early convert – this self-confessed 'hobby' has intensified. In tandem, her publishing work has been instrumental in reflecting the rise of photo-sharing and particularly

the explosion in street photography. She strongly believes, for example, that the book *Street Photography Now* (2010) would not have been possible without its online audience.

Much of that audience provided the impetus for the inaugural London Street Photography Festival in 2011, in which Neurath was invited to exhibit, alongside Anahita Avalos, Polly Braden, Tiffany Jones and Ying Tang, in *A Woman's Perspective*. This group show confirmed her standing in the street photography community, irrespective of gender.

Neurath takes delight in many kinds of visual media but singles out Alex Webb's *Composing Maps*

Stephen Shore and William Eggleston as influences on her photography, specifically for their use of colour and subject matter.

Her photographs on the street are predominantly of designs, which are carefully collected, almost like books, into sets. One of her most distinctive collections is of Columbia Road flower market in London's East End, where she photographs discarded and informal arrangements of flowers in situ on the street. Startling in their simplicity and beauty, they are arguably very feminine. They are also a refreshing reminder that the street does not have to rely on heaving masses of people. This flower market is famously jammed with people every Sunday, but Neurath catches the market as it winds down, ignoring the dwindling crowds to focus on what interests her.

Another motif for Neurath, amongst several, is snow. She captures snow as a blank page with a

minimum of squiggles or plants like calligraphy. She also has a liking for petals because they decorate the page, and it's worth highlighting one particular image of hers of a car with a blanket of petals over it. It is not a difficult photograph to take; hardly any of her photographs are of moving targets – but they work. They are like leaves pressed into the pages of a diary, very personal but quite exquisite.

An important point about her photographs is that they always seem to resonate with people, almost as a relief amidst all the predictable or 'clever' street photographs. Neurath's photographs are a refreshing reminder that people need not be the main subject

Neurath constantly reminds us that the everyday is eminently photogenic. How many people would consider taking this photograph? It's beautiful.

OBJECTS

Street objects are part of the flow of people on the street, but approached singularly they have character just like people.

One of the problems of trying to categorise the different concepts and subject matter of street photography is that most practitioners work with a broad palette. In the middle of their wanderings, they would never consciously consider whether their photographs are peopled or not.

Looking at the folios of most street photographers would probably reveal at least 75 per cent of their photographs to have people in them, either prominently or minimally. Arguably, for the majority of street photographers, objects are an occasional but natural part of their photography.

ALL THAT EVER MATTERS IS WHETHER SOMETHING IS WORTH PHOTOGRAPHING.

Photographing objects comes during lulls in a day's shooting. Photographers continue shooting as they move from crowded scenes to places with no people. This is the conventional view, however; there are some photographers who are far more interested in objects and shapes, to the point that having their photographs with even minimal people would distract their vision. Clear evidence of people would equally be a distraction.

The Californian photographer Trevor Hernandez, who is better known (intriguingly) as Gangculture, is one of these singular street photographers. He makes little reference to people; even the dogs in his pictures are independent. Instead, his focus is on what might be called neglected things. There are objects – discarded boxes or litter – but his fascination is seemingly collecting things that other people would not look at. His vision is so consistent that it becomes riveting; an up-close section of sidewalk is nothing, but it has been noticed and posted on his Instagram page. Instagram has a particular aesthetic, too, which is utterly appropriate for this type of collecting and sharing online. Some people collect litter to help the community; others collect things to show others.

There is pleasure in collecting objects and the impact of the whole collection can matter more than the single photograph. There is a long tradition in photographing chairs, for example, as seen by Shirley C. Burden's book *Chairs* (1985), which features only chairs and includes the dedication: '*In Paris chairs are alive and well*'.

I concede that the terms object, project and subject can be one and the same thing when applied to street photography, but perhaps applying the phrase 'objects of desire' can help catch the spirit of collecting. And objects, unlike probably the things that we surround ourselves with in our living spaces, can be quite different on the street. Chairs can be beautiful, as can doors or windows, but any of these objects in decay can be equally stimulating to the eye.

Those are fixed objects but consider a balloon floating haphazardly on the street – I seem to see them quite often in London and I find them fascinating. I have often talked about a photograph taken by Stephen McLaren of a blue balloon caught in the wind

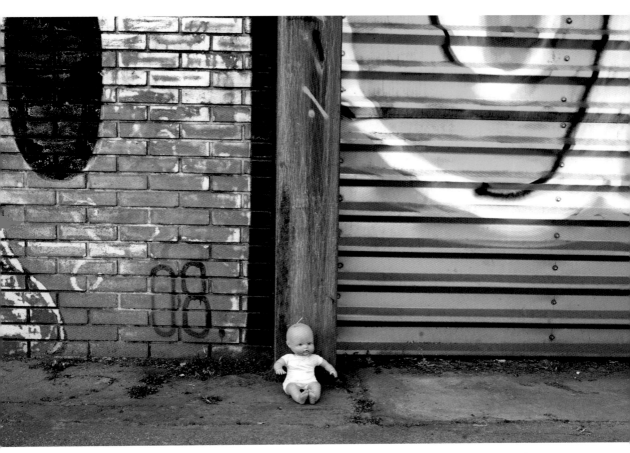

David Gibson, Athens; 2012

on an East London street. It is 'just' a balloon, but this photograph always resonates with people. Perhaps you can't quite figure out how big the balloon is; is it a crashed hot-air balloon at the end of the street; or maybe people just recall a prolonged scene from the film *American Beauty*?

What other tangible objects do I collect? Certainly umbrellas, which could be a project alone, not just when it is raining, but when they are half unfolded like flowers or even abandoned. Bikes appear quite regularly in my photographs and I am often drawn to mannequins and dolls. Dolls are little people and are easy to photograph. Many might walk past the abandoned doll in the photograph on page 147 – or is it a baby mannequin not long discarded from a shop or stall? Either way, this is a good example of 'collecting' objects because once carefully framed, the doll becomes important. The space around it accentuates everything; this needed to be a horizontal shot. Taken on the outskirts of Athens, the little person will surely be gone very soon.

The final photograph here shows a group of objects – some old but elegant cutlery. It was at a craft fair in West London and rain prompted the stallholder to cover up the cutlery with transparent plastic. That is what made the photograph; it's a layered photograph, which adds texture, almost like negative film.

CONCLUSION

Photographing objects is an opportunity to photograph what truly interests us – our collections should be sincere and personal, almost like a diary. The overriding point is that there is a long and varied tradition of photographing objects. We look at objects all the time but when they are photographed they can become something different. It is a perfectly valid part of street photography.

- Look at the work of singular 'collectors' on Instagram, such as @gangculture or Michael Wolf's website – photomichaelwolf.com – Informal Seating Arrangements, a celebration of chairs in Hong Kong (China).
- Think 'still life' – the street is the studio.
- Photograph decaying objects on the street: fruit and flowers, for instance.
- Photograph abandoned objects as evidence of people.
- Think mannequins, one of the greatest subjects throughout the history of photography.

David Gibson, London; 1998

DAVID GABERLE

born 1989, Prague, Czechoslovakia. www.davidgaberle.com

David Gaberle's photographs are all about urban life. It is worth quoting from his book *Metropolight* (2018), which hauntingly captures his concerns and intent:

'*METROPOLIGHT* IS ABOUT THE RELATIONSHIP BETWEEN THE CITY, THE PEOPLE WHO INHABIT IT AND LIGHT THAT SHAPES ITS ATMOSPHERE. IT IS A RECORD OF WHAT THE CITY MOULDS US INTO, AND HOW WE TRY TO REMAIN AUTHENTIC TO OURSELVES AT THE SAME TIME. THE ALIENATING CULTURE OF THE SEEMINGLY DEVELOPED CITIES CONTINUES TO CHALLENGE OUR HUMANNESS IN THE 21ST CENTURY.'

The photographs are a culmination of Gaberle's five years as a serious photographer. This is a remarkably short time in the life of a photographer to make such an intense mark. You can link *Metropolight* to an earlier book, *Ostrava* (1986) by Viktor Kolár, which Gaberle first owned in 2012. That was a beginning of sorts. Of course, Gaberle took inspiration from other photographers: Saul Leiter, Henri Cartier-Bresson, Ernst Haas – it's an expected roll call for any aspiring and dedicated photographer embarking on their own personal learning curve. But one name hovers over Gaberle's photographic odyssey: Gueorgui Pinkhassov.

It is completely understandable that Gaberle should relate so strongly to Pinkhassov's work. In a pilgrimage-like moment in 2014, Gaberle travelled to Greece to experience a five-day workshop with the Russian master. But ever soul-searching, Gaberle felt that he could never quite match Pinkhassov's control of light and mood. He felt he had to break free and forge his own path. Arguably Gaberle has done this, but equally something of Pinkhassov shines in his work, which is a good thing. Not many photographers can match Pinkhassov beyond the odd pastiche.

Pinkhassov would surely approve of the next two independent photographs from Gaberle. The first taken in Prague, his home city, is seemingly devoid of people but the building mesh dances, the back foot on the right seems arched – poised – as if embraced for a tango, and the chiffon-like or lace material is exquisite.

Turn to the next page and the Hong Kong (China) cityscape broods in the darkening sky, with the exception of one building: The International Commerce Centre, which positively glows bright white and is momentarily magical. Gaberle took it while on his eight months of travel for *Metropolight*. He had climbed to the roof of his host's building, as he recalls:

'TO MY SURPRISE, THE CLOUDS JUST MOVED OVER HONG KONG VERY QUICKLY WHILE THE CITY WAS STILL LIT BY THE REMAINDERS OF LIGHT. IN THE LATE AFTERNOON, THERE WAS A LOT OF HUMIDITY FROM THE EVAPORATED WATER, WHICH IS WHY THE REFLECTED LIGHT WAS SCATTERED THROUGH THE AIR IN THIS WAY. IT WAS A VERY LUCKY DAY FOR ME.'

Taken in Prague, this elegant chiffon-like material dances, as if embraced for a tango.

David Gaberle, Hong Kong (China) International Commercial Centre; 2015

PROJECT 16

GRAPHIC

Taking pleasure in lines and street graphics is a particular strand of photography that is sometimes more striking without people.

You need only consider the Greek roots of the word 'photography' – literally meaning light and drawing – to appreciate how all things graphic are so embedded in the medium.

A photographer's style can be termed graphic. The work of Robert Häusser or Ralph Gibson, for example, has strong graphic elements. My whole approach to photography is graphic because I like tidiness and I have an appreciation for the graphic shapes in buildings and signs. Calligraphy, fonts and textures – even a brick wall to me is graphic.

The concerns here are some of those singular graphic elements in street photography, especially those already written on the street. The artist Henri Matisse likened drawing to taking a line for a walk, which describes the serendipity of a creative process. For street photographers, their canvas already has its lines; functional street markings are everywhere to assist drivers and pedestrians, but they are integral to street photography too. Street markings can provide the backdrop; sometimes they reinforce framing and balance when peopled, but alone they can be a stark celebration of graphics. Every country has its own street graphics; a pedestrian crossing is different in Spain compared to one in the United Kingdom, for example.

On the street, graphics generally photograph best in black-and-white. The classic street font is simple white lines on black tarmac. Perfectly spaced and with the right light, they are even more striking, especially when wet. There is an argument that you should only photograph when it has been raining, a dry road

simply does not look so good. Rain clears the air and exaggerates road markings. Snow is another cleansing element that provides a startling graphic; it blankets the street, reducing everything to shapes and lines. The photograph can be what remains – the black outlines of objects poking out of the snow.

The sky can provide a graphic backdrop; its sheer whiteness – captured in black-and-white – accentuates shapes against it. Consider power lines, often six of them like a blank music staff, awaiting birds as musical notes.

The best street graphic in my opinion is the arrow, not simply for its shape but there is also its visual function; an arrow suggests a narrative for people. There are also traffic cones, which provide another punctuation. Street cones are not fixed but are temporarily arranged, their purpose to frame and separate. Consider them as chess pieces on the street, especially when viewed from above.

My arrows shot here, taken in 1996 close to Waterloo Station in London, started with the road markings. The woman on her journey made it complete. She is in the right place at the bottom of the page with the bold arrow beckoning.

Arrows feature strongly in the Edinburgh photograph too – this is also a waited photograph – waiting for the right person to come into the scene. No one would believably carry an arrow but this workman carries a graphic line that breaks up the circle.

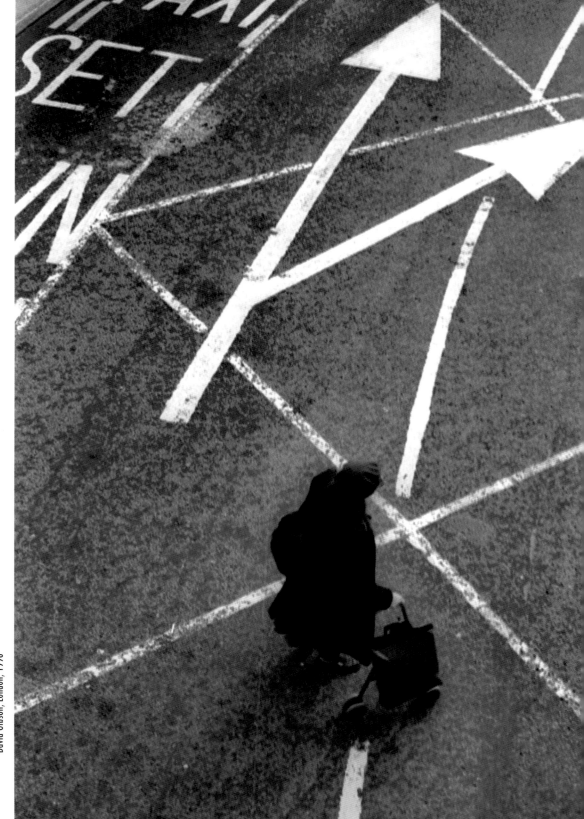

CONCLUSION

Graphic is a very general term to apply to most photography, but it is a very important ingredient in how photographs should be taken and interpreted.

Interestingly, graphic designers often make very good photographers; even their visual doodles can be at the very least pleasing graphic exercises. Equally, photographers frequently have a strong interest in what graphic designers do; indeed they sometimes collaborate on commercial work.

- Look at road markings and signs and how they can be photographed with and without people.
- Look at the graphic photographs of photographers like Ralph Gibson.
- Road markings age and take on different textures. Light, too, changes their look. You could photograph a road marking like a tree in different seasons, or even time of day.
- Posters age, become torn or replaced. A poster glimpsed under another is graphically reinvented.
- Do a project on arrows.
- Read graphic shapes as something else. The alphabet, for instance, is everywhere on the street.

David Gibson, Edinburgh; 2002

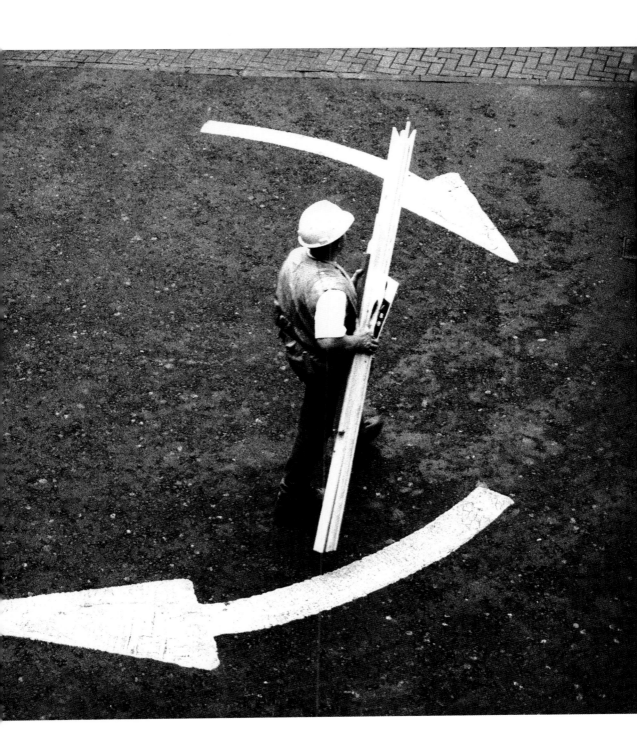

CHAPTER

5 SUBJECTS

What are the subjects on the street? People, objects, surfaces, light... they're just too broad to define, but photographers do have their favourites.

In some respects this final chapter is an opportunity to linger a little longer on certain subjects within street photography. Some have been touched upon already, but it is important to give further consideration to subjects or issues that prompt questions. And some aspects of street photography should also be discussed more directly.

Children, for example, have been dealt with as part of the general street population, which is ideally how it should be. A particular point about children is that it was once common for them to play freely on the street in the West. Children now play indoors, thus street photography has to a certain extent lost one of its traditional subjects.

By contrast, humour does not really change, and in its varying shades remains one of the key ingredients – or subjects – of street photography. Street photographers respond to the absurdities of life and humour inevitably surfaces. However, it would be contrived to set a project to take funny street photographs – as ever, it is what occurs naturally. Children do funny things, they have a sense of humour that is freer, and it's a pity that photographing children on the street has lost some of its spontaneity.

Animals do not intend to be funny but they add colour and irony to our world, especially with humans

in tow. They are always present in the 'supporting cast' on the street. Sometimes they are the stars; pigeons, for example, have been central to many of the best street photographs. I mention Matt Stuart's well-known pigeon shot as being a hard one to capture, whilst mine (page 161) – also in Trafalgar Square – was an easy one. I was just there to witness this pigeon that had somehow managed to get its head stuck in a polystyrene cup.

One of Garry Winogrand's best-known books, *The Animals* (1969), posed the question: who are the real animals – the animals in the zoo or the people watching them? In one particular photograph of a wolf skulking in a cage, the real predator's eyes belong to the man staring menacingly at a woman as they stand together outside the wolf's cage.

The zoo, like the street, provides raw material for Winogrand's skewed and surreal world. In his accompanying text, John Szarkowski, then curator of photography at the Museum of Modern Art in New York, questions whether, on the evidence of the pictures, Winogrand likes zoos, but that is not necessarily the point. He instinctively knew the zoo to be a good 'hunting' ground for his kind of pictures.

A lesser-known homage to people-watching/animal-watching is *Please Do Not Feed* (2003) by Andy Morley-Hall, which casts a more affectionate and gentle English eye over zoo life. Morley-Hall's photographs are both lyrical and charming. He does like zoos.

In zoos there are a variety of animals, but the street is mainly the domain of cats and dogs – cats in the suburbs, dogs in the city centre. It is dogs that offer

▌PROJECTS

*CHILDREN	page 162
*PROJECTS	page 168
*VERTICAL/HORIZONTAL	page 174
*ETHICS	page 180

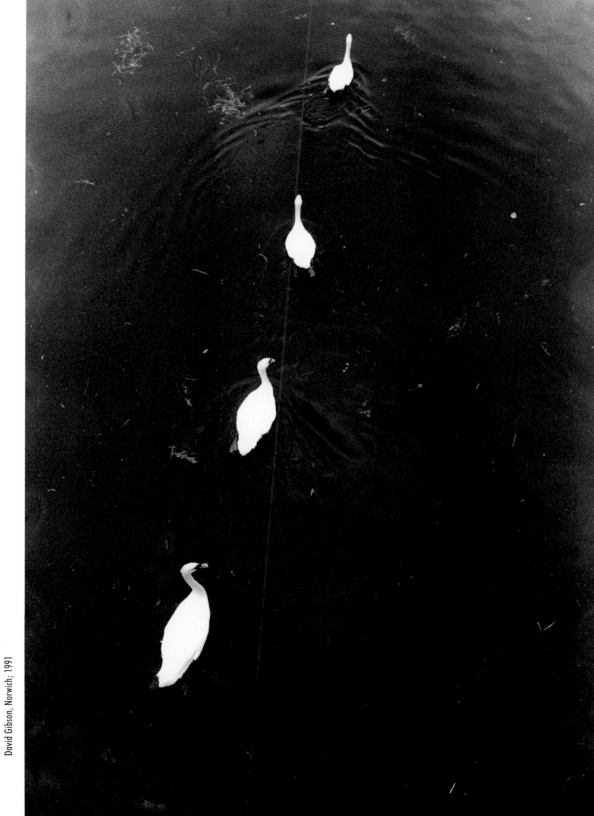

David Gibson, Norwich; 1991

true collaborations. Individually, they have character and attitude; when they partner humans, as in many of Elliott Erwitt's pictures, they bring out the best – or the surreal – in humans. In Erwitt's eye, the owners really do look like their dogs.

In Athens, many of the dogs are independent yet tame. They live on the street and are looked upon kindly by people. Big dogs wait at pedestrian crossings like everyone else because they are citizens, too.

There is no particular technique for 'working' with animals but it could be said that photographers aesthetically lean towards either cats or dogs. Perhaps dogs are busy, while cats are quiet.

Unexpected animals often provide the best street photographs. An elephant in New York or a penguin in Edinburgh, for example, have been captured on the street respectively by Jiří Makovec and Werner Bischof at different times. The reason can always be explained – it's usually connected with a circus or zoo – but the photographer seizes such rare moments. What a great idea for a long-term project.

It is worth noting that camera phones are not just a means to take street photographs; they are arguably the most ubiquitous subject on the street. Body language has been transformed by mobile phones; everybody fiddles and checks their phone. It's taken for granted but imagine trying to take photographs on a crowded street without the slightest evidence of mobile phones; it would be like trying to exclude people with glasses. Suggested project: take street photographs where the mobile phone does not exist. It would be a challenge.

Of course, there is also inside, which is a continuation of the street. The territory of street photography extends to any public space and this can include airports, museums, art galleries, train stations, subway systems, indoor markets – the list is practically endless and you might just as easily call it street photography without the sky. The familiar shadows stay outside, while inside the light may be artificial or natural, but low light conditions can be an asset for a different mood.

On the street people are mostly moving from A to B, while in museums and art galleries people's movements are less hurried. The urgency of the street has gone and they are engrossed in something slower. This is classic territory for the street photographer. Elliott Erwitt did a whole book on people-watching at museums.

Galleries have clean lines and space and each exhibit offers a ready-made frame for people-watching. Nils Jorgensen, another 'inside street photographer', has a bald-headed man in front of a landscape painting with trees; the foliage when aligned provides a toupee for the man, which fits perfectly. It's a cliché, but one picture has made another picture.

Airports and railway stations are far more frenetic. People have arrived at departures but then commence a period of waiting. This can obviously be quite ordinary, but equally waiting can provide something different from the street. It is a different public arena; people behave and look a little different. Garry Winogrand was a frequent people-at-airports-watcher, which eventually became the book *Arrivals & Departures* that was published posthumously in 2004.

Most subjects or situations on the street are potential projects. The beach, where the city goes to unwind, is a subject – and a territory – because again it is a place where people behave differently. There is a whole tradition of beach or seaside street photography. The photographs of Tony Ray-Jones and Martin Parr are prime examples.

The conclusion is that it is difficult to talk about subjects because the adage that a picture is worth a thousand words thankfully holds true. Pictures come first where subjects are naturally revealed. They provide direction and push us to take even more pictures.

But of course sometimes the subject list comes first; it has to because a brief may have very clear ambitions, as with a documentary project. Walker Evans photographing for the FSA (Farm Security Administration) in 1930s America worked from a list. All the photographers for that historical project,

the aim of which was to record the difficult living conditions of American people during the Great Depression, worked from a list of subjects to photograph.

The best photographers tend to be methodical; when they are not photographing, they are writing lists of what they want to photograph. The trouble is for an outsider these lists appear quite mundane: Walker Evans for example listed: 'Automobiles and automobile landscape, advertising, the movies, etc'. The FSA was a documentary project, but identifying subjects in advance can be motivational for anyone and it primes the eye. You are basically telling yourself what you need to photograph and this discipline can work for some street photographers.

Evans it should be noted became friendly with the young Robert Frank in the 1950s and encouraged him to apply for a Guggenheim fellowship. In his application he crystallised his ideas as a list that included a 'town at night, a parking lot, a supermarket' and intriguingly 'the man who owns three cars and the man who owns none', which sounds far more interesting.

With the fellowship Frank set out on a road trip across America and took nearly 700 rolls of film, from which he printed 300 negatives and then arranged them into categories, such as 'symbols, cars, cities, people, signs, cemeteries, etc'. When you consider this the resulting book seems far less spontaneous. The pictures might appear random at first glance but in reality a great deal of thought and organisation went into the process.

Tony Ray-Jones was an obsessive writer of lists; it was important to him because it clarified his mind to move forwards with his picture-taking. His notebooks from the late 1960s reveal much about his approach:

- Be more aggressive.
- Get more involved (talk to people).
- Stay with the subject matter (be patient).
- Take simpler pictures.
- See if everything in background relates to subject matter.
- Vary compositions and angles more.
- Be more aware of composition.
- Don't take boring pictures.
- Get in closer (use 50 mm less).
- Watch camera shake (shoot 250 sec or above).
- Don't shoot too much.
- Not all at eye level.
- No middle distance.

The best one is 'Don't take boring pictures', which is obvious but utterly true. Tony Ray-Jones was never satisfied, which is the trait of many photographers. They try to understand the subjects in their photography and by doing so feel emboldened and clearer about what to do next.

David Gibson, London; 2008

17 CHILDREN

Children are part of the street like everyone else and while there are no laws over photographing them, they require special sensitivity as subjects.

If ever there was a subject that encapsulated the joys and pitfalls of street photography it is children. It is also a subject that varies in sensitivity around the world. Photographing children in Thailand or India, for example, is regarded as 'innocent' and perfectly acceptable, whereas in some European countries it is almost the opposite, the situation is far less comfortable. In the West there are huge and complex issues surrounding the photographing of children.

One of the aims of street photography is to avoid obstacles – whether it is concerns about camera settings or legal issues – because they get in the way of taking photographs. From the outset, therefore, it should be clear that – in the United Kingdom at least – there are no special laws about photographing children in public spaces; they are exactly the same as for adults. However, it is worth considering some of the attitudes to photographing children. We live in strange times, in a world dominated by Facebook, on which many share their private lives, including the lives of children, yet in physical public spaces there exists a creeping paranoia about photographing children. That is the bleak view: it is not about legal issues but is more about a loss of innocence. The West has grown to be suspicious of people, especially men, pointing their cameras at children. Parents are concerned, schools are concerned and children sense something dark.

Should we dwell too much on this? No. The only way forward is to show common sense and respect when taking photographs of people on the street, and extra sensitivity is required when it comes to photographing children.

We should celebrate children and capture the joys of childhood. Once children routinely played on the street; that changed in the UK, probably some time in the 1960s or later, it's difficult to pinpoint. That shift would have varied according to the locale. Look at the photographs taken in New York by Helen Levitt in the 1940s and 1950s, which captured the wonderful theatre of children playing on the street. In the past a far greater proportion of people's lives was lived outside on the street. Photographing children should not be considered furtive or strange in any way. They remain one of the best subjects for a street photographer.

My two black-and-white photographs here feature children, though not prominently. Arguably their age is incidental because they are almost props for the whole scene. The photograph in Gourock in Scotland started with the strange playground ride that was an interesting subject alone, but essentially this is a waited photograph. The boy came into the picture and his slightly awkward pose and especially his outstretched fingers, which mimic the wings of the playground bird, make the scene complete.

The crossroads photograph in Spain (pages 164–165) was a fairly prolonged wait. My fascination was with the shapes of the zebra crossing taken from above – all typical ploys in my picture-taking – and the young boy suddenly came into the frame. His body language echoes the zebra crossing and again there is tension in the photograph.

Neither of these photographs have the child situated in the centre of the photograph, but somehow they are still balanced.

David Gibson, Gourock, Scotland; 2003

CONCLUSION

My earlier series in the Order project (pages 52–55) exemplifies what photographing children should be. The scene of the assorted Annies is light and joyful – everything that childhood should be – and captured in that same spirit by the photographer. It should also be acknowledged that for a female it is far easier to photograph children. Indeed female street photographers probably naturally gravitate towards children.

A final point is that unlike adults, children will naturally play to the camera, which immediately changes the dynamic. It's nice to have children laughing at the camera, but this becomes portraiture or travel photography rather than street photography.

- Be aware of parents (or teachers) and where they are in proximity to the children you are interested in photographing.
- Do it quickly, as you would in most situations, and do not overdo it - get a few shots and then move on.
- If you are 'caught', smile. A smile is an acknowledgement that what you are photographing deserves a smile and it reassures everyone.
- If you have your own children with you, you have a big advantage.
- You do not have to photograph children as 'children'; they are people and are part of life on the street too.
- See the child in adults; that's what street photography is sometimes.
- Be sensible, but don't be anxious about photographing children. It is not illegal and is perfectly normal.
- Look at the photographs of Roger Mayne, who captured children playing on the street in 1950s London.

MICHELLE GROSKOPF

born 1975, Toronto, Canada. www.mgroskopf.com

In her book, *Sentimental* (2018), Michelle Groskopf explains how she views life up close in attempt to frame the energy and beauty of passing moments. She describes her book as:

'A MAP OF MY WHIMS. IT'S A DIARY, IN MEMORY OF ALL THE DAYS I TROTTED HALF IN LOVE DOWN THE STREET. IT'S HOW I SEE COLOURS AND HOW I HOLD FACES UP TO BE WORSHIPPED. IT'S MY LOVE LETTER TO THE INDUSTRIOUS NATURE OF HANDS AND ALL THE WAYS THEY SHOW US OUR BUSYNESS AND OUR BUSTLING...'

How should we take the title *Sentimental*? Is it meant ironically or in a heartfelt way? Groskopf's photographs – a mix of street photography, portrait and, arguably, fine art – are strangely hypnotic, but are they mildly cruel or kind? As a clue, Groskopf describes her childhood warmly, reminiscing of her days growing up in the suburbs of Toronto 'surrounded by shopping carts and old ladies in headscarves'. Her childhood was comforting and once she grew up and hit she city, she began to seek these familiar memories:

'I FLED STRAIGHT FOR THE CITY... AND STARTED TAKING PHOTOS OF SHOPPING CARTS AND OLD LADIES IN HEADSCARVES, PEOPLE WANDERING AROUND STRIP MALLS. IT DIDN'T MATTER WHAT CITY I WAS IN, I'D FIND THEM, THESE PEOPLE WHO SEEMED SO FAMILIAR TO ME. I'D GET SO CLOSE TO THEM WITH MY CAMERA THEY WOULD BE FORCED TO TALK TO ME. THEY'D ASK ME WHY AND I WOULD TELL THEM THAT I THOUGHT THEY WERE BEAUTIFUL.'

Groskopf's chosen city is Los Angeles, where she consistently catches unlikely beauty. But what influences can we discern in her work and who are the photographers that have inspired her? Asked directly, Groskopf will pointedly tell you that she doesn't believe in having photo heroes, as 'you can drown under the weight of history and never take a single shot. We're all of us out there trying to say something, that's good enough for me.'

This attitude refreshingly sets Groskopf apart. Her work is original, surprising and direct. Her focus is people – particularly parts of people – often taken from odd angles. There are hands, backs of legs, and boldly coloured or just lacking or strange hair. Clothing too may be eccentric or ironic. Groskopf delights in the overlooked – she is sympathetic, almost tender in her work.

Groskopf's original, surprising, direct and tender approach is present in these four photographs. The anonymous couple (bottom left) are ageless, out of time, beyond expected fashion but completely comfortable. And consider those hands (top left) – delicate, surprising. What will emerge from the bag?

PROJECTS

Projects are 'the dog that needs walking' for
many street photographers – you need motivation,
an excuse, for somewhere to go.

Projects are a common part of street photography
and it often seems a prerequisite to be 'working on a
project' as opposed to the broad mess of simply taking
street photographs. That mess – life on the streets – is
largely what street photography is. However, as with
any artistic pursuit there still remains the need for
motivation. It should not be a trick, but if you 'have a
dog' it needs to be walked every day.

Beginners in street photography often bemoan,
'What do you photograph when you go out?'
The simple answer is: take photographs over a
concentrated period and it will be revealed in what
you end up with. You may realise that you have many
images of bikes, or umbrellas, or it might be something
with a broader narrative, a singular emotion or a place.

Elliott Erwitt has an archive of his interests that
have become books. Although publishers see potential
in grouping images together, it is interesting to
consider 'the piles of photographs' from someone like
Erwitt. Apart from dogs, he has produced books on
hands, museums, beaches and children. Another US
photographer, who thrives on themes, is Sylvia Plachy.
Her book, *Signs and Relics* (1999), includes thematic
sections such as flight, sit, frames, smoke, obsession,
roundness and trees. You suspect that she reached these
themes by originally putting photographs into different
piles that then developed into a conscious pursuit of
the topics. That is how it should be.

André Kertész's book *On Reading* (1971) was
described modestly as 'a small number of photographs
of various people reading'. That idea is still vitally alive

today, albeit with the addition of e-books. There's a
project – updating a classic photography book.

Projects can be the lifeblood of a street
photographer, and several projects, some vague, others
more advanced, in the photographer's head give
purpose to wandering on the street.

One of my ongoing projects is to 'collect' hearts,
which are a universal theme. Hearts pierced by arrows
are scrawled on walls – declaring that one name
loves another – but more satisfying are the occasions
when the shape of a heart appears naturally and
sometimes surprisingly.

A man walking past a London shop carries the
remains of a heart, a red plastic bag, which seems
almost to have been ripped from the shirt in the
window. It's a stretch of the imagination to believe but
if you're collecting hearts, the possibility leaps out. A
woman leans tenderly against a large tree with a heart
in its trunk, and two bikes clearly in love is confirmed
by the heart shape in the background window.
My original plan was to collect twelve hearts for a
Valentine's Day calendar but who knows where this
particular project might go.

HEARTS

David Gibson, London; 2006. Bottom right, Athens; 2011

HOOKS

David Gibson, London; 2008

David Gibson, London; 2005

I freely admit that I am better at having ideas for projects than I am at seeing them through. A 'sleeping' project I have is loosely called 'Hook' and shows people on the street who seemingly carry things with no hands. I have two good 'starter' photographs for this but realistically this idea will not grow quickly. The idea is there, however, and a good third photograph might suddenly resurrect the project with vigour.

My head is full of projects: they are my dog that needs walking.

CONCLUSION

Look at the websites of a few photographers; most will have specific galleries for their projects or themes. Some will be places where various photographs have been shunted under vague or elaborate titles, but the better photographers are revealed in the diversity and the thought they put into their projects because their photography demands it.

We can't all be like Sebastião Salgado, whose 'projects' last years and take on biblical proportions. A simple and sincere idea, even with just a handful of photographs, is worthwhile.

- It doesn't matter if you don't finish a project; you might still get one or more decent photographs.
- Let projects evolve naturally; don't force them.
- Identify 'starter' photographs with potential for a series.
- Don't be put off by an idea that has been covered by someone else; yours will inevitably be different.
- Consider text to accompany a project; it clarifies it and makes it more interesting.
- Understand the importance of the project's title; it sets the tone and sharpens your approach.
- Enter competitions with themes; especially on a series.
- Ultimately think potential book; it may never happen but the process of editing and sequencing is invaluable.

NARELLE AUTIO

born 1969, Adelaide

Narelle Autio is primarily known for her rich, warm-coloured photographs of beach suburbs in her native Australia. You sense she is never photographically very far from water and it is this that makes her work all the more restful and beautiful.

Autio's signature style uses slightly saturated colour. In many of her photographs, taken in the surf or on the beach, and even inland, there is always that sense of it suddenly going a little dark, as if a prelude to a storm. Everything is intensified – the colour, the light and the mood.

Her photographs are reminiscent of Alex Webb's in her arrangement of people, but there seems to be a drama going on too. In one a man walks past an industrial building, intense, darkening colours everywhere, and there is what seems like blood on his face, richly red, probably a wound.

She has completed several works with her husband, Trent Parke, most notably *The Seventh Wave*, which became a prize-winning book in 2000. The book of black-and-white photographs, none of which are credited to either photographer specifically, is an exploration of Australian beach culture quite literally in the water and often underneath the waves. In the words of Geoff Dyer, 'You don't look at this book. You open it up and plunge in.'

Like Parke, Autio has won several awards; they have been successful together and individually. Autio herself has won two first prizes in the World Press Photo Award and she has also been a member of the prestigious VU agency.

One of her most startling works is *Not of this Earth*, a series of photographs from the Sydney Harbour Bridge looking down onto parklands. The composition and rich colours leap out, everything is still but full of life. The photographs are surprising – such a simple idea to look down, but an unusual point-of-view – and quite beautiful. Is it fanciful to imagine that only a feminine eye could so acutely appreciate such things?

The beach is never far away in Australian cities, and indeed in Autio's photographs. Her 'Spotty Dog', taken in 2001, celebrates beach culture. Here there are giant rolling clouds in the sky, a rainbow, dense colours and then the dog, with the curve of its tail. The head is deliberately left out and the tail balances with the rainbow; that's the whole point. Rainbows are always possible in her photographs, and she admits to being a bit of a romantic, saying,

The slightly saturated colours, the curl of the dog's tail, the clouds, the shadows; everything is intriguingly balanced and nothing is accidental. The real spark is the rainbow.

'MY PHOTOGRAPHS ARE MY IMAGINARY WORLD, THE WAY THE WORLD SHOULD BE.'

VERTICAL/HORIZONTAL

The question whether to shoot vertically or
horizontally is a vital one in street photography,
but the answer should come to you naturally.

This aspect of street photography is absolutely crucial and is often overlooked by novices and experts alike. When reviewing people's work, I can hear myself repeating, 'That's quite good, but why didn't you take it as a vertical?' You've seen the moment but you've cooked it wrong, and there's no going back. No amount of cropping will rescue the dish.

Admittedly, there are scenes which would suit both horizontal and vertical framing. A picture can very occasionally work both ways, but the overwhelming point is that a scene will naturally suggest its framing. It is up to the photographer to be in tune with this and to make the most of the shot.

Perhaps unusually, my ratio of vertical/horizontal (or portrait/landscape) is probably more than 60 per cent vertical. I have always been naturally inclined to take more vertical photographs. To me this approach simply makes taking street photographs easier – everything is tidier – and to not have this option would be a severe handicap.

The first two examples here are typical of my approach of instinctively selecting the best composition. A wedding couple in London's Trafalgar Square were being photographed, and hovering around on the outskirts of wedding shoots is always potentially interesting because you do not have to take 'proper' wedding photos. As always, the street photographer has a different agenda. The official wedding photographer could not include another couple, but for me this became the main point of interest.

The horizontal version works to an extent, but there is too much space on the top right, which becomes a distraction because it is too busy. Your eye naturally drifts to the distance in the photograph as opposed to focusing on the two couples. In the vertical version there are no distractions, everything is tightly contained and the eye naturally considers the juxtaposition of the two couples. The two couples fill up the frame and everything is clearer. The stripes on the man's red top in the foreground reinforces the lines of the photograph – the photograph is all about lines – including the alignment of the two hands that nicely provide the bottom of the photograph.

Basic framing is not an exact science but it is very important to be aware of it, and if you study enough examples – amongst your own shots and more importantly in those of established street photographers – the benefits are clear.

The two photographs of the girl with the red umbrella offer a similar natural conclusion. This time, however, the horizontal version is more effective. In the vertical photograph there is wasted space at the top, while in the horizontal version the building naturally prompts the framing. There is a left, centre and middle here – the rule of thirds – but additionally it is the ability to read the script above the door which dictates the outcome. The top has a little too much space, but in general this shot works better as a horizontal.

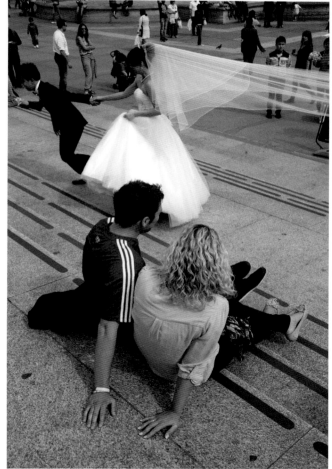

David Gibson, London; 2011

175

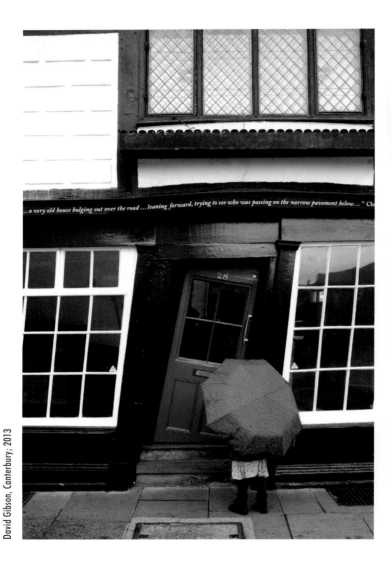

David Gibson, Canterbury, 2013

CONCLUSION

Always consider framing scenes vertically. There are very few photographers who can justifiably only shoot street scenes as horizontal.

- People are vertical, so always consider shooting vertical.
- 90 per cent of street photographs will naturally suggest vertical or horizontal. Allow this natural selection to occur.
- Vertical affords more control over the top and bottom of a photograph.
- Most books and magazines show vertical images.
- Verticals are portrait and horizontals are landscape. Therein lies logic.
- Try to take verticals, to improve your framing instincts.

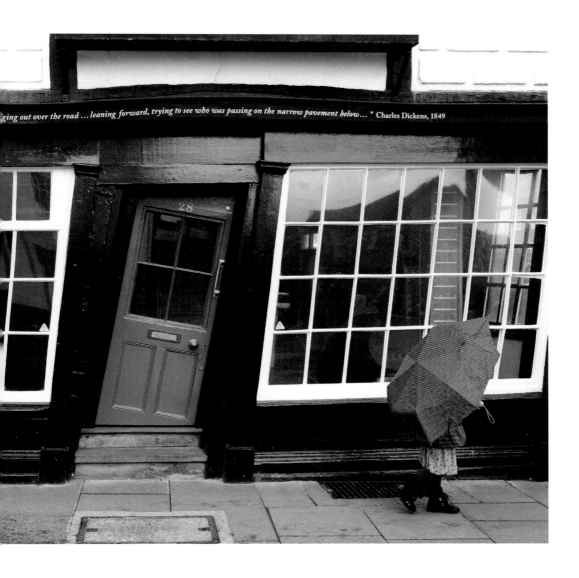

ging out over the road ... leaning forward, trying to see who was passing on the narrow pavement below ... " Charles Dickens, 1849

CRAIG WHITEHEAD

born 1988, Kent, UK. www.sixstreetunder.com

Craig Whitehead – better known as sixstreetunder – is a prolific street photographer. Looking through his Instagram feed is a little overwhelming, with so many striking images winning you over – and many other people too, as his following on Instagram is impressive. To give a figure would soon be out of date because it is constantly increasing.

Whitehead lists his top inspirations, in no particular order, as Gueorgui Pinkhassov, Ernst Haas, Constantine Manos, Saul Leiter, Sebastião Salgado, Fred Herzog and Josef Koudelka. He adds that, outside of the candid street photography range, he loves 'Gregory Crewdson and Ryan Schude for their handling of light and complexity.'

To gain further insight, you might add a list of clear subjects in Whitehead's photographs, such as men's hats, umbrellas and people behind glass, but a better summing up might be light and colour, which are often abstracted. Then there are the careful angles and framing. The latter brilliantly employed in London's Trafalgar Square, where a slightly low-down perspective frames Nelson's column within the elegant curve of an umbrella's upturned wooden handle.

An initial thought is that Whitehead's colour work is derivative of Saul Leiter, or at least of that old Kodachrome film era that might seem overly pronounced. But Whitehead owns it – his version – on the streets of London, Cambridge and beyond.

London, for instance, becomes filtered through a 1950s New York colour sensibility, but if you keep scrolling through his many pictures this assertion becomes shaky. Whitehead is versatile: if he were a tennis player you could argue that he is working hard on his all-round game and is improving.

There is a surprise landscape, it might be from an airplane, but the shimmering light over the green hills and darkening sky is beautiful. Or in complete contrast, a conventional street photograph of a mother and daughter. Taken from behind they walk with a red balloon, which is perfectly lined up with the mother's head.

Here, though, is one of Whitehead's more typical images – light and reflections – a little like Pinkhassov. With framing, angles and surprise, it is one of those photographs that keeps you looking.

Whitehead is a popular street photographer, his retrospective style appeals to many and he takes advantage of this by regularly leading workshops. But it's his energy and high hit rate of artful imagery that mark him out. He might get better.

The prominent hand grasping the flowers is so well seen against the man's reflected profile. The flowers seem to be a gift for the man.

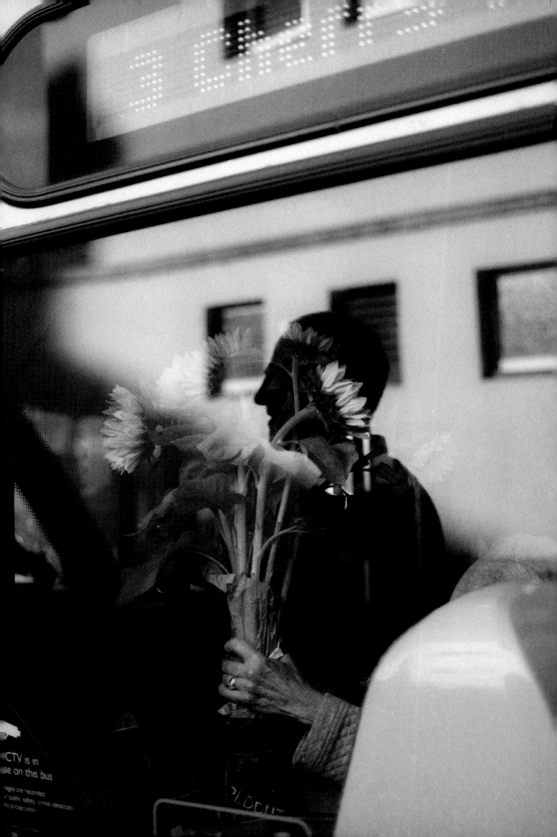

20 ETHICS

Ethics and manners are important aspects of street photography because ultimately they show in the pictures.

It is worth identifying what street photography is in a slightly detached yet considered way. Many people, given a choice, do not want to be photographed on the street, although in reality they are usually unaware of being photographed. Therein lies an uncomfortable truth about pursuing street photography, because objectively it could be considered furtive, strange and at times intrusive or annoying.

These facts are not presented as deterrents but merely aspects that should be recognised. The ethical principle underlying the practice is simply respect for other people. However, these considerations need not be obstacles to taking street photographs, but more a construction of values, which can become personal and evident in the type of photographs you take.

A sense of humour is a fine attribute and it is justifiable to poke gentle fun at humanity in its absurdities and paradoxes. It is not acceptable to depict people cruelly or in an unflattering way. That is my ethos. I hope that I have not strayed from that over the years. It would trouble me if in some way I had caused hurt by my photography.

There are clearly different types of street photographers who ultimately present different values to the public on the street. Diversity is good but there should always be a core respect for people.

I personally dislike an aggressive style of street photography, what you might call 'mugging' people, so that their reaction becomes the picture. This style simply gives street photography a bad name. You could easily include Bruce Gilden in this category; his style is divisive, but it is arguably justifiable because he does it so well. The problem is that many street photographers mimic this mugging style and only achieve agitation; there is no subsequent worthwhile photograph.

Interaction with people on the street is a moot point. I personally dislike it because it is a hindrance to a natural moment, but I concede that some photographers gain instant rapport with people on the street. There is nothing wrong with this if it is after the photograph has been taken. It might well be generous to explain what you are doing, having already got the shot, but not the other way round because it is not within the true spirit of street photography.

It is not the role of the street photographer to alienate people either when photographing them or later in how the photograph is then used. Street photography has been rejuvenated in an age overwhelmed by images, particularly online, but its serious practitioners have responsibilities, both to themselves and the wider photographic community. These are not rules exactly but there are definitely values in street photography for the greater good.

Personality is an important factor in street photography and largely determines the type of photographs that you take, but kindness, empathy and celebration should take precedence. Street photography can be very good at that.

A last word should go to one photograph and imbued in this are my values. 'Last Few Days' was taken in Brighton in 1998 and was a very deliberate – and waited – photograph. I was lucky, the 'casting' was perfect, and it was exactly what I wanted. It is not a cruel photograph but I accept that it is a raw photograph. The man depicted is elderly and it was not his last few days but very likely his last few years.

I avoid photographing the homeless or anyone in distress and 'Last Few Days' is the extent of my 'cruelty', I hope. The image actually went into an exhibition about the elderly and some friends of the man depicted recognised him. I therefore had some indirect correspondence with him and he was apparently not happy about the photograph. But the photograph was taken in a public place – and crucially it was not being used commercially to sell a product.

This photograph has been published many times and in one photography magazine it prompted someone to write: 'Perhaps when Mr Gibson is older, someone will photograph him like this and he will not find it quite so funny.'

I find this photograph more poignant than funny because it is an inescapable fact for all of us. And it grows ever more relevant.

David Gibson, Brighton; 1998

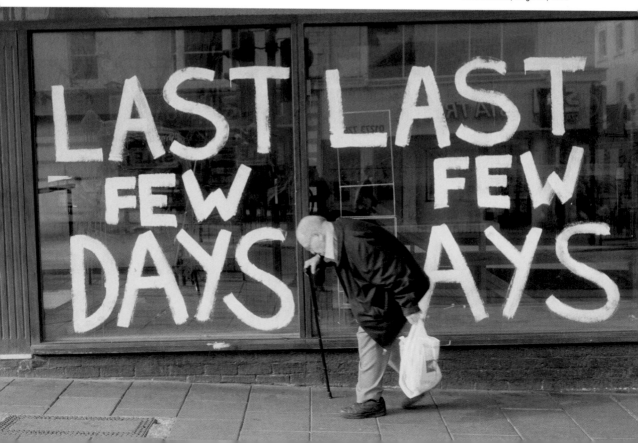

CONCLUSION

This book was born out of leading street photography workshops and to some extent is aimed at the type of enthusiasts who have attended them. I have led innumerable workshops in London and other cities around the world and I have learnt one stark truth that grows steadily with conviction. You cannot realistically 'teach' participants to take meaningful photographs because ultimately everybody has to be self-taught. You cannot teach a hunger for something; you can only be an example of someone who has been through that process.

If there is an inkling within you to do something creative like street photography that spark will ignite. Empathy, then, with other photographers who have built upon that first spark, will enrich and accelerate your own progress.

That then is a parting shot – seek out like-minded photographers online, but more importantly in the flesh. Because there is a paradox with street photography, it is a singular activity best done alone, but it is unquestionably nurtured collectively. Just consider all the street photography collectives that have emerged together with meet-up groups. The whole of photography thrives upon the pull of kindred spirits. The history of photography is built upon small groups and schools of photographers long before the Internet. Feedback and support is essential.

Should you consider doing a street photography workshop or even a short course? The answer is probably yes; do one with a photographer whose work you admire; maybe even do another workshop with another photographer. But that should be enough. It's then up to you.

The other point I wish to conclude with is simply inspiration, whose theme I hope shines brightly throughout this book. You have to feed your inspiration, and an analogy might lie in street photography itself because there is always the possibility of something new around the corner. You keep going; you hope for something better to arrive.

Don't get bogged down into what is and is not street photography. It does not matter. Find kindred spirits, join with other photographers, share your discoveries, but above all *look* at photographs and particularly look at them in books. Put your own photographs aside. Never be obsessed with your own photography; enjoy and be inspired by the work of others because some of that will come out in your own photography.

Seek out the best and let that speak to you. Yes, everybody's 'best' is different but you will eventually find your way if you listen hard enough. You should then go looking for *your* photographs. This might seem a vague piece of advice but consider how comfortably the photographers in this book own their photographs.

Arguably there is too much photography now and some might say that everything has been done before and that there is nothing truly original anymore. That is not true; there are just so many more resources to tap into – just look at the popularity of Instagram – so it's a really exciting time to be a street photographer.

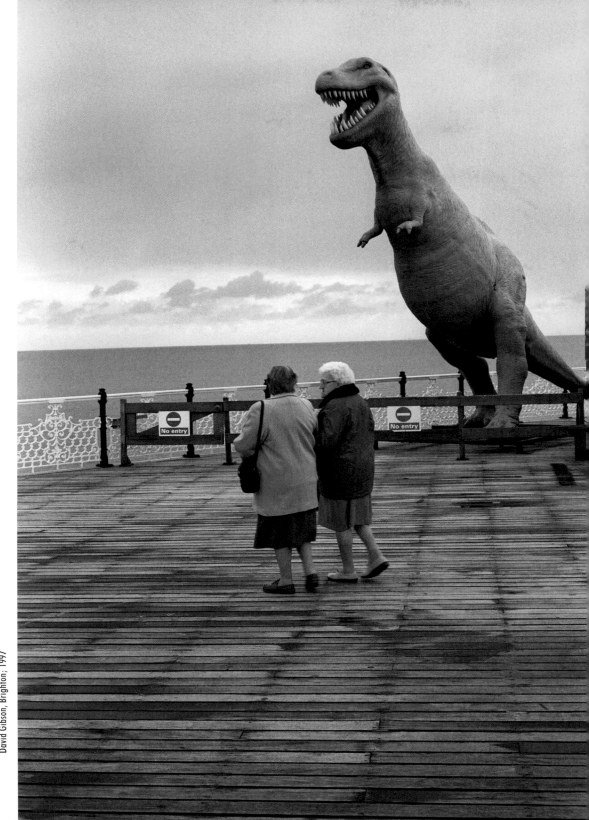

David Gibson, Brighton; 1997

GLOSSARY

35 mm camera. Commonly used for street photography. So named because of the 35 millimetre film (analogue), but which can obviously be digital.

Apps. Software, especially with mobile devices for Instagram, such as Snapseed.

Aperture. The aperture is the hole in a lens that light travels through to reach the film – or sensor in digital cameras. Controlling the size of this hole determines the amount of light entering the lens.

Bracketing. To take a series of pictures at different exposures.

Burn. A traditional darkroom term that means to darken parts of an image under the enlarger – and a tool that has migrated to digital post-processing.

C.41 processing. The chemical process used for colour film.

Compact cameras. Also known as point-and-shoot cameras, designed for simplicity of use.

Curves. The curve tool is an important aspect in photo editing software, controlling the tones and contrast in images.

Depth of field. DOF is the range of acceptably sharp focus in front of and behind the distance the lens is focused on. Generally a low f-stop – the aperture more open – gives a low DOF, whilst a higher f-stop – the aperture closed down more – gives an increased DOF. The DOF is both a result of available light but can also be a deliberate style.

Dodge. A traditional darkroom term that means to lighten parts of an image – and a tool now used in digital post-processing.

DSLR. Digital single-lens reflex camera; see SLR.

Exposure. A combination of the aperture and shutter speed, a term that is generally prefixed with 'correct', which may or may not be true for every photographer or situation.

Grain/noise. A grainy look consisting of specks; a result of using a high ISO in low light.

Image stabilisation. Some digital cameras have a built-in image stabilisation system which can be very helpful in reducing blurred images when only a slow shutter speed is possible. It is especially helpful with a long lens.

Instagram. An online photo sharing and social networking service that enables users to take pictures and videos and apply digital filters. A distinctive feature is that it showcases photos as a square shape similar to a Polaroid camera.

ISO. The sensitivity of a film, which translates to digital photography. Traditionally known as the film speed and also the ASA. Generally speaking, a low ISO (100–200) is ideal in good, even light conditions whilst in low light conditions the ISO can be set from 1600 to 6400 depending on the capabilities of the camera. Setting the ISO is also a personal choice; many photographers will routinely set the ISO at 800 or higher even in good light, to guarantee a fast shutter speed of, say, 250th or 500th of a second.

JPEG. A universal image file format that is recognised by all computers and photo displaying devices.

Lomography. A particular kind of camera and photographic movement. The Holga camera, for instance, is a cheap plastic film camera that produces dream-like images with strange effects such as vignetting and unusual saturation and contrast.

Prime lens. A lens with a fixed focal length, usually in the range from 28 to 50 mm.

Pushing and pulling film. A traditional term for allowing a photographer to make a particular film type behave like that of a 'faster' or 'slower' film. This is a very personal choice but typically a street photographer might set a 400 ISO film at 800 to allow a little more flexibility with the exposure.

Rangefinder camera. A camera that contains a rangefinder device; a mechanism to determine distance and focus without looking through the lens to focus. It is a very particular way of taking photographs, traditionally adopted by photographers such as Cartier-Bresson, who used a Leica rangefinder camera.

RAW. A very large file format that allows much more flexibility in post-processing images. The best 'negative' in digital photography is a RAW file.

Resolution. A word generally interpreted as the quality of an image, similar to a negative that is blown up and then scrutinised closely. In digital imaging, it usually refers to the number of pixels per inch in an image file. Low resolution is suitable for posting images online, printing ideally requires a high resolution.

Shutter speed. The shutter on any camera is closed until you click the shutter button, which opens and closes the shutter for a period of time, allowing a specified amount of light to reach the film or camera sensor.

SLR. A single-lens reflex camera uses a moving mirror system so that when looking through the viewfinder you are actually looking through prisms and mirrors.

Zoom lens. A lens that has a varied focal length allowing a photographer to shoot various distances – that in a sense crops without moving.

BIBLIOGRAPHY

Adams, Robert, *Why People Photograph*, Aperture, 1994

Barthes, Roland, *Camera Lucida: Reflections on Photography*, Vintage, 1993

Campany, David, *The Open Road: Photography & the American Road Trip*, Aperture, 2014

Cartier-Bresson, Henri, *The Mind's Eye: Writings on Photography and Photographers*, Aperture, 2004

Cartier-Bresson, Henri, *Photographer*, Thames & Hudson, 1980

Cartier-Bresson, Henri, *The Decisive Moment*, Simon & Schuster, New York, 1952

Crawford, Alistair, *Mario Giacomelli*, Phaidon, 2001

Delpire, Robert & Koudelka, Josef, *Exiles*, Thames & Hudson, 1997

Dyer, Geoff, *The Ongoing Moment*, Abacus, 2005

Dyer, Geoff, *But Beautiful*, Abacus, 1998

Erwitt, Elliott, *Sequentially Yours*, teNeues, 2011

Erwitt, Elliott, *Personal Exposures*, W W Norton & Co, 1988

Fieger, Erwin, *London: City of Any Dream*, Thames & Hudson, 1962

Frank, Robert, *The Americans*, Robert Delpire, 1958 (Paris)

Gibson, David, *Street Photography: A History in 100 Iconic Images*, Prestel, 2019

Gibson, David, *100 Great Street Photographs*, Prestel, 2017

Gilden, Bruce, *Facing New York*, Dewi Lewis Publishing, 1997

Higgins, Jackie & Kozloff, Max, *The World Atlas of Street Photography*, Thames & Hudson, 2014

Howarth, Sophie & McLaren, Stephen, *Street Photography Now*, Thames & Hudson, 2011

Hurn, David & Jay, Bill, *On Being a Photographer*, LensWork, 2001

Jay, Bill, *Occam's Razor: Outside-in Viewing Contemporary Photography*, Nazraeli Press, 1994

Jeffrey, Ian, *A Concise History of Photography*, Thames & Hudson, 1981

Kertész, André, *On Reading*, Grossman Publishers, 1971

Koetzle, Hans-Michael, *Photographers A–Z*, Taschen, 2011

Kozloff, Max, *Saul Leiter (Photofile)*, Thames & Hudson, 2008

Maloof, John, *Vivian Maier: Street Photographer*, Powerhouse Books, 2011

Marks, Lee & George, Alice Rose, *Hope Photographs*, Thames & Hudson, 1998

Mermelstein, Jeff, *SideWalk*, Dewi Lewis, 1999

Meyerowitz, Joel, *Joel Meyerowitz: Where I find Myself: A Lifetime Retrospective*. Laurence King Publishing, 2018

Parke, Trent, *Minutes to Midnight*, Steidl, 2013

Parke, Trent, *Dream/Life*, Hot Chilli, 1999

Riboud, Marc, *The Three Banners Of China*, Macmillan, 1966

Salgado, Sebastião, *Genesis*, Taschen, 2013

Sandburg, Carl & Steichen, Edward, *The Family of Man*, MoMA, New York, 1955

Scianna, Ferniando, *To Sleep, Perchance to Dream*, Phaidon, 2008

Sire, Agnès & Leiva Quijada, Gonzolo, *Sergio Larrain: Vagabond Photographer*, Thames & Hudson, 2013

Solomons, David & Gibson, David, *Up West*, Bump Books, 2009

Stuart, Matt & Dyer, Geoff, *All That Life Can Afford*, Plague Press, 2016

Stiletto, Johnny, *Shots from the Hip: Another Way of Looking Through the Camera*, Bloomsbury, 1992

Szarkowski, John, *Looking at Photographs: 100 Pictures from the Collection of The Museum of Modern Art*, MoMA, 1974

The Street Photographs of Roger Mayne, The Victoria & Albert Museum, London, 1986

Westerbeck, Colin & Meyerowitz, Joel, Bystander: *A History of Street Photography*, Laurence King Publishing, 2017

Winogrand, Garry, *The Animals*, MoMA, New York, 1969

Online:
blakeandrews.blogspot.com
magnumphotos.com
instagram.com/burnmyeye
instagram.com/calle_35
instagram.com/joel_meyerowitz
instagram.com/unposedcollective
instagram.com/upphotographers
instagram.com/observecollective
instagram.com/streetphotographyinternational

INDEX

Page numbers in **bold** refer to main entries; *italic* page numbers refer to reproductions.

A
abstract photography 104–7, 124
Adams, Robert
 Why People Photograph 29
Agou, Christophe
 Life Below 48
Allard, William Albert 24
Andrews, Blake **84–5**
animals and birds 158, 160
aperture setting 36–7
Araki, Noboyoshi 10
Arbus, Amy 48
Arbus, Diane 46, 48–9, 62, 90
Arnold, Daniel 56
Asa, So 39
Autio, Narelle 136, **172–3**
 Not of this Earth 172
 The Seventh Wave 172
auto-focus 36
Avalos, Anahita 144

B
backgrounds 80–3, 86
Bailey, David 17
balance 46, 55, 120, 132, 134, 154,
 162, 172
Barthes, Roland
 Camera Lucida 112
Bayer, Jonathan
 Bottle in the Smoke 140
behind, views from **92–5**
bird's-eye views 98–101
Bischof, Werner 106, 160
black-and-white 24, 36, 37, 76
blurred imagery **108–11**
body language 68, 94, 160, 162
Boubat, Edouard 45
Braden, Polly 144
Bram, Richard 28, 29
Brandt, Bill 142
Breyer, Melissa 39, **124–5**
Brown, Clifford 102
Burden, Shirley C.
 Chairs 146
Burn My Eye 30, 118

C
Capa, Robert 49, 106
cars 141
Cartier-Bresson, Henri 6, 8, 17, 18–19, 21,
 45, 46, 50, 52, 66, 76, 78, 80, 85, 96,
 102, 106, 107, 136, 141, 150
 The Decisive Moment 45
character 62, 94, 141, 146
children 158, 162–3, **162–5**
Chrobak, Damian 30
clouds 141
collectives 29–30, 103, 118, 182
colour 24, 37, 49, 73, 76, 102–3
 blurred shots 110, 117
competitions 171
composites 16

composition 161
 vertical/horizontal 174, 176
Contemporary Urban Photographers
 (CUP) 10
Crewdson, Gregory 178
Crobak, Damian 30

D
Daguerre, Louis 138
Dakowicz, Maciej 73
decaying objects 148
Delpire, Robert 96
depth of field 36–7
digital cameras 36, 37, 84, 106
 test shots 82
digital manipulation 15–16
distortion 14, 114, 120, 122
Doisneau, Robert 45
Donovan, Terence 17
doubles **132–5**
Düsseldorf School 142
Dyer, Geoff 172
 But Beautiful 8
 The Ongoing Moment 8

E
editing 32, 37
Eggleston, William 145
Einzig, Melanie 48
empty streets 141, **142–3**
enigma 124
equipment 32, 36, 42
Erwitt, Elliott 16, **50–1**, 64, *64*, 90, 120,
 160, 168
 Personal Exposures 50
ethics and manners 21, 49, **180–1**
Eugene Grid Project 85
Evans, Walker 104, 160–1
events **58–61**
exposure
 compensation 37
 test shots 82

F
Facebook 30, 32, 103, 162
Facio, Sara 73
fashion photography 16–17
Fauer, Louis 126
Feininger, Andreas
 The Complete Photographer 6–7
Fieger, Erwin 17
 London: City of any Dream 20
film cameras 36, 37, 84
filters 36, 114, 117
Flickr 30, 73, 103, 141, 144
flow 52, 55
focus 36, 108–11
fog 117
following **86–9**
framing 100, 112, **174–7**
Frank, Robert 45, 46, 66, 74, 161
 The Americans 26, 45, 62
Freed, Leonard 42, *43*, 66
Freud, Lucian 106
Friedlander, Lee 46, 52, 66, 78, 85

G
Gaberle, David 39, **150–3**
 Metropolight 150
Gangculture (Trevor Hernandez) 146, 148
Gernsheim, Helmut and Alison 42
Giacomelli, Mario 106, 107
 Little Priests 106, *107*
Gibson, David 27, 47, 53–5, *59*, *60*, *69*,
 70, *75*, 81–3, 87–9, 93–5, *99–101*, *105*,
 109–11, *115–17*, *120–3*, *127–9*, *133–5*,
 139, *143*, *147*, *149*, *155–7*, *159*, *161*,
 163–5, *169–71*, *175–7*, *181*, *183*
Gibson, Ralph 154, 156
Gilden, Bruce 46, 48, 49, **62–3**, 180
 Coney Island 62
 Facing New York 62
graphic subjects **154–7**
Groskopf, Michelle **166–7**
 Sentimental 166
Gruyaert, Harry 73

H
Haas, Ernst 107, 108, 110, 150, 178
Harding, John 56
Häusser, Robert 154
Herzog, Fred 178
high-definition 106, 108
Himmel, Paul 118, 124
Ho, Fan 11, *11*, 17
Holden, Troy **56–7**
 Hope Photographs 74
Hopper, Edward 137
horizontal shots 174, 176
Hudson, Don 30
humour 50, 158, 180
Hurn, David 26

I
imperfections 80
indoor subjects 160
In-Public 9, 29, 37, 42, 58,
 64, 136
inspiration 26
Instagram 39, 146, 182
Invisible Photographer Asia (IPA) 10
ISO setting 37, 108

J
Jay, Bill
 Occam's Razor 25
Jay, Bill and Hurn, David
 On Being a Photographer 26
Jeffrey, Ian 42
Jones, Tiffany 144
Jorgensen, Nils 37, 64, *65*, 73, 76, **90–1**,
 160

K
kaleidoscopic effect 132
Kalvar, Richard 71, 85
Kardianos, Zisis 118
Kelsang, Rinzing *12–13*
Kertész, André 42, 45, 90, 92, 98, 114
 On Reading 168

Kim, Eric 30
 103 Things I've Learned About Street Photography 32
Kimura, Ihei 102
Kirkwood, Kate 9
 Spine 9
Klein, William 17, 62
Kolár, Viktor
 Ostrava 150
Kouldelka, Josef 78, 136, 178

L
Larrain, Sergio 32, *33*
layers 112, **114–17**, 118, 148
Lee, Kevin W.Y. 10
Leiter, Saul 76, 104, 150, 178
lenses 14, 36, 37
Levitt, Helen 56, 162
light conditions 36, 82, 84
Lightroom 37, 39
light as subject 142
lining up **68–71**
litter 140
location 10
long lenses 14
looking down **98–101**
looking up 100
Lowry, L.S. 90

M
McCullin, Don 76
McDonough, Paul 56
McLaren, Stephen 146, 148
Magnum 12, 21, 26, 30, 42, 50, 62, 66, 103, 130, 138
Maier, Vivian 76, *77*, 78, 127
Makovec, Jirí 160
mannequins 138, 148
Manos, Constantine 144, 178
Marlow, Jesse 39, 73, **136–7**
 Don't Just Tell Them, Show Them 137
 Wounded 137
Matisse, Henri 154
Mayne, Roger *44*, 163
Mermelstein, Jeff 48, 56
 Sidewalk 48
Meyerowitz, Joel 32, 45, 46, 48, 66
middle distance 161
Minas, Gustavo 39
mist 117
mobile phone cameras 21, 39
Moon, Sarah 17
Moriyama, Daido 10, 52, 102
Morley-Hall, Andy 29, *31*
 Please Do Not Feed 158
movement 108–11

N
Nares, James
 Street 46
Neurath, Johanna 140, **144–5**
Newhall, Beaumont 42
night 141, 142
Noguchi, Shin **102–3**
 Sweet Dreams 102
 Umbrella 102
Nurala, Rammy 39

O
objects **146–9**
O'Brien, Colin 20, *20*
online collectives 29–30
order **52–5**

P
Pagnano, Patrick D. 56
pancake lens 36
Papageorge, Tod 46
Parke, Trent 24–5, *25*, **130–1**, 136, 172
 Dream/Life 130
 Minutes to Midnight 130
 The Seventh Wave 172
Parr, Martin 24, *25*, 49, 78, 112, 160
photo-essays 25
photography books 26, 32, 45, 130, 168
Photoshop 37, 39, 126
Picasso, Pablo 17
Pinkhassov, Gueorgui 73, **112–13**, 150, 178
 Sightwalk 112
Plachy, Sylvia
 Signs and Relics 168
Plotnikova, Maria **72–3**
Polaroid camera 104
Portland Grid Project 85
portraits 17, 21, 48–9, 92
post-processing 32, 37, 39
Powell, Gus 48
privacy 21, 49, 180
Programme mode 36
projects **168–71**
'punctum' 122

Q
quiet photography 74–7

R
Rai, Raghu 10, *10*, 108
rain 117, 126, 127, 154
Ramachandran, Sasikumar *22–3*
Ray-Jones, Tony 66, 90, 136, 160, 161
 A Day Off: An English Journal 58
reality 14–16, 84
reflections 112, 118, 124, **126–9**, 132–5
rhythm 52, 55
Riboud, Marc *38*, **96–7**
 Three Banners of China 96
Rothko, Mark 104
rule of thirds 174
Russell, Paul 9, 37

S
Salgado, Sebastião 73, 76, 106, 112, 171, 178
 Genesis 76
 Workers 76
Sandler, Richard 56
Sanguinetti, Alessandra 73
Schoneveld, Merel **78–9**
Schude, Ryan 178
Scianna, Ferdinando *16*, 17
 To Sleep, Perchance to Dream 74
self-portraits 120, 127
sequences 64–5, **64–5**
shadows 66, 82, **120–3**
Shore, Stephen 145
shutter speed 36, 37, 106, 107, 108, 110
Simon, Jack 17, **118–19**
simplicity 96, 161
single-lens reflex (SLR) 37
Siskind, Aaron 104
skies 100, 141, 154
Smart, Jeffrey 137
Smith, W. Eugene 25, 45, 106
smoke 117
Snapseed 39
snow 117, 145, 154

Sontag, Susan
 On Photography 42
space 74, 77, 94
staged photographs 14–15, 80–3
steam 117
Steinert, Otto 108
Stiletto, Alias Johnny
 Shots from the Hip 17
still photographs 138–41
Strand, Paul 90
street furniture 140, 141
street markings 100, **154–7**
Street Photographers Collective 73, 103
Street Photography Now 103, 118, 144
Strömholm, Christer 45
Stuart, David
 A Smile in the Mind 66
Stuart, Matt 14, *15*, 58, **66–7**, 158
subject matter 14–17, 32, 158–61
Sungthong, Angkul **40–1**
surrealism 9, 102, 107, 114, 132
Szarkowski, John 158

T
Tang, Ying 144
telephoto lens 20
test shots 82
text, accompanying 171
That's Life 30
time as factor 74, 141
titles 171
Towell, Larry 76
trees 140–1
Tumblr 32
Turnley, Peter 32
Turpin, Nick 8, 29, 42
typography 140, 156

U
Un-posed 30
upside-down imagery 122, 127

V
vertical shots 174, 176
Vohra, Vineet 39
Vulf, Roza 39, *48*

W
waiting **80–3**
Walker, Robert
 Color Is Power 49
 New York: Inside Out 49
weather conditions 61, 117, 126
Webb, Alex *34–5*, 73, 104, 112, 136–7, 144, 172
 Hot Light/Half-Made Worlds 137
Westerbeck, Colin and Meyerowitz, Joel
 Bystander 45
Whitagram 39
Whitehead, Craig 39, **178–9**
wide-angle lenses 14
Winogrand, Garry 46, 48, 56, 66
 Arrivals & Departures 160
 The Animals 158
Wolf, Michael 148
 Tokyo Compression 115

Z
zoom lens 37

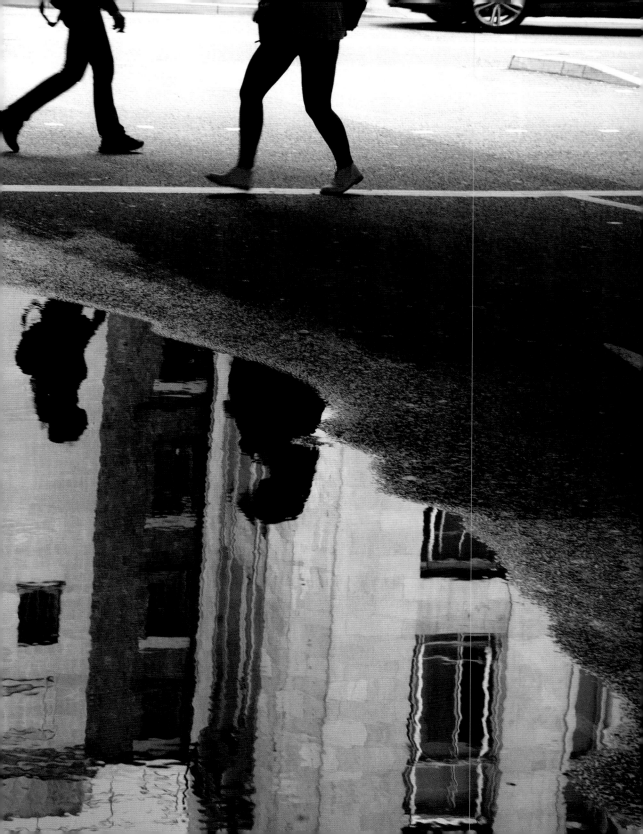

ABOUT THE AUTHOR

Zisis Kardianos, Athens; 2011

David Gibson was born in 1957 in Ilford, Essex, UK – the very same Ilford that still manufactures photographic films and paper – a fact that has always delighted him as some sort of destiny. In his black-and-white photography days, Gibson regularly had a handful of Ilford films stuffed in his bag and he still has a stack of Ilford boxes at home, full of prints and contact sheets.

Gibson has taken street photographs for over 30 years and his work has been widely published and exhibited. He is included in *Street Photography Now* (2011), an anthology of the world's leading street photographers, and more recently in the revised edition of *Bystander: A History of Street Photography* (2017). He is one of the founders of the international street photography collective In-Public, now called UP Photographers.

In 2002, Gibson completed an MA in Photography: History and Culture at the University of the Arts in London (previously London College of Printing).

In addition to his photography, Gibson has regularly led street photography workshops in London and other cities around the world.

The Street Photographer's Manual, first published in 2014, is a bestseller and has been translated into seven languages. His other books are: *100 Great Street Photographs* (2017) and *Street Photography: A History in 100 Iconic Images* (2019).

www.gibsonstreet.com
www.in-public.com
upphotographers.com
www.instagram.com/upphotographers
www.instagram.com/
 davidgibsonstreetphotography/